PHOTOS
THAT SELL

PHOTOS THAT SELL

The art of successful freelance photography

Lee Frost

David & Charles

To my daughter, Kitty,
born during the writing of this book

A DAVID & CHARLES BOOK

First published in the UK in 2001

Copyright © Lee Frost 2001

Lee Frost has asserted his right to be identified as author of this work
in accordance with the Copyright, Designs and Patents Act, 1988.

A catalogue record for this book is available from the British Library.

ISBN 0 7153 1115 8

Printed in Italy by Lego SpA
for David & Charles
Brunel House Newton Abbot Devon

Publishing Director Pippa Rubinstein
Commissioning Editor Anna Watson
Art Editor Diana Dummett
Desk Editor Freya Dangerfield

All photographs by the author except for the following:

Tim Gartside, pages 30–1, 54 (top left and right); Paul Cooper,
pages 36, 56 (top), 59, 62–3, 66, 68, 76; Kathy Collins, pages
51–2, 144; Graham Peacock, page 53; Malc Birkett, page 72; Chris
Rout, page 75 (right), 78, 82–3, 133, 143, 145; Tom Mackie,
pages 107–108; Peter Adams, pages 120–1; Simon Stafford, pages
128–9, 130, 131, 132, 135, 136; Duncan McEwan, pages 138
(top right and bottom right), 168–9; Derek Croucher, pages 148
(both); Granville Harris, pages 160 (both); Geoff Du Feu, pages
163, 167 (both)

CONTENTS

Introduction

Whether it's gardening, horse-riding, coin collecting or painting, most hobbyists harbour dreams of one day turning their spare-time interest into a money-making occupation. And why not? If you're stuck in a frustrating routine of nine-to-five wage slavery, doing a job you don't really enjoy merely to pay bills and put food on the table, being able to earn a living by pursuing something you love quite naturally seems the most amazing thing on earth to do.

For most people, of course, this dream remains exactly that – a dream – simply because making money from many hobbies is difficult. Fortunately, photography is one of the rare exceptions, and a growing number of enthusiasts are realizing that it's possible to profit financially from their interest, *without* having to take huge financial risks or throw in their day job.

The reason for this is simple: out there, in the big wide world, there are thousands of businesses that rely on photography every day of the week to promote their services or create products. Books, magazines, newspapers, postcards, catalogues, brochures, leaflets, advertising campaigns, labels, posters, greetings cards, packaging, company reports – all these things and many more could not survive without photographs, because although words are powerful they don't come close to the potency of a photograph in getting over a message, illustrating a fact, creating a feeling, showing what something looks like or suggesting a lifestyle.

All these photographs have to come from somewhere, of course, and in every country throughout the world there are professional photographers ready and waiting to satisfy that need. Unlike in most professions, however, you don't actually have to be a 'professional' photographer to take a slice of the action. Most picture buyers aren't interested in who took a picture, providing it's of a high enough standard and does the job for which it was intended. Consequently, there are thousands of hobbyist photographers up and down the land who between them earn millions every year by selling the use of their work.

Quite often, the individual returns are small and merely contribute to the cost of pursuing what is essentially an expensive hobby. But if your intentions are more serious, the opportunities are there to make large sums of money, and turn that hobby into a lucrative part-time business.

The first step in achieving this is to realize that although it's possible to take pictures of what you like, when you like, and then find markets for them, your chances of making sales will be increased significantly if you shoot with a particular market in mind. This needn't involve a radical departure from the subjects you normally shoot – it just means thinking in a more commercial way while you are taking pictures of those subjects.

It may also mean looking for specific opportunities to take saleable pictures, instead of merely going out for the day with your camera and shooting whatever attracts your eye. For many enthusiasts, the joy of photography comes more from the act of taking successful pictures than from what those pictures contain, so if making money also figures into the equation, you should give priority to those subjects that are most likely to sell.

The next step is to read this book, because *Photos That Sell* has been written to help enthusiast photographers just like you to make money from the pictures you take during your spare time. If you are already an active freelancer, you will also find lots of advice and inspiration on how to exploit new markets and increase sales. This will be achieved in two ways.

Part 1 explores the different markets open to part-time photographers: markets

such as magazines, books, calendars, postcards, newspapers and local businesses, where a large proportion of the pictures used are obtained from freelance contributors.

Next, you will find advice on joining a picture library and the benefits this can offer, on making use of digital technology, and the factors to consider if, as a result of your freelance activities, you are asked to take on a photographic commission. Each chapter also features an interview with a photographer working in these areas, so that you get advice and tips from a real expert.

Part 2 then takes an in-depth look at the main subjects that part-time photographers can shoot and sell: People and Lifestyle; Nature and Scenics; Holidays and Travel; Sport and Fitness; Business and Finance; Transport, Industry and Science; Animals and Wildlife; Agriculture, Food and Drink; and Concepts and Style.

Each chapter offers advice relevant to that particular subject, including the type of pictures that sell, the markets that use them, how to vary your approach when dealing with different markets, and the equipment you need. You will also find 'live' examples of shoots that have been set up specifically to show how even the simplest approach can produce saleable pictures, examples of pictures that have sold – and how much money they have made – plus more advice from specialists in each field.

All in all, this makes *Photos That Sell* the most inspirational and informative book on freelancing ever written, and although I can't guarantee that by reading it you will make money from your photography, I can say with confidence that it will be an essential aid in putting you on the road to freelance success.

Good luck.

Lee Frost

May 2000

PART 1
MARKETS AND MARKETING

SPECULATIVE SELLING

The vast majority of photographers get their first taste of freelancing by sending in pictures to a market on the off-chance that a use can be found for them. This is known as an on-spec, speculative or unsolicited submission.

More often than not, magazines are the first market to be targeted, simply because there are so many to choose from, dealing with all manner of subjects. However, there are many others worth considering, too, such as calendar and postcard publishers, tourist boards, local businesses, newspapers, book publishers, Photo-CD publishers, design agencies and so on.

Clearly, working in this way can be very hit-and-miss because you're literally taking shots in the dark: posting off an envelope full of pictures in the vague hope that someone you've never met before, and who has never heard of you, will like what they see and select your work for publication over all the other submissions.

But it's a valuable learning curve, because with every rejection slip – and believe me, you'll see plenty of those in the early days – your resolve to do better the next time will grow stronger, and eventually your success rate will increase to the point that almost every submission you make will see a financial return.

The key to success in making on-spec submissions lies in studying the requirements of your chosen market. You need to look at the photographs already being used and establish if the work you're producing is suitable, not only in terms of subject matter but also in style and quality. You also need to think about *when* to make that submission, so that your work is being considered at the right time – there's little point in sending pictures to a calendar publisher a month after they have finished the selection process for the following year's calendars. Presentation of your work should also be given some thought.

Initially these factors tend to be ignored simply because the excitement of making

your first submissions takes priority, but over time you'll become more choosy about what you send, where you send it and when you send it.

It's also vitally important to analyse the outcome of each submission, so that you get a better feel for the needs of a particular market. As well as asking yourself why certain pictures were rejected, you also need to look at the ones that are accepted for publication because they, more than the rejects, hold the secrets of future success. You may find that one postcard publisher has a fondness for blue skies and bright sunshine, for example, while another prefers more dramatic lighting, or that the editor of a particular magazine has a penchant for certain locations.

Ultimately, speculative selling is a process of elimination. It's about seeing the opportunity to make a sale, then eliminating all the factors that could make your submission unsuccessful.

Initially, this is no easy task, but if you have the determination to succeed and are willing to work hard you will be rewarded with regular picture sales. You will also establish a strong relationship with the markets you supply, and this almost always leads to bigger and better things.

To help stack the odds of success in your favour, this chapter takes the main markets for on-spec submissions in turn and explores the factors you should consider when thinking about targeting them.

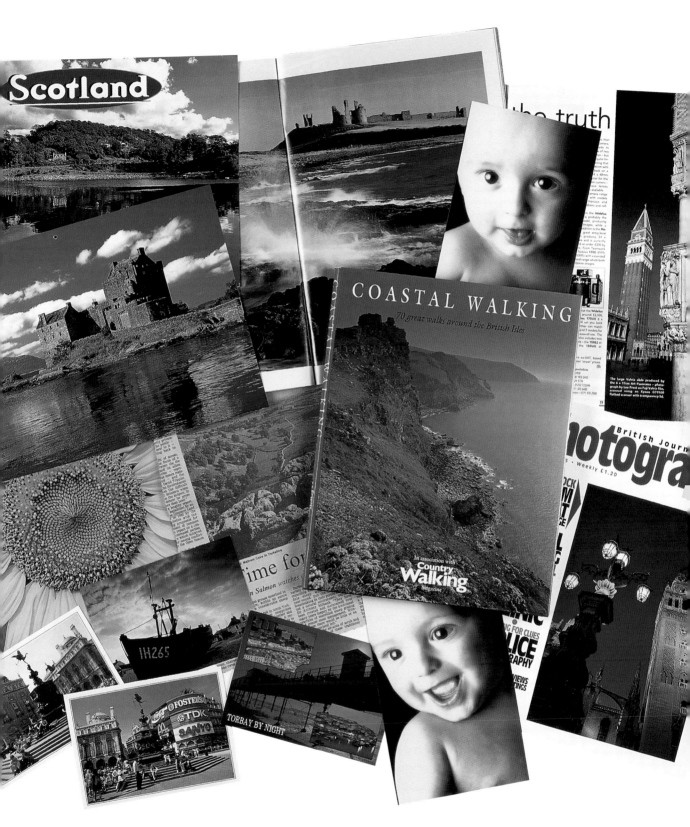

Here are just a few of the hundreds of tearsheets I have amassed over the years through making on-spec submissions to different markets – everything from magazines, books, calendars and postcards to brochures, tourist guides and newspapers.

The magazine market

Of all the markets available to freelance photographers, magazine publishing is by far the biggest and most accessible – if only due to the sheer volume of different titles in print that cater for every conceivable subject, interest and taste.

In the UK, for example, there are several thousand different magazines in print, many of which lack the budgets to commission top photographers and rely instead on freelance contributors to satisfy their voracious appetite for images. This means that every month of every year, tens of thousands of photographs are required and millions of pounds are paid out in reproduction fees.

What's more, you needn't be an established freelancer to take a slice of this business – many of the images used by magazines come from enthusiasts who have other careers outside photography and take pictures in their spare time. If that sounds like you, then read on.

Specialist subjects

The easiest way to sell your work to magazines is by targeting specialist titles that deal with a subject you're interested in. Photographic magazines are the most obvious, but as well as photography, the chances are that you have another hobby (or two), be it gardening, classic cars, backpacking or fish-keeping.

Whatever the subject, you will probably buy magazines that deal with it, so you should have a good idea of the type of photographs they require. Not only that, but being a photographer it's inevitable that you will have involved picture-taking with your other hobbies, so you probably have saleable pictures on file already – pictures that could be making money for you.

If you shoot landscapes, outdoor magazines are an obvious target market for your work – here are two of my photographs used by Country Walking magazine, on the cover and across a spread inside. Both pictures were taken with a Pentax 67 medium-format camera on Fujichrome Velvia colour transparency film.

I began my freelance career in exactly this way while still a teenager, initially sending off my best pictures to the photographic magazines I used to read at the time – and which, in some cases, I am still supplying to this day – hoping that they would be chosen to illustrate how-to-do-it articles, or would be published in the 'reader portfolio' pages. Inspired by early sales, I then started to explore other areas of the magazine market such as the walking and outdoor titles, and within a couple of years I found that my income from picture sales more than paid for my photographic hobby – which seemed amazing then, and still does today, even though it is now my career.

Know your market

Before making a submission, spend a little time analysing your chosen magazines.

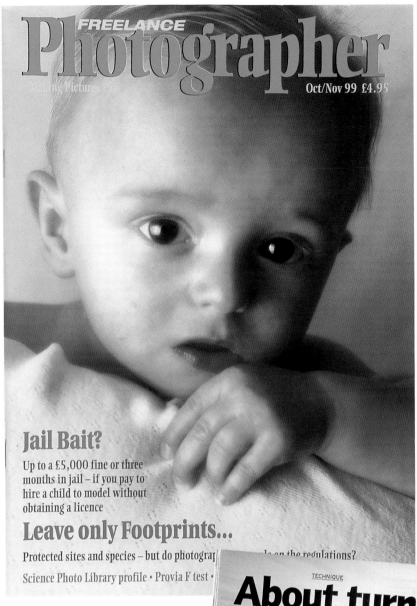

Jail Bait?

Up to a £5,000 fine or three months in jail – if you pay to hire a child to model without obtaining a licence

Leave only Footprints...

Protected sites and species – but do photograp[...]

Science Photo Library profile • Provia F test •

The easiest way to make sales in the magazine market is by concentrating on subjects you're familiar with, then finding suitable titles for them – as with this portrait of my young son used on the cover of a photographic magazine. Success is 80 per cent judgement and 20 per cent luck.

Any pictures you take that illustrate photographic technique are ideal for photographic magazines – especially comparison pictures of the same scene or subject with different lenses, filters, films, exposures, viewpoints and so on.

Check the staff list to see if an in-house photographer is used. This is rare on most specialist magazines, but where it is the case, it will considerably reduce the sales opportunities available.

Next, check the name credits next to each photograph to see who is supplying them – lots of different names is a good sign, whereas one or two suggests the magazine has major contributors. Again, this doesn't mean you shouldn't send in your own work – magazine editors are always on the lookout for good new contributors – but it will slim down the chances of success.

Magazines dealing with subjects that don't have mass appeal, such as arts and crafts, are a good bet, because there will be fewer photographers sending in their work. Titles covering photography, walking, climbing, camping, railways and trains also offer excellent opportunities. However, once you get into homes and gardens, cars, motorbikes and most sports, you will find that a lot of photography is commissioned and the market for speculative submissions is much smaller – though it does still exist.

If the magazines you intend to supply are those that you already buy

About turn

Turning your back on the sun deprives your pictures of the most dramatic light

back on to colour transparency film and then submit the copy slides.

More and more magazine publishers are also using digital technology these days, so you may be able to send your work on a CD-Rom, or e-mail scanned images direct to a computer in the magazine's office. This level of technology is still relatively rare, but it's worth asking.

In terms of format, the majority of magazines will happily accept 35mm, but for bigger reproductions such as full page or dps (double-page spread) and the main cover image, medium-format is preferred.

In all cases, your pictures should be well captioned with all relevant information. This will vary according to the market – for an outdoor magazine specific location information is vital, while for a photographic magazine the camera, lens, film, filters and exposure used will be more valuable. This information can either be entered on to the slide mount or the back of the print, or in the case of technical photographic details, provided on a separate sheet.

and read, you should have a good idea of the style of photography favoured and the sections in the magazine where freelance contributions tend to be used. Factors such as whether those pictures are black and white or colour should also be noted, and it's worth flicking through the pages to see if there's a text box anywhere stating that unsolicited contributions are welcome, along with any general terms and conditions which may steer you in the right direction.

Technical requirements

Unless you are told, or have read otherwise, assume that only transparencies will be accepted if you're submitting colour photographs – photographic magazines and some low-circulation titles will accept colour prints, but they will be rejected by most publishers. Where black and white pictures are used, you can submit prints – ideally 10x8in in size, printed on glossy paper and unmounted. Alternatively, copy black and white prints

First submission

The most common way of supplying magazines is to make a general submission of stock images, with a covering letter saying you are happy for them to be held on file for possible future use. Magazines that use freelance contributors on a regular basis tend to have filing cabinets in the office where these submissions are stored – either under the name of each photographer or by subject/location. When pictures are

required to illustrate a feature or fill a particular slot in the magazine, the editorial team will then refer to these files and make their selection. If you don't mind saying goodbye to your photographs for six months or more, this is a good way to work because there's a greater chance of them being used – some photographers may have hundreds of images lodged with a magazine at any given time, and have something published in every issue.

Another option is to send in material for a specific issue, or a particular section – such as the 'reader portfolio' in a photographic magazine. By doing this there will be less chance of you making a sale, but your submission will also be turned around fairly quickly if it's rejected.

The main thing to consider when making a submission like this is that magazines tend to work well in advance. With a monthly publication, the August issue will go on sale in July but work will begin on it as early as late April/early May, for instance. So, if you intend sending some winter pictures to a walking magazine, say, you need to post them off during early autumn otherwise you'll miss the boat. These 'lead-in' times should also be considered for any magazine that has a seasonal bias.

Alternatively, you could send in pictures to support ideas for features. This is the trickiest approach of all, because if the idea is rejected, your pictures probably will be, too. That said, magazine editors are always on the lookout for new, interesting and different ideas, and if you know a lot about the subject there's no reason why you can't come up with them.

Whichever route you take there are no guarantees of success, and initially you will probably amass enough rejection slips to sink a ship. However, if you analyse why a submission has been rejected, learn from your mistakes and keep on trying, eventually you will see your work in print

– even if it's only a tiny photograph tucked away on some obscure page at the back of the magazine.

Continued success

Once you have achieved your first sales, it's surprising how easily this initial success can be followed up. It's almost as if everything clicks and suddenly makes sense. Instead of making silly submissions that don't stand a chance of being used, you become more choosy about which pictures to send and when to send them.

It's also a fact of life that once the editorial team of a magazine become familiar with your name and your work, they will make more of an effort to use you. Writers, editors and designers are busy people, so if they know that by going to a certain file they will find what they're looking for, then that's exactly what they will do, instead of looking under names they've never heard of before. That's why you often see the same names cropping up month after month in magazines. It's not just because they take good photographs, but also because the magazine's staff know that, too – hence the importance of perseverance.

Once this stage is reached, and your reputation as a capable, reliable contributor is established, you can start phoning the magazine every month or so

New magazines tend to have a greater need for pictures than established titles, so look out for new launches. I heard that this magazine was about to be published so I got in touch, made a submission and got one of my pictures on the cover of the very first issue.

to see if they have any specific requirements – thus putting the odds of success more firmly in your favour. The magazine may also start contacting you with specific requests for pictures, or even phoning you a few weeks in advance so that you have the chance to shoot something specifically for them. There are still no guarantees that your work will be used, but it would be highly unlikely for you not to make a sale.

The key to success lies not only in taking the right pictures, but in getting them in on time, not making excuses if you miss a deadline, and not being a nuisance.

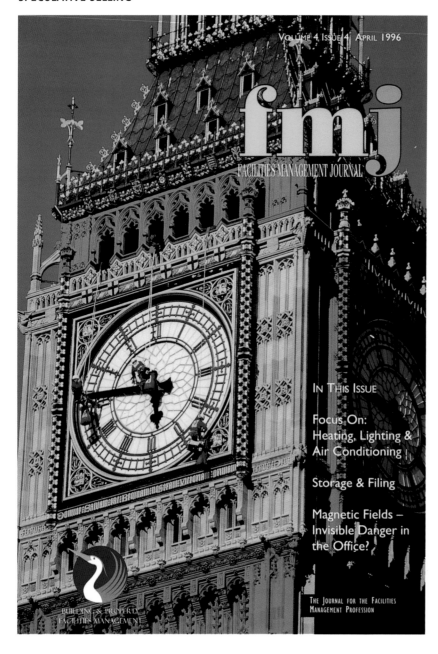

VOLUME 4, ISSUE 4, APRIL 1996

fmj
FACILITIES MANAGEMENT JOURNAL

IN THIS ISSUE

Focus On:
Heating, Lighting &
Air Conditioning

Storage & Filing

Magnetic Fields –
Invisible Danger in
the Office?

BUILDING & PROPERTY
FACILITIES MANAGEMENT

THE JOURNAL FOR THE FACILITIES
MANAGEMENT PROFESSION

Once your work starts appearing in print on a regular basis, new sales can come from all manner of sources. This shot of Big Ben in London was used on the cover of a trade magazine after the editor saw the same shot in a national newspaper (see page 26).

A magazine editor or writer will quickly tire of people who phone up every couple of days for leads or to see if something has been used, but if you do as you're asked, promptly, and leave everyone to get on with their job, then you will win a lot of friends.

This fact in particular is worth bearing in mind, because journalists tend to move around a lot. So, if you've struck up a good working relationship with certain individuals, there's no reason why they won't continue to use you when they go to work on a different magazine, even if it's in a completely different market.

Branching out
Speaking of which, once you have found your feet in a familiar market you should seriously consider looking for other magazines to supply. If you enjoy photographing landscapes and interesting locations, there are various countryside and heritage titles worth checking out. Similarly, if you have young children or a baby, you could photograph them and send the results off to a parenting magazine – even if you don't normally read such publications.

A good habit to get into is to make a weekly or monthly visit to a large newsagent and to spend a little time checking out the magazines on sale. This will ensure you don't miss any new magazines, and it will also give you the chance to flick through titles or sections you would normally ignore. In fact, it's worth making an effort to examine a different section of the magazines on sale on each visit, because you never know where opportunities might exist.

WHAT THEY PAY
This varies enormously depending on the circulation of the magazine – how many copies it sells – and the market it caters for. Rates tend to be pro rata, based on the size of the pictures used.

The average fee in the UK is rather low at around £80 per page for magazines that freelancers can usually sell pictures to – photographic, outdoor and other specialist-interest titles – though some magazines pay less and others more.

Cover pictures generate higher fees. Again, the average is around £150 for hobbyist-type magazines, but the editor of a small-circulation title may only offer £50, while a market leader may pay £500-plus.

If you feel the fee being offered is too low, haggle politely – you may be offered a little more if your work's worth paying for.

Calendar publishing

Compared to magazines, the calendar market is rather more competitive. This is mainly because there are fewer publishers to target, but also because typically only 12 or 13 images are required to illustrate a whole calendar. A publisher producing 50 calendars – which is quite a high number – will therefore only need around 600 images in any given year, but may well receive submissions from 100 photographers or more.

Despite these drawbacks, if you're producing the right type of work it is possible to make regular sales.

Target markets

The easiest way to locate calendar publishers is by referring to guides such as

The Freelance Photographer's Market Handbook and *The Writers' and Artists' Yearbook* (see page 191) or similar publications in other countries. These will give you a list of the main players, contact names and also brief picture requirements.

The main drawback with this approach is that hundreds of other aspiring freelancers will be doing exactly the same thing, so inevitably competition becomes even more intense.

One way around this is to visit local newsagents, bookshops and department stores, and check out the calendars on sale – October to December is the best time, as stocks are high. If you see a calendar hanging in an office, factory, workshop, hotel reception or anywhere

Always be on the lookout for potential new outlets. I discovered the publisher of this calendar completely by chance while on holiday and have been supplying the company with images ever since – this is one of my shots on the cover of a Scotland calendar.

else, it's also worth noting the publisher's name, address and telephone number.

Inevitably you will come across products from well known publishers while doing this, but there's also a chance that you will discover one or two names you weren't familiar with and which could present better opportunities. By looking at calendars already in print you can also study the type of pictures being used, which will point you in the right direction.

Once you have this information, phone

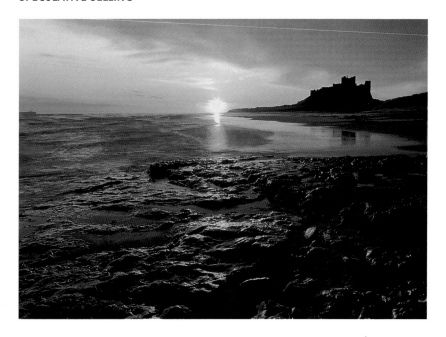

Here's a perfect example of the type of photograph that is likely to appeal to calendar publishers: dramatic scene, stunning light, powerful wide-angle composition and a strong sense of place.

the publisher, explain that you've seen some of their products and that you are interested in making a submission. Key questions to ask are:

• When is the best time of year to submit photographs?
• Who should they be submitted to?
• Which formats are accepted?
• Do you need to enclose a stamped, addressed envelope?
• Which year is being selected next?
• What copyright terms apply?
• Which subjects/locations are currently being sought?
• Would it be possible to receive a product catalogue for the current range or some sample calendars to use as guidance?

Most calendar publishers have set times of the year when they select pictures – usually in the early months from January to March, though it can vary. And while smaller companies tend to work a year in advance, the bigger players often work two years ahead.

Knowing which year is being worked on is important for copyright reasons. Calendar publishers usually request exclusive calendar rights on any pictures they select for the year the calendar is in print. This means that if you sell the rights to a picture for use in a 2003 calendar, you must not then let another calendar publisher use the same shot in another 2003 calendar. Do so and you will have breached the copyright agreement made with the first publisher which may end up with you at worst being sued and at best being blacklisted by both publishers.

A more positive reason for knowing which year you're supplying pictures for, however, is that you can sell calendar rights for the same picture to different publishers, providing they want to use it in different years – if one company has already selected an image for 2003, you can still sell exclusive calendar rights on that same shot to a different publisher for 2002 or 2004.

Keeping records of who you have sold what to and for when is advisable here, so that you can avoid copyright disputes and maximize sales – good pictures will sell year after year.

Picture pointers

In terms of subject matter, at least 80 per cent of calendars published feature scenic pictures, so these obviously provide the greatest sales opportunities. Other subjects used include gardens, flowers, pop and sports stars, classic cars, glamour, sport, royalty, animals and so on, though in many cases these 'other' subjects are usually obtained direct from photographers or agencies that specialize in them, so it's harder to make sales unless you have a good range of high-quality shots to choose from.

And that really is the key with submitting work to the calendar market – quality. There are few, if any, calendar publishers who will accept anything but colour transparencies. Images composed horizontally (landscape format) are also generally preferred to upright images.

Some smaller publishers will accept 35mm transparencies, but the majority demand medium-format (6x4.5cm, 6x6cm, 6x7cm or 6x9cm) and a few won't entertain anything smaller than 5x4in. There's also a growing market for panoramic photographs, but they usually need to be 6x12cm or 6x17cm shot on rollfilm. No matter how good you think your work is, forget about submitting formats smaller than the minimum stated as they will be rejected out of hand.

In all cases, your pictures should be perfectly exposed, pin sharp, well lit and preferably shot on slow-speed film such as Fujichrome Velvia or Kodak Elite Chrome 100. Scenic pictures should also be taken in good light. That either means bright sunshine with blue sky – a polarizing filter will come in handy for making the most of such conditions – or more dramatic stormy conditions in the case of wild landscapes. There's also scope for sunrise and sunset shots, and pictures that are

taken in frosty, snowy or misty weather.

Avoid dull, grey days, and keep out of your pictures people, traffic, litter, graffiti, electricity pylons, telegraph poles and other things that date them or spoil the view.

The main thing to remember is that a complete calendar charts seasonal changes throughout the year, so if you have taken pictures through spring, summer, autumn and winter you stand a greater chance of making sales.

A good geographical spread of subject matter is also important. So rather than photographing one region in great depth, try to cover lots of different areas, otherwise there will be a limit to how many pictures one publisher can use in any one year.

Although landscapes are by far the biggest sellers to the calendar market, there are opportunities to make money from other subjects such as cars, boats, flowers, gardens and animals.

Given the right light and weather, you can take saleable calendar pictures literally anywhere. This scene, captured close to my home, normally doesn't demand a second glance, but on a crisp winter's day under a coat of freshly fallen snow it's a different story – it has already sold several times to calendar publishers.

WHAT THEY PAY

In the UK, the fees paid for calendar rights vary from around £50 to £250, with £100 being about the average. This is per image, for calendar rights for a single year.

Picture postcards

As with calendars, the majority of postcards are produced by a relatively small number of publishers – in the UK, you could count the main players on one hand. However, in a typical year they will produce hundreds of new 'views' so there are ample sales opportunities out there.

In all cases, the pictures that sell the best are those showing the most popular scenes and attractions. So, if you intend submitting pictures of a seaside resort, top of your list should be pictures of the beaches, any popular coastal views, the harbour, significant buildings and monuments, and so on.

These shots are often referred to as 'generics' because they immediately say 'this is London, this is New York, or this is Paris'. More so than with calendar publishing, the postcard market has little or no place for obscure photographs that could have been taken anywhere.

A good tip is that if you're going to somewhere specifically to take pictures for submission to a postcard publisher, check out the postcards already on sale. The chances are you'll see the same views cropping up time after time – they're the ones you should photograph first, aiming to produce something better than the postcards you've already seen.

As well as classic postcards in touristy areas, most postcard publishers also work alongside salespeople and other smaller companies around the country, producing postcards for sale in lesser-known locations – to the point that there are few towns and cities where you can't buy postcards showing local scenes. The results aren't always inspiring, but someone has to take the pictures for them, so why couldn't it be you?

Breaking in

If you've never submitted work to a postcard publisher before, the easiest way to get your foot on the ladder is by putting together a small submission of perhaps 20–24 colour transparencies that represent a good cross-section of locations. Alongside this, enclose a list of other locations you have photographed, either generally – the English Lake District, the French Riviera, the hill towns of Tuscany and so on – or in detail with specific subjects/locations listed beneath each regional heading. This will allow the picture editor not only to gauge the quality of your work, but to note which places you have photographed as well.

You'll find details of the main publishers in freelance directories such as *The Freelance Photographer's Market Handbook* or equivalent, but checking out the postcards on sale in any places that you visit is advisable, too – and perhaps buying a few from the range for future reference.

When first making contact, ask the publisher for any 'wants' lists they might have, so that you have details of exactly which locations are required. Also, ask for your name to be added to the mailing list for future picture requests.

In some cases, this may mean that you receive lists of literally hundreds of locations if a publisher is having a major update or branching into new areas. Even better, the lists tend to be sent out months, even a year, in advance, so you will have time to visit and photograph some of the locations listed.

In the picture

The picture style and content required will vary according to the location.

Places where tourists go to sightsee, sunbathe and generally have a good time should be revealed at their best. That means bright sunshine, blue sky, perhaps a few cottonwool clouds thrown in for good measure. Sunrise and sunset shots can also be good sellers, as well as twilight shots of floodlit buildings or scenes full of colourful illuminations such as seaside proms and harbours. Dull, cloudy weather and rainy days are a no-no.

If you're shooting an area where people go to walk, camp, climb and enjoy the scenery, then clear, blue-sky weather can also be a benefit. It's not essential though, and often you'll find that stormy, dramatic lighting sells better because it's more typical of the area. Pictures taken in different seasons of the year can also be popular, so don't just shoot the Rockies or the Scottish Highlands in summer – venture up there in autumn when the landscape is alive with fiery colours, or in the depths of winter when it's under a blanket of pristine snow.

Because postcards are small – usually around 15x12cm (6x5in) – publishers are happy to accept 35mm as well as larger formats. Slow-speed transparency film should still be used, however, and your pictures must be technically excellent.

WHAT THEY PAY

£35 to £50 per shot seems to be the range for touristy postcards, though you may be offered £100-plus by upmarket publishers of 'art' cards. This is usually for exclusive postcard rights for five years, either specific to one country or worldwide.

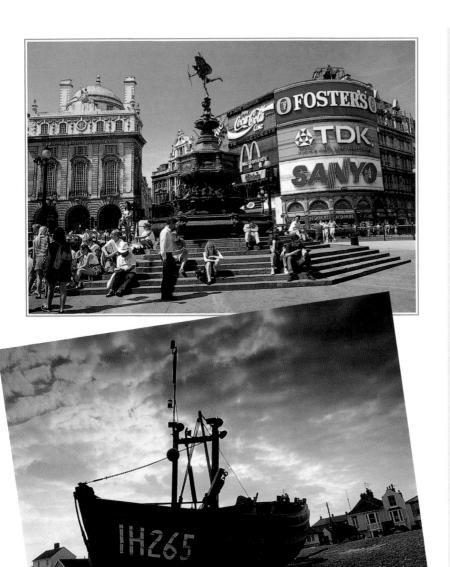

SELF-PUBLISHING

Instead of supplying postcard publishers, some photographers actually publish their own postcards which are then sold on to the retail trade.

This is certainly worth considering, but don't expect to get rich quick – you need to sell tens of thousands of cards each year to see even a decent return, and achieving this can be costly and time consuming unless you live in an area that's frequented by tourists and there are lots of potential outlets close by, so that you don't incur high costs travelling to and from them.

As well as underwriting the cost of having the cards printed – you will need at least 3,000 copies of each card in a range of 12 or 16 cards to make it worthwhile – you must then find outlets for those cards and keep them stocked up, which can be hard work in the busy summer season.

A safer way to try self-publishing, perhaps, is by having one or two shots of local scenes made into postcards and seeing how they sell. If the response is positive, you could then have more cards printed and gradually build up the range by reinvesting your profits.

TOP Popular tourist attractions shot in bright, sunny weather are ideal for the postcard industry – this view of London's Piccadilly Circus, shot with a 35mm SLR, 28mm lens and polarizing filter, is still on sale throughout the capital several years after publication.

ABOVE Over the years, postcard publishers have become a little more ambitious in their use of photography, so pictures taken in more dramatic lighting – like this shot of Aldeburgh Beach in Suffolk – are much easier to sell.

RIGHT When visiting a location with the aim of shooting postcard pictures, concentrate on the major attractions first – you should be able to sum up the character of a place in a single image.

Greetings cards

Today, greetings card publishers are far more imaginative in their use of creative photography than ever before. This is especially true of blank cards that contain no message and have wide-ranging uses. Here, the most popular subjects seem to be garden-based – flower arrangements shot both indoors and out, scenic gardens, garden details such as hanging baskets, arrangements of pot plants, specimen plants and so on. There's also some scope for pictures of animals – everything from cats and dogs (especially kittens and puppies) to horses and ponies, and farm animals such as lambs, pigs, ducks and geese.

At the other end of the spectrum, black and white greetings cards have become incredibly popular, though here the emphasis seems to be on humour, with a witty caption or thought-bubble added to the photograph. Children and babies in funny clothing, or striking amusing expressions, are top of the list, along with animals again – apes, giraffes and elephants can be added to farm animals and domestic pets.

Garden and flower pictures are the easiest to shoot and sell because the subject matter is more accessible. They need to offer something special, however, so consider visiting well known gardens that are stocked with perfect specimens and maintained by experts. Alternatively, purchase cut flowers and photograph them in different arrangements.

As with any market, study what's already out there and try to come up with images that are at least as good. Large department stores and specialist card outlets very often stock a good range of greetings cards that are illustrated with photographs.

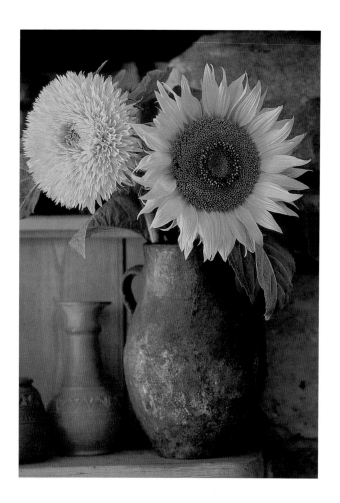

Sunflowers are a perennial favourite among greetings card publishers. This picture, taken in windowlight using a 35mm SLR and 105mm macro lens, is the best-selling card in its range. And I even grew the sunflowers in my garden specially to photograph them. Talk about commitment!

Publishers of contemporary greetings cards will usually accept 35mm images, though medium-format is preferred for garden scenes. Generally, they also prefer 'straight' shots that show the subjects as they really are, but it's worth shooting variations with soft-focus filters, or on high-speed grainy film – especially arrangements or close-ups of cut flowers.

Bright but overcast days, or diffused sunlight, provide optimum conditions for garden photography – direct sunlight can be too harsh and contrasty. Misty spring mornings or crisp, frosty days in autumn and winter can also produce saleable shots for this market – experimentation is the name of the game. If you're photographing arrangements of cut flowers, use windowlight on a dull day and bounce light into the shadows with a large white reflector.

My experience of supplying this market suggests that there are no set times of year when pictures are required: it varies from publisher to publisher, and really depends on whether or not they are actively looking at new ranges of cards.

Your best bet, therefore, is to put together a small submission of suitable images and send them off to the art department, with a covering letter asking for any current 'wants' lists and some sample cards to give you a better idea of the type of images used. If your work is of a high enough standard, this request will be granted – the rest is down to your judgement and a little luck.

WHAT THEY PAY

Payment varies, but £150 is a good average to expect for greetings card world rights for three to five years.

Local business

If you actively photograph your local area, there may be opportunities to sell the use of some of those shots to businesses and organizations based nearby. Local authorities and colleges often require pictures of popular scenes and landmarks to promote the region. The same applies to designers and advertising agencies who put together brochures and reports for local clients, or there may be local businesses that are interested in producing a corporate calendar.

If you live in an area that is popular with tourists, the opportunities will obviously be much greater. But every town and city has its 'nice' parts – historic buildings, beauty spots, a country park perhaps – and at some point, someone will need pictures of them. You may also be able to sell the use of pictures that have been taken elsewhere, or of subjects other than landscapes.

Word of mouth

Freelancers tend to break into this market by chance: a friend of a friend hears that you take pictures and needs some local views; your brother-in-law's design company is putting together a brochure to promote the area and would like some nice scenics. If you can come up with the goods, your name then gets passed around and more requests may result.

You could also do some canvassing yourself, perhaps sending a small submission of colour transparencies – 6 to 12 will do – to various local designers, tourist offices, advertising agencies and so on, with a letter introducing yourself and outlining the subjects you hold on file.

Better still, have a postcard printed featuring your best shot of a local scene

Photographs by **Lee Frost** (Telephone 01733 222895)

Gildenburgh

CREATING AN IMPRESSION WITH DIGITAL PRINT

Gildenburgh Reprographics, 50 Stapledon Road, Orton Southgate, Peterborough, PE2 6TD. Telephone: 01733 391181 Fax: 01733 361101

and your telephone number – small runs of 250 cards can be produced relatively cheaply – then mail it with a covering letter to every local business and organization that might need stock shots. The local commercial telephone directory will furnish you with names and addresses of suitable businesses. The main obstacle with this kind of market lies in actually letting people know you exist, but once they do it's surprising how many may be able to use your work.

In the meantime, it's also a good idea to start building up your library of local scenes and subjects. That means photographing anything remotely interesting in the area, and not just once, but at different times of day, in different seasons and from different viewpoints so that you have plenty of variety to offer. You could also look beyond the immediate area and cover the whole county.

Exploiting local sales opportunities can prove very lucrative. For the last two years I have supplied photographs to illustrate the corporate calendar of a reprographics company based in my home town.

WHAT THEY PAY

This really depends on who uses the pictures and what they're used for. A small business requiring shots for a leaflet may offer £25 per image, whereas a design agency putting together a high-quality corporate report should pay three or four times that amount, and £1000-plus is not uncommon if you supply all the pictures for a corporate calendar.

Book publishers

In recent years, the book publishing industry in many countries has seen radical changes. With rising costs and increased competition to contend with, book publishers are no longer willing to take huge financial risks on titles that might not show a decent return. This not only makes it even harder for unknown photographers to break into the market, but in many cases even successful photographers with a string of previous titles behind them are finding it difficult to get new projects off the ground.

Despite this, photographers still clamour to illustrate books for one simple reason – it's enormous fun. Having a year or more to explore an area and photograph it in detail, or to visit lots of interesting places, is one of the most rewarding ways to work. And then, at the end of it all, you're presented with a glossy book that shows the fruits of your labour – plus a large collection of photographs that you can place with a picture library or sell direct to other markets to earn extra income.

Trial and error

Actually getting to this stage can take a lot of time and effort, of course, so don't expect things to happen overnight.

Initially, you need to come up with a saleable idea. Perhaps there's a region that hasn't been covered by a book. Often there's a good reason for this, but you never know until you try. Or maybe you have a new angle on a well photographed place. Simply asking a UK publisher if you could produce another book on, say, the Lake District is unlikely to get you very far.

Here is the cover and an inside spread from the very first landscape book I illustrated – on Northumbria in northern England. I spent many weeks exploring and documenting the region over the course of a whole year, and although hard work, it was an incredibly rewarding experience.

WHAT THEY PAY

The advance offered could be anything from £1,000 to £19,000, depending on the publisher and the size and/or type of project. Royalties are offered as a percentage either of the book's cover price or the publisher's receipts – the money they actually receive from the sale of the book. This tends to be around 7.5–10 per cent for the former and 10–15 per cent for the latter.

DARTMOOR

Photographs by LEE FROST
Introduction by IAN ROBINSON

The market for landscape books is incredibly competitive, so if you want to get a project off the ground you not only need a saleable idea but your work must be of the highest standard, too.

One approach that proved successful for me was to suggest a follow-up to a new book I saw on sale. That title, on the Yorkshire Dales, was presented as part of a series – even though it was the first book in the series at that time. I contacted the publisher and suggested producing a similar title on Dartmoor, which was eventually accepted and is now in print. But even if the idea you submit is rejected, that doesn't mean you and your work will be. Prior to the above experience I had contacted another, much bigger, London-based publisher with a proposal for the Dartmoor book. This was rejected, but the editorial director liked my work and asked if I would be interested in illustrating a book on a completely different area. Naturally, I jumped at the chance.

It all sounds very easy, but in both cases it took perhaps two years from an idea being accepted or suggested to contracts being drawn up and the work getting underway. In that time I had to research the areas and provide initial photographs, knowing full well that plans could be changed and ideas shelved at any moment.

Making contact

The first step in this long process is to decide on a publisher, and the easiest way to do that is by looking at books already on sale to see which publishers have already produced similar titles, or at least deal with the subject you have in mind.

Next, you need to put together a proposal or synopsis. This should be kept brief, to two or three typed pages, and outline not only what the book will be about – including a proposed chapter breakdown – but why you think there will be a market for it and who you think will buy it. Any existing books it will be competing with should also be listed, along with the publisher and first date of publication, plus a brief biography of yourself and if possible a list of publications in which your work has appeared – handy but not essential.

You will need to supply a set of photographs – 10 to 20 will suffice initially – showing the subject or place you intend photographing for the book. Medium- or large-format colour transparencies are easier to view than

35mm, so if you work in 35mm consider having your selection duplicated up to 6x9cm. Publishers of landscape and travel books generally favour formats larger than 35mm because image quality is higher.

It is highly unlikely that your first idea will be accepted, but don't lose heart. Most publishers will give a reason for rejection, so you can modify your approach the next time. Remember, also, that the more publishers you contact, the more people will be seeing your work, and eventually this may pay dividends.

Contracts

If you are lucky enough to have an idea accepted, it will usually be presented and discussed at a new projects meeting. This may lead to your initial idea being modified to make it more saleable, and you may be expected to do some groundwork. If all goes well, contracts will be drawn up specifying the title of the book, number of pages, the number of photographs you must supply, when the deadline is, the proposed publication date and how much you will be paid.

Payment could be a one-off fee, but more often than not you will be offered an 'advance on royalties'. This means you are paid a fee usually in three parts – when the contract is signed, when your work has been accepted, and when the book goes on sale – and this money is then paid back to the publisher through royalties received on the initial sales of the book. Then, once your account is clear, you will receive the royalties, usually paid once or twice each year.

Newspapers

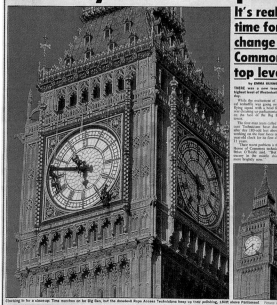

From a photographic point of view, newspaper publishing tends to work on two distinct levels – local and national.

Local papers are by far the most accessible to freelancers interested in making the occasional contribution. The downside is that compared to national newspapers the financial returns are paltry.

In either case, the key lies in coming up with the right pictures, and that usually means something that is going to make people take a second look – in other words, it has to be dramatic, scandalous, shocking, heart-wrenching, dangerous, unusual or simply fascinating.

On a local level, these things are easier to achieve because the audience is smaller and readers of local newspapers tend to be familiar with local issues – so it doesn't take so much to shock them. On a national level, you need something very special if it's going to be of interest to millions of readers.

Pictures of a fatal car crash in a small village might shock the local inhabitants, for example, but people living hundreds of miles away won't be interested. That's not to say pictures taken locally won't sell to a national newspaper – if that car smash involved a celebrity, or if there was a twist to the story, such as the car ending up stuck in a tree, it could be a different matter.

Anything quirky or amusing could have national news value – a rare bird nesting in an unusual place, a gardener growing the world's heaviest pumpkin. This is especially true during midsummer, when nothing much happens, most people are on holiday and newspaper editors are desperate for interesting pictures and stories.

Unless you intend to look actively for newsworthy pictures, your best bet is simply to keep an eye open for photo opportunities when you're out and about, both locally and while travelling further afield, and hope that you're in the right place at the right time. Carrying a camera with you at all times – even if it's a simple compact loaded with colour negative film – is also a good idea, because you never know when you might strike lucky.

Today's news

Should you be fortunate enough to capture something on film that you think is newsworthy, speed is generally of the essence because yesterday's news is old news on a national level, and if you don't get those pictures into the papers within 24–48 hours the opportunity will be lost.

So, as soon as possible start phoning the picture desks of national tabloid newspapers – their numbers are listed in freelance directories – to see if anyone is interested in your photographs. If the response is lukewarm, you may be asked to send the film, unprocessed, by special delivery so that it reaches the desk the next day. If the pictures sound hot, however, the paper will dispatch a courier to pick up the film from you and take it direct to them.

If the pictures are going to be used, they will usually appear in print within a day or two – you should be informed of this. In extreme cases, where the pictures have mass or international appeal, the paper may also ask if they can sell the rights for you to other newspapers. You may even be

Being in the right place at the right time is the key to success if you want to shoot newsworthy pictures. This shot of engineers cleaning the clockface of Big Ben was snapped up by a national tabloid newspaper and a fee of £700 was paid. However, on the day the paper was printed I received numerous phone calls requesting use of the picture and within hours those extra sales took the total payment well into four figures.

contacted by correspondents from overseas newspapers, asking if they can use the shots, or by an agency which specializes in syndicating news pictures worldwide.

WHAT THEY PAY

Fees from local newspapers are generally very small, if anything at all is offered. National newspapers – especially tabloids – can be extremely lucrative, however, with fees running into hundreds of pounds for anything remotely interesting. If you capture a major event on film, that could be increased a hundredfold, while really sensational pictures can, literally, turn you into a millionaire overnight.

Image building

An important aspect of speculative freelancing is that you must present a professional image. Ultimately it's the quality of your work that counts, but you will be taken more seriously in some markets — and possibly offered higher fees — if you give the impression that you're an experienced freelancer rather than a rank amateur hungry to see your work in print. Here are some guidelines that will put you on the road to success.

Putting together a submission

When you're selecting images to send off to a market, be ruthless. Reject anything that isn't pin sharp and perfectly exposed, and clean any transparencies that may have marks on them from handling or prior use.

Colour transparencies should be mounted. For 35mm, use white self-adhesive card or plastic mounts and present them in transparent file sheets which usually hold 20 or 24 slides — never post glass slide mounts as they break very easily. Medium-format transparencies look their best when presented in individual 5x4in black card masks which are slipped inside clear sleeves. Similar masks and sleeves are available for 6x12cm and 6x17cm panoramic shots, while 5x4in large-format transparencies can either be placed in individual 5x4in clear sleeves or presented in 10x8in black masks and sleeves.

Beyond photographic magazines, the market for prints, whether colour or black and white, is limited. However, if you do submit prints, they should ideally be 10x8in or 12x8in in size — anything smaller is difficult to appreciate and anything bigger is simply unnecessary — and unmounted.

Make sure your name and copyright symbol (©), address and telephone number are on each slide mount or the back of each print, along with a caption detailing the contents of the image, for example: Grasmere from Loughrigg Fell, Lake District, Cumbria, England.

For many years now I have produced name/address and caption labels using a computer program called the Craddoc Captionwriter, which allows up to five lines of text to be printed on white self-adhesive labels that are the exact size to fit the top or bottom edge of 35mm slide mounts — though I use them on all transparency masks and mounts.

Covering letter

Enclose a letter with each submission briefly outlining the contents of the package, the number of photographs enclosed (48 x 35mm and 35 x 6x7cm transparencies, for example) and why you are submitting them. Ideally this should be typed or printed from a computer rather than hand-written.

You don't need expensive personalized stationery — if you have a computer you can create a template with your name at the top, your address and contact details at the bottom, and space between for the letter itself.

Packaging the submission

Place sheets of mounted 35mm transparencies, prints, or bundles of medium- or large-format transparencies secured by elastic bands, between two sheets of stiff card that have been cut so they fit snugly inside the envelope you will be using. Stout corrugated card from boxes and packaging is ideal.

Make sure you use either card-backed

Neatly presented transparencies, shown here on my viewing lightbox, will not only make your work easier to view but will also present a polished, professional image to your clients.

paper envelopes (for small submissions), or better still, padded bags – they offer a higher degree of protection and can be reused. If you do reuse padded bags, remove previous labels and stamps so that they look reasonably neat.

Make sure the destination address of the package is clearly entered – I always print it off the computer in large type – and write your own name and address on the back.

Finally, if you need to seal the envelope or bag, use packing tape sparingly. Metres of the stuff just isn't necessary – it merely makes the package difficult to open. Also, avoid stapling the package closed as this can make it lethal to the poor recipient – injuring a picture editor won't win you any favours.

Record keeping

Keeping a record of each submission is essential for a number of reasons.

Firstly, you will know which pictures are where at any given time, and how long they have been out of your files.

Secondly, it will prevent you sending the same (or very similar) pictures to competing markets at the same time, which could result in them appearing in, say, the same issue of two rival magazines or two rival calendars in the same year. As already mentioned, this can lead to a copyright dispute and land you in court, but at best it will probably result in your work being rejected in the future by those clients.

Thirdly, it means that when a submission is returned you can check the contents against your records to make sure everything has come back – or amend your records if part of the submission has been returned and part of it held for possible use.

The record could take the form of a complicated computer database using

Make sure your photographs are well protected and well packaged before mailing them – otherwise they could be damaged in transit.

specially written software. Most part-time freelancers needn't go to such lengths, however, and a simple typed or handwritten list of the shots submitted – ideally with a reference number for each – will suffice.

You can buy books of delivery notes from some professional photographic bodies (such as BAPLA in the UK, see page 191), which come in duplicate or triplicate so that both you and the client have a copy. These allow you to enter details of the submission, but more importantly they list the accepted terms and conditions for the submission of 'stock' images, such as your right to be recognized as the author of the work and the need for copyright clearance before any images are used. They also allow you

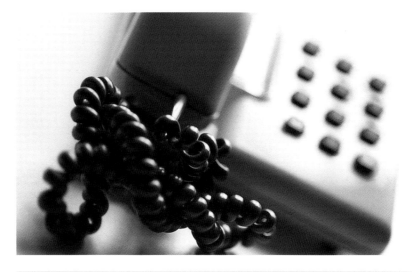

It may be tempting to chase a submission soon after sending it off, but keep that phone on the hook.

to enter an amount which you will claim – in the UK, typically £500 to £750 per original transparency – if your work is lost or damaged. Acceptance of this form implies acceptance of the terms and is basically a safeguard for you.

The main problem with these forms is that they are intended more for photographers who are sending out pictures that have been requested by a client, rather than for making an on-spec submission out of the blue. Consequently, if you use them for such submissions, you may get a phone call or a letter saying the form cannot be accepted. This is usually because the fee payable for pictures that are lost or damaged is too high, and most clients are unwilling to be made liable for pictures they never actually requested.

The good news is that you should rarely, if ever, experience problems. In all my years of freelancing I have only made one claim against a client for damage of a transparency, and that was caused while it was being returned to me by post.

Following up

Once you have posted off a submission, avoid the temptation to start phoning the recipient for feedback two days later. Most people working in the design and publishing world are busy, and it may take them a week or more to look through a new submission – unless they specifically requested it. Phoning them up so soon will therefore do you more harm than good.

As a rule, you should have heard something – either acknowledgement of receipt, or return of the submission – within seven to ten working days. If, by the end of this period, you have heard nothing, a polite phone call won't go amiss, and then again a week later if there's still no feedback.

MAILING

Photographs have no material value beyond the cost of the film or paper, so when posting you should insure them for 'consequential loss' – loss of future earnings from their sale should they be damaged or disappear without trace.

In the UK, the only way to do this is by choosing Special Delivery posting and specifying the level of consequential loss you require: at the time of writing the maximum is £10,000 and costs £3 extra. This makes it relatively expensive to mail large packages, but at least you know that in the event of a problem you can claim compensation.

Original colour transparencies are obviously the most valuable, so this level of cover is recommended every time you make a submission. However, you may decide that it's unnecessary for prints because you can easily make another one from the original negative; the same applies to images submitted on CD-Rom, which are copies from the original on your computer.

When submitting work to a new market, you should also enclose the same level of postage for the return of your photographs – a completed Special Delivery form and sufficient stamps to cover the full cost. This shouldn't be necessary once you have

established a working relationship with a particular company or individual, as they will be happy to cover the cost of return postage. However, you should still specify in your covering letter that consequential loss of £10,000, or whatever sum, is required when the submission, or any part of it, is returned to you.

By doing this, if your work is lost or damaged, you can make a compensation claim against the client and they can re-claim it back from Royal Mail, or the relevant postal organization in other countries. Be aware, however, that these postal companies will look for any excuse *not* to pay compensation. So avoid problems by making sure your work is adequately packaged and protected, and that you write, very clearly, on the front and rear of the package, 'Photographs – Please do not bend' or a similar warning.

Special Delivery with consequential loss cover is the safest way to mail photographs in the UK.

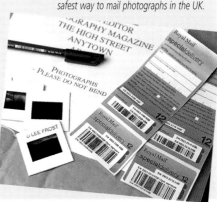

Expert view: Tim Gartside

Ever since his early days as a keen amateur photographer, Tim Gartside has been making on-spec submissions to a wide range of markets, from magazines and books to calendars and postcards. He also supplies picture libraries with his work and takes on commissions to shoot everything from property to weddings.

Tim's Spanish landscapes are still selling well, even though he returned to the UK several years ago and now only visits during his holidays.

While living in Spain, Tim realized that sunflowers were a highly saleable subject and since then he has taken hundreds of pictures of them. This shot generated his biggest single sale to date by being used to promote a brand of margarine.

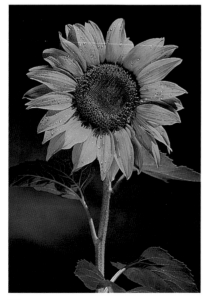

'I remember my first sale like it was yesterday,' he recalls. 'It was a dramatic blue-toned black and white print of Stonehenge. I sent it in to a photographic magazine just on the off-chance they would like it and it was used across a double-page spread. The best part was that they paid me about £100, which, being a hard-up student at the time, was a fortune.

'To be honest, it was a while before I followed that submission up. I was a bit of a fine-art snob at the time so money wasn't a strong motivating force behind my photography. However, after leaving college, getting a job and being made redundant, I joined my parents in Spain where they had retired, and that's when I started getting more serious about selling my work – and taking pictures with sales in mind.

'A lot of photographic enthusiasts are under the impression that you need lots of expensive equipment to take saleable pictures, but during my time in Spain I literally had just one 35mm SLR with wide-angle and standard lenses and a few

filters. Despite that, the pictures I took started to sell quite well – and some of them are still selling today.'

These days Tim still shoots 35mm, but now has lenses from 17mm to 400mm. Several years ago he also added a Mamiya 645 medium-format system with lenses from 35mm to 300mm, and more recently a 5x4in large-format camera with 58mm and 150mm lenses, plus a 6x12cm panoramic rollfilm back.

'I bought the Mamiya kit initially because certain markets – such as calendar publishers – demand formats bigger than 35mm, and picture libraries prefer them too for most subjects,' he says. 'It's all about making your work as saleable as possible at the end of the day, which to a certain extent is why I also bought the large-format camera. It's fiddly to use and the cost per shot is high, but the old saying, "A good big 'un always beats a good little 'un" still applies.'

Since the early days, Tim's hit rate when making on-spec submissions has always been very high because he makes a point of

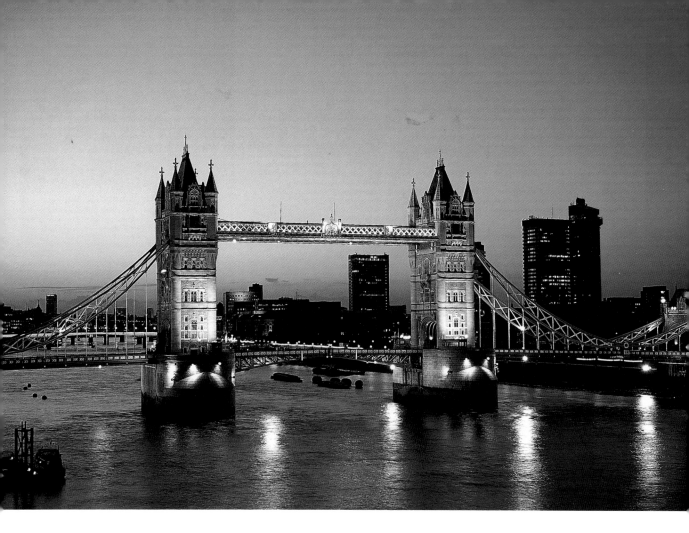

Tim took this superb night shot of London's Tower Bridge from the balcony of a plush apartment – his work in the property industry made this possible.

studying the market and its photographic needs before sending off pictures.

'If you've got a good picture and you send it to the right market, it will sell,' he says. 'I've never been one for sending off huge submissions either – I'd rather select ten really good shots than 200 that are just okay, because when you do that, the good stuff gets lost among the rest.

'You also have to be careful that you don't undersell yourself. I had a sunflower picture published in a calendar, for example, which was seen by a design agency who were looking for something similar to advertise a brand of margarine. Initially, the fee being discussed through the calendar publisher was paltry, so I basically told them to phone around a few

picture libraries, see what fees they would charge and I would accept the lowest. This ended up being a four-figure sum, the biggest payment I've received so far for a single sale.'

During his time in Spain, Tim admits that his biggest obstacle was having lots of time but no money. However, every spare penny was ploughed back into his photography. He also assisted a photographer for a while, which led to him joining a Spanish picture library.

'After about two years I decided to return to the UK and really start pushing my work. Pictures were sent out to photographic magazines, travel magazines, calendar publishers and other markets. I've always been an experimental photographer, playing around with filters, that kind of thing, so my work has always been well received by photographic magazines in the UK.'

Tim then took the plunge and moved to London, hoping this would present him with more opportunities to take saleable shots. For a time he worked as a photographer for a company that dealt with estate agents, which involved shooting property around London. An offshoot of this was that he often found himself visiting properties with incredible views – overlooking Tower Bridge and other famous sights – and by asking permission was usually able to take some pictures for himself.

More recently, Tim has had a book of Spanish landscapes published in Spain which is selling quite well. Hopefully this will lead to further projects from the same publisher, but he also intends using that book as a lever with publishers in the UK – it's always easier to be taken seriously when you have one successful project under your belt.

PICTURE LIBRARIES

Although it's possible to make regular sales by submitting work on spec to different markets (as discussed in Chapter 1), most part-time freelancers come up against a major obstacle when working in this way – time, or rather, a lack of it.

If you're trying to hold down a busy career, raise a family and take care of all those other day-to-day chores like cleaning the car and tending the garden, the time you have left actually to go out and take saleable pictures will be limited enough. Unfortunately, finding potential new outlets for your work, putting together submissions, keeping records, packaging them up and mailing them off can be surprisingly time consuming, so if you're not careful you can suddenly find that weeks have passed and you haven't taken a single new photograph.

The number of markets you have access to as an individual freelancer is also severely limited, so what tends to happen is that everyone targets the same small selection of magazine titles or calendar and postcard publishers, competition for sales is intense because the markets are generally over-subscribed, and your hit rate per submission tends to be rather low.

The easiest way to avoid this dilemma is by finding someone else to market your work, so that you can make best use of the limited spare time you have. Which is where picture libraries come in. These work in a similar way to traditional public libraries, but instead of dealing with books they handle photographic images.

Here's how it works. Freelance contributors like you supply the images and the library sells the use of them to anyone who has the need for photography – this might include publishers, advertising and design agencies, PR companies, private businesses, TV and radio companies, holiday tour operators and so on.

The amount of money each sale generates depends on what the images are used for. Advertising sales attract bigger fees than editorial sales to book and magazine publishers. Similarly, exclusive use costs the client much more than single use, as it limits future sales of that image. So, the big money comes from sales such as worldwide exclusive advertising rights, while single editorial use in a book or magazine tends to represent the lower, 'bread and butter' end of the market.

Whatever rights are sold, the image – typically a colour transparency – is returned to the picture library after use where it is cleaned, re-mounted, re-filed and made available to other markets, in the same way that a book is returned to a traditional library after it has been read. If a client happens to lose or damage the image while it's in their possession, a penalty fee is charged.

In return for doing this, the library takes a cut of all sales made – typically 50 per cent. This may seem a heavy commission, but picture libraries invest vast sums of money in editing, filing and promoting their stock. A good library can also sell your work internationally, to markets that as an individual you would never have access to, and the right pictures can sell dozens of times, earning surprisingly large amounts of money.

You will see evidence of this in the Best Sellers section at the end of each chapter in Part 2. There you will find examples of pictures that I and other photographers have taken, and details of their sales to date. The pictures that have earned the most money and achieved the largest number of sales are inevitably the ones marketed through my picture library.

Chapter 2

Big business

For a long time picture libraries were generally considered a convenient dumping ground for pictures that no one else seemed to want, and commissioned photography was regarded as the only way to make decent money. Now, however, all that has changed, and stock photography has become a multi-billion pound industry – which is good news for part-time photographers.

Recession can be thanked for this to a certain extent, because it changed the perception of stock photography. When times are hard and money is short, one of the first things to get slashed by companies is their photography budget. Consequently, during the economic slump of the 1980s, businesses that normally spent large amounts of money commissioning photographers to take pictures specifically for them began to look to picture libraries for their visual solutions – knowing that it would cost far less to buy the use of existing photographs than to commission someone to shoot them.

The requests being made to picture libraries therefore became more creative and ambitious, this was fed back to the photographers supplying images to the library, and within a few years the whole business had changed, with companies and organizations routinely using stock images when only a few years before they would never have considered it.

Today, picture libraries are at the cutting edge of creative photography. If you flick through a general stock catalogue from a leading library, or go to one of their websites, the images on offer bear no resemblance to those you would have expected ten years ago – they are stylish, imaginative, innovative, versatile, and of a standard equal to that of the very best commissioned photography. The choice of images is also vast, with every conceivable subject photographed in every conceivable way, and the type of photographers supplying picture libraries has changed, with many libraries now actively recruiting top-end professionals to shoot stock for them. An increasing number of professionals are also realizing that they can make more money from stock photography than they can from commissioned work, with far fewer hassles and almost total creative freedom, and are becoming involved with picture libraries to a greater or lesser degree.

All in all, this has raised the standard and profile of stock photography immeasurably, and although it means that actually being accepted by a library is becoming more difficult, and competition to make sales is greater, there are significantly more sales opportunities out

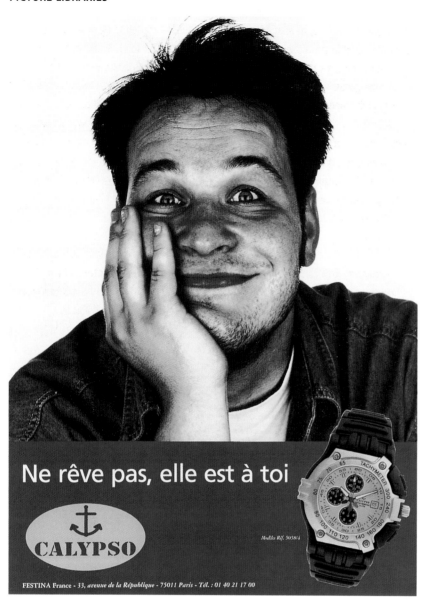

Versatile stock shots will sell to a wide range of different markets and can earn the photographer large sums of money. This portrait, shown here in an advertisement for a sports watch in a French magazine, is my most successful picture to date, and is still selling literally every week. See page 86 for the story behind it.

there for photographers producing the right kind of images. Moreover, digital technology means that picture libraries can market their stock on a global scale, and the financial rewards are better than ever before.

Any photographer serious about selling their work would be foolish to ignore this.

Joining a picture library

Having made the decision to supply a picture library, you need to find one that suits the type of pictures you take. With hundreds to choose from this is no mean feat, so in an attempt to make the job slightly easier, here are answers to some of the most common questions that photographers ask.

Should I opt for a general picture library that deals with all subjects, or look at specialist libraries?

This depends on what you yourself shoot. The biggest and most successful picture libraries tend to have a general subject base, which means they appeal to a vast range of markets. Mainstream subjects such as landscapes, travel, people, lifestyle and so on are general in terms of appeal, so even if you specialize in any one of them, I would still advise you to look at general libraries.

The only time specialist libraries are worth considering is if the type of subjects you shoot are themselves highly specialized and not likely to sell in general markets – perhaps you only photograph trains, dogs, horses or marine life? In that case, a specialist library requiring in-depth coverage of the subject will be a better bet for the bulk of your work. However, I would still offer some of the more generic shots of that subject to a general library, simply because you are likely to achieve more sales by doing so.

Will I make more sales by joining a small library with fewer photographers or a bigger library with lots of contributors?

Smaller libraries are generally easier to get involved with, competition is less intense, and because they are keen to expand their picture collection they tend to accept more photographs, so you could see your stock on file with them grow quite rapidly. The downside is that they also provide fewer sales opportunities, so on balance they're not always the best option.

At the other extreme, the biggest and best-known libraries tend to be more choosy about the pictures they accept, simply because they already have huge numbers available and are more experienced in knowing what will sell. They also take on fewer contributors, and your work will be competing with that of perhaps hundreds of other photographers. However, the biggest libraries also make

considerably more sales, have access to a broader range of international markets, and have the facilities to market their stock more aggressively, so if your work is of a very high standard and you are

LEFT It's surprising what your images end up being used for when you supply a picture library, and where you find them. This book cover caught my eye recently while I was shopping in a local supermarket, and on closer inspection I realized why – I took the photograph!

BELOW Good-quality scenic pictures make popular stock shots, but they need to have something special to sell well. This shot, taken at dusk in the Lake District, oozes atmosphere and symbolizes all kinds of moods and thoughts.

fortunate enough to be taken on, you would almost certainly make more money.

The ideal would be to find a library that's somewhere in the middle – already established, but with big plans for growth and the financial backing to make it happen. Libraries in this position tend to be actively looking for new talent, they're more receptive to new ideas, and your work will be given a big push once that growth surge begins.

What other factors should I consider when choosing a picture library?

Assuming your work is of a high enough standard, the main thing you need to determine is whether or not the libraries you're considering are likely to be effective

Digital manipulation is becoming more popular among stock photographers as it makes endless creative effects possible. Working closely with your library is advisable, however, if you want to generate saleable images.

in marketing and selling your work.

If you target the biggest and best-known libraries then you don't really have to worry, because they have only achieved that status by being effective. However, lesser known libraries may well require further investigation.

Obvious things to look at initially include the following:

Where the library is based
In England, the biggest and most successful libraries tend to be based in central London, because traditionally that's where the bulk of domestic sales came from.

Today, a central London address isn't so important as far fewer people visit the

libraries personally, and the majority of sales come from catalogue images which are ordered using telephone, fax or e-mail. However, it's always a good sign, and a library that is tucked away in some rural backwater is unlikely to be as effective at selling your work unless it specializes in a particular subject and has a good reputation based on that.

How many offices the library has
Having a fleet of offices is no guarantee that a library will make your fortune – in practice, it means much greater overheads, more complicated logistics and a greater risk of financial problems. At the same time, multi-office agencies do tend to be

bigger and more successful than those with a single office, and are able to market your images to a wider audience.

The main library I supply is based in Leeds in the north of England, but also has an office in central London. Since I became a contributor it has also taken over a picture library in the USA, so all catalogue images are duplicated and held on both sides of the Atlantic. Doing business in North America is vital today as it represents some 50 per cent of global stock sales, and any library selling in the UK alone, or even the UK and mainland Europe, will be losing out on a huge share of the market.

One way that picture libraries do this, without having to open offices all over the world, is to use established picture libraries in other countries as their overseas sub-agents. When the library produces a new stock catalogue, copies of it and duplicates of all the images featured are sold to the sub-agents. They then market the images as their own, but pay a large commission to the library who supplied the catalogue and dupes; often, these sub-agents put their own cover on the stock catalogue to make it look like one of their own. The libraries that are associated in this way often exchange stock images when they are putting together new catalogues.

My own library has many overseas sub-agents, but acts as sub-agent for other libraries as well. As a result, not only do my pictures have the chance to sell all over the world, from Turkey to Taiwan, Canada to Colombia, but many have also been selected by overseas libraries who act as sub-agents to my own library in England, for use in their own catalogues.

Food and flowers are two of the more popular stock subjects which picture libraries are always crying out for, and which any keen photographer can shoot with simple 35mm equipment. I took these pictures on my kitchen windowsill, using daylight as illumination. You can't get simpler than that.

The only downside to making sales through sub-agents is that you actually receive less of the total sale – usually 30 per cent instead of 50 per cent. However, the volume of sales can be increased significantly, so overall the financial returns are better than if you only ever sold pictures through a single library in your home country.

How well the library markets its stock

Although the market for stock photography has increased dramatically in recent years, so has the number of libraries competing for a slice of the action – in the UK, for example, the number of libraries registered with the British Association of Picture Libraries and Agencies (BAPLA) has almost doubled. Consequently, if a library is to maintain a market share and not be left behind by its rivals, it must be willing to invest a lot of money in promotion and keep up with the latest trends in technology.

Traditionally, people requiring the use of stock images would visit the library in person and spend a morning or afternoon looking through the files in search of suitable images. Over time, the bigger general libraries then began to produce catalogues of their most commercial images, which were mailed out to clients so that specific images could be ordered over the telephone.

Today, catalogues are essential rather than a luxury. Few end-users – with the exception of freelance picture researchers, perhaps – can now spare the time to visit a picture library in person, so instead they turn to stock catalogues to make their choice. Any general library not producing catalogues on a regular basis is therefore missing out on a huge part of the market – it is no exaggeration to say that as much as 70 per cent of a library's total picture sales can come from catalogues.

From a contributor's point of view, this can be either a good or a bad thing, depending upon which side of the fence you're on – good if your own pictures are chosen for inclusion in catalogues, as they are almost guaranteed to sell; bad if they're not, because there will be 50–100 times more photographs in the library's files than there are in catalogues, probably accounting for less than half the library's sales. Libraries that are prolific catalogue producers are also less keen to keep taking on pictures for file use only, so if your work isn't up to catalogue standard,

or is simply unsuitable for inclusion in catalogues, you may well find that very little of it is retained.

Personally, I would not even consider joining a library that didn't produce stock catalogues at least once a year – unless it was very specialized and had cornered a niche market.

Internet options

Equally important are the library's plans and intentions to take advantage of digital technology and the Internet.

Over the next few years, the Internet will take over from catalogues as the main promotional vehicle for stock images, and already the bigger libraries are investing heavily in websites in an attempt to be ahead of the game. Getty Images, the world's largest photographic archive which continues to buy up leading picture libraries at a rate of knots, predicts that most library business will be conducted on-line within three years. Choosing a library that's active in this area is therefore important, because in five years' time any general picture library not established on the Internet will face serious problems.

The beauty of the Internet is its efficiency. It costs far less to post images on a website than it does to print catalogues. The timescale is also much shorter because libraries can update the images on their website almost daily if necessary, whereas there is usually a 12–18 month production period for catalogues and a further 6–12 months before sales start rolling in. As a result, it could potentially take over two years for you to see a return on new pictures that are selected for a catalogue, whereas with the Internet, images can be viewed and selected within days of you sending them to the library, in which case sales can be almost instantaneous.

And then, of course, there's the market. A big library would have perhaps 100,000

copies of a stock catalogue printed. This sounds like a lot, but once you distribute those copies throughout a whole country or continent – and possibly beyond – the numbers begin to pale. With the Internet, every picture buyer in the world can look at a library's website, an order can be e-mailed to the library, and images can be electronically mailed to the client in a matter of minutes.

The potential this offers is staggering, but only for libraries that are willing to commit themselves to it in a big way.

Is it okay to submit work to more than one library?

Generally, yes. In the UK, one or two of the biggest libraries demand complete exclusivity, but the vast majority don't, and in order to maximize the sales potential of your work I would advise you to get involved with more than one library. I know some photographers who supply up to ten different libraries around the world.

The usual approach is to give one library – the one that generates the most sales – first refusal on new pictures. You could have an arrangement whereby one library only takes images for catalogue use, for example, but doesn't hold anything in its files. Some photographers

An important aspect of stock photography is experimentation, and coming up with conceptual images that could have many uses. For this 'Needle in a Haystack' shot I bought a bale of straw from a pet shop, borrowed a large needle from my wife's sewing box, then simply played around until I had a composition that worked.

supply only a few dozen new pictures per year in this way to their first-choice library, but those pictures often earn more in sales than the thousands of shots that are placed with other libraries.

Once this library has gone through a new submission and taken what they want, you can then offer what's left to the next library down the line, and so on. By working with two or three libraries, you can therefore spread your work out as much as possible.

Another option is to shoot different subjects for different libraries – sending landscapes to one, people to another, and so on. These could all be general libraries, but over time you will begin to see that certain pictures you take sell better through one and others sell better through another. There are also a few libraries that specialize in panoramic photography, so you could shoot 'pans' for them and use conventional formats for another.

In my case, I started out by supplying one well known general library in the UK more than a decade ago, then a few years later I got involved with another general library. Today, the vast majority of my stock sales come from this second library, which has grown considerably since I first started submitting work to it and is my first choice for any new stock images I produce.

Anything rejected by this library is sent to the first library, though any material that I feel won't be suitable for the second library is offered to the first straightaway. At the time of writing I have around 1,500 original images with the first library and over 7,000 with the second. Of these 7,000, perhaps 80 per cent of my sales come from just 60 or so images that have been published in stock catalogues –

Social issues such as smoking, drinking and drug abuse are always in the media, so pictures that illustrate them are in constant demand. This still-life of cigarette butts in an ashtray is simple yet highly symbolic.

which just goes to show how effective catalogues can be in attracting sales.

What you shouldn't do is offer the same or very similar pictures to more than one library, as this could result in the same shot being used by competing markets at the same time. If this happens there may be legal repercussions, especially if both libraries have sold the same rights on the picture or one has sold exclusive rights. But even if you manage to stay out of court, it will undoubtedly cause bad feeling with the libraries and you could end up being blacklisted.

Are on-line picture libraries worth considering?

With the advent of the Internet, it was only going to be a matter of time before picture libraries sprang up that only operate on-line. In other words, they don't have offices where clients can pop in and look through the files, and they don't

produce printed catalogues containing their most commercial images.

Instead, picture buyers access the library's website, browse the files on-line, make their selection and place an order. A high-resolution scan is then sent out on CD-Rom, Zip disk or another storage media, so that the client can use it.

In theory, on-line picture libraries are a

great idea as they're cheap to get up and running, the image files can be updated regularly and new work can sell quickly. The downside is that many picture buyers greatly dislike on-line browsing as it can be slow and frustrating, and flicking through a printed catalogue or phoning through a general request to a film-based library is still preferable.

No doubt this will change over the next few years as use of the Internet in all walks of life becomes more common. At present, however, Internet-only libraries are limited in what they can offer you.

Once I'm supplying a picture library, can I still sell my pictures direct to different markets?

Generally, yes, but with caution.

If the pictures that you offer direct to markets such as book, magazine and calendar publishers are different to the pictures you have submitted to the library, there won't be a problem.

However, if you offer the same or very similar shots, then you need to keep the library informed of any important rights that you have sold. If you sell exclusive calendar rights on a shot for a particular year, for example, you must let the library know so that they don't sell the same rights on the same picture for the same year.

The same applies if you sell a shot for use on the cover of a book or magazine, to a greetings card publisher, or another use where there could be a breach of contract or embarrassment if your library then sold the same rights to a rival publisher.

Will I need to shoot medium-format or is 35mm okay?

This depends on the library and subject. Most libraries prefer medium-format for landscape and travel subjects, but 35mm is fine for people, lifestyle, business, nature and other subjects. For advice related to specific subjects, see Part 2.

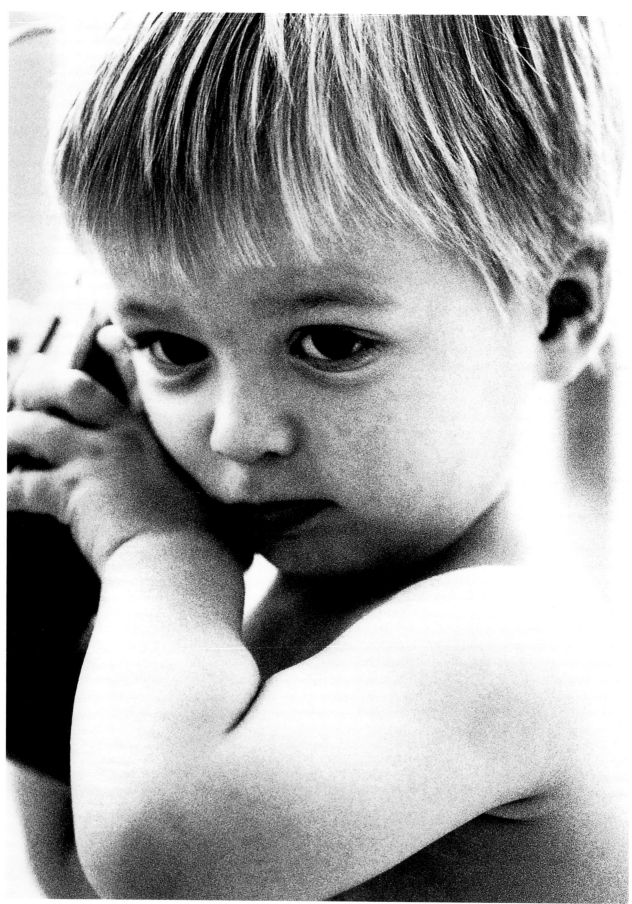

What about film?

Picture libraries only accept transparency film, not prints. For colour photography you should therefore shoot colour slides, and for black and white, the prints should be re-photographed back on to colour transparency film or scanned and supplied on CD.

Where can I find out about picture libraries?

There are various organizations and publications that list picture libraries in different countries (see page 191).

When I have decided on a library, what should I do next?

Initially it's a good idea to compile a shortlist of perhaps five or six libraries that you are interested in supplying, then get in touch with them all and ask them to send any information they have for new contributors, a list of terms and conditions, a copy of their standard contract, and copies of recent catalogues so that you can study the type of images they accept.

Find out how long the library has been established, how many contributing photographers it represents, how many pictures it holds on file, and so on. If you know of other photographers who supply picture libraries, speak to them too and ask them what they think about their own library. It's surprising how many stock photographers keep in touch and discuss the relative pros and cons of their libraries.

If you are based in the UK, or are interested in joining a library that originates in the UK, check out BAPLA's website (see page 191). BAPLA monitors picture libraries in the UK and any library worth its salt will be a member. The

Knowing that good pictures of children can be good sellers, I photograph my own kids, and those of friends and relatives, at every opportunity. This is my son, Noah, shot candidly while he was listening to a musical toy.

website provides general information, and it also offers links to the sites of many member libraries where you can obtain information about that library. Alternatively, if you don't have access to the Internet, write to BAPLA and ask for information.

From these initial enquiries you will probably narrow the list down to two or three libraries. At this point it's perhaps worth making an appointment to visit the library so that you can have a look at the set-up, and discuss your work with the senior picture editor. Alternatively, you could put together an initial submission of images first and send it in to the library. If the response is positive, you may then be asked to pop in for a chat, and to show some more work.

If, on the strength of your first submission, you are basically told 'Thanks, but no thanks', try to find out why. Rejection is always a bitter pill to swallow, but it may have nothing to do with the quality of your work, so don't be disheartened. For instance, the bigger picture libraries are becoming more and more choosy when it comes to taking on new photographers, and you may be rejected simply because your style of photography is too close to that of another photographer already represented, or the subjects you shoot are already over-subscribed by existing contributors.

Depending upon the reasons given, you can then decide whether to approach a different library, or to go away, produce some new work, and then try to get in with your first-choice library again. The majority of photographers would take the easy option and try a different library. But this isn't always the best solution, and if, by rethinking your approach to stock photography, you are eventually accepted by one of the main players, the long-term benefits will almost certainly be greater than if you accept second best.

How many pictures do I need to send?

The majority of picture libraries will state how many images they like to see in an initial submission. It could be as few as 50 or as many as 1,000. Saying that, libraries are in the business of making money, so if you send in 10 amazing pictures that are likely to be big sellers, you will almost certainly be taken on – even if you don't have any more material for them at the time.

Equally, if you are already established with one library but decide to look elsewhere, providing your work is up to standard you could be accepted on the understanding that any new stock material will be sent to them first.

Ultimately, it's quality that counts, not quantity. No library will turn away a talented photographer just because they can't instantly provide hundreds or thousands of pictures.

Equally, no library will take on a photographer who can't produce work of the highest standard. So when putting together your initial submission – the most important one you will ever make to the library – I cannot stress enough the importance of weeding out any shots that aren't pin sharp, perfectly exposed, well composed and visually strong. If by doing this all you're left with is 10–15 images, so be it. At least by sending only your very best work each image will stand out, whereas if you mix those 10–15 strong images with 50–100 weaker ones, the whole submission will look weak.

Presentation is important, too. Once you become a contributor to a library, its own preferred way of receiving new work will be detailed to you. Initially, however, you should ensure your first submission is polished and professional.

The most popular way of presenting 35mm colour transparencies is in self-adhesive white card or reusable plastic

mounts, which are presented in transparent polyester file sheets that hold 24 shots for quick and easy viewing. Medium- and large-format transparencies are best presented in individual black card masks that slip into protective polyester sheets.

Whichever format you work in, make sure that your name, address and telephone number appear on each mount, along with a suitable caption (see page 27).

How do picture libraries pay their contributors?

The usual procedure is that you are sent a statement either monthly or quarterly (every three months) which lists the sales of your pictures since the last statement was received and a total amount due to you. Contributors usually have to submit an invoice, then either a cheque will be sent direct to you, or the amount will be paid direct into your bank account if the library uses the BACS banking systems.

Some libraries provide more information than others – the statements from my library detail the pictures that have sold, which countries they were sold to, what they were used for in the case of home (UK) sales, the gross value of the sale and how much I will receive from that sale – usually 50 per cent of the gross figure.

Having this breakdown is invaluable, because it will help you to analyse which pictures are selling, and how much certain pictures have earned in total.

Will it cost me anything to shoot for a picture library?

Obviously, you have to cover all your own costs for film, processing, travelling, model hire, buying equipment, postage and packing and so on.

The only other cost you may incur is if any of your photographs are chosen for inclusion in a stock catalogue. Because these catalogues cost so much to produce

– upwards of £500,000 for a big general catalogue – most of the bigger libraries charge an insertion fee for each picture selected. These fees are then deducted from initial sales of the catalogue images.

Some libraries retrieve the fees in one lump sum if your sales are healthy enough to allow it, but others deduct it bit by bit. The library I supply takes no more than 25 per cent of fees due from catalogue sales from any one statement.

Libraries that operate only on the Internet (see page 38) may also charge a fee for every image they post on the website, to cover the cost of scanning. Just because an image appears on the Internet there are no guarantees that it will sell, so you could be throwing money away – and the library may want the fees up front. With stock catalogues, however, you are at least 80 per cent certain of making sales, and the insertion fees you are liable for are taken out of sales, rather than your pocket.

I would think very carefully before getting involved with a library, be it traditional or on-line, which expects its contributors to hand over any kind of payment up front. Libraries that are confident of selling your work would not demand or expect this.

If I'm accepted, what next?

Being accepted by a picture library can be a long, drawn-out process. It may take several weeks, perhaps months, for your initial submission to be assessed and a decision made.

Part of the reason for this is that more and more libraries are being bought out by larger organizations, so the amount of red tape you need to get through is increased. Also, because taking on new, unknown photographers and new work involves a great investment of time and money on the part of the library, they are reluctant to rush into making a decision. In the meantime, you simply have to sit back and be patient.

Should you be taken on, a contract will be drawn up outlining the terms and conditions of your acceptance. Read through this carefully, question anything you don't understand, and only sign once you are clear about *everything* – especially the commission taken by the library, the minimum length of time you must leave accepted images with the library (usually three to five years), and the level of exclusivity required from you.

Once these formalities are dealt with, you can consider yourself a fully fledged player in the stock photography industry. That's when the fun really begins.

Long-term investment

One of the biggest mistakes photographers make on joining a picture library is to expect cheques for huge sums of money to fall on to their doormat literally overnight.

Unfortunately, stock photography isn't like that, and you need to look upon it as a long-term investment. When new submissions are made to a library it could take several months before they are mounted, captioned, logged and filed. A big library will have perhaps 200–400 contributors, so at any given time there will be thousands of new images waiting to be dealt with, and working through them is a slow process.

Remember also that when your pictures do make it into the files they will be competing with hundreds, perhaps thousands of similar pictures, so sales are by no means guaranteed. You may think that your latest pictures of the Eiffel Tower are the best ever taken, but the library may have 100 or more already, shot from every conceivable viewpoint, in different seasons, weather conditions, during the day, at night and so on. And if someone does request pictures of the Eiffel Tower, yours may be just one of

Like investments, which we are always warned can go down as well as up, libraries are also unable to guarantee that your pictures will sell, so it is possible to make some expensive mistakes along the way – perhaps spending a lot of money going on an exotic photo shoot, only to find that the pictures you take lie unused for years. Fortunately, it is also possible to produce pictures for next to nothing that sell and sell, so everything tends to balance out.

a dozen sent out – if it's included in the search at all.

Assuming one of your pictures is chosen, the client may not use it for several months, and even from the point it is used, another 60–90 days may pass before the invoice is settled. Most picture libraries also send out sales statements every three months – some do it monthly – and payment is usually forthcoming a month after that. What this means in reality is that from the point at which your first submission is accepted it could be at least a year, and possibly longer, before

you actually make any sales or receive any money, and even then this will probably be small-scale sales.

This time-frame is being reduced by use of the Internet, which makes it possible to expose new images to the market immediately, but you should still expect it to take 6–12 months to see sales from new submissions, and if you shoot landscapes and travel, at least two years to cover the initial cost of each trip before you eventually break into profit. This isn't always the case, but it's a good average to work to.

The numbers game

Ultimately, stock photography is a numbers game – the more pictures you have with the library, the more sales you will make.

At the top end of the market there are some talented photographers who earn enormous sums of money from just a handful of shots. It's not uncommon for certain images in a stock catalogue to sell perhaps 100 times over two or three years and gross £20,000 or more, and most of the bigger libraries can cite occasions when an image has attracted a fee of £20,000 to £30,000 for a single sale.

For the vast majority of photographers submitting work to a picture library, however, the story isn't quite so glamorous. Average sales to book and magazine publishers, travel companies and other mainstream markets attract fees of £50 to £100, while the occasional advertising sale will be rewarded with a high three-figure or low four-figure sum. This means that you generally need to have several thousand pictures with a library in order to see high returns, and that can take several years to achieve.

The number of pictures you need to have on file in order to see a good return also depends on the type of subjects you shoot. People and lifestyle pictures tend to attract relatively high fees and there are fewer photographers shooting them, so 1,000–2,000 good quality pictures could earn a lot of money. With landscapes and travel, however, competition is much more intense and average fees per sale are lower, so you would perhaps need 10,000-plus pictures with a library in order to make a similar amount of money. This isn't always the case, but don't expect to become an overnight millionaire if you specialize in landscape photography.

A handy average that many stock photographers use to calculate how much they are likely to make in sales is £1 per year for every picture they have on file

with the library. If you are fortunate enough to have pictures chosen for stock catalogues, this average can go up dramatically, but initially it's a good target to aim for.

The irony is that no matter how many pictures you have with the library, the bulk of the money you earn will come from just a small proportion of your pictures, and the majority will probably never achieve a single sale. Even more frustrating is that the pictures you feel will be good sellers are the ones that often languish unused, while those you submit almost as an afterthought are the ones that are the most successful.

Either way, the more pictures you have with the library, the better, so it's important that you make full use of any spare time you have, that you work hard to produce work of the very highest quality, and that you make submissions on a regular basis so that new images are constantly being pumped into the system.

Some stock photographers tend to wait until they have a large selection of new pictures before sending them in, and maybe only make two or three submissions per year. But the bigger the submission is, the longer it will take before the pictures are selected, logged and filed, so I prefer to make smaller submissions more frequently.

This usually means that new material is sent to the library each time I return from a trip away, and it's rare that a month goes by without me sending in something.

In terms of deciding what to send and what to reject, I let the library make that decision because they know best. Different libraries have different systems in place for new submissions. The library I supply prefers unmounted colour slides, so after having the films processed I cut out any images that aren't up to standard and then submit the rest, making sure each sheet of cut film is captioned. The picture editors then snip out the shots they want to keep and return the rest.

I always get lots of out-takes because I always send far more shots than I know the library will want – they rarely take more than three identical original copies of the same shot, for example, and I might

The best-selling travel pictures are those which contain generic subjects and scenes, so make sure you get these 'in the bag' before thinking about anything else. Whenever I visit London, Big Ben is always top of my shot list because it's an internationally recognizable monument, while no visit to Provence in southern France would be complete without a few shots of the beautiful lavender fields.

supply 15 or 20. However, by working in this way I know that the library have chosen exactly what they want, instead of me making the choice for them.

Forward planning

Stock photography is big business, and the days when you could shoot what you wanted when you wanted and then simply off-load the results on to a library are gone. There are photographers who still work in this way, but it's unlikely that they sell many pictures, and more and more are being weeded out because successful libraries are no longer interested in carrying 'dead wood'.

So, if you're serious about making money from stock photography, even on a part-time basis, you need to be serious about the type of pictures you take, otherwise you will simply be wasting time and money.

As soon as you are established with a

library, begin studying the market and the type of pictures that sell. Stock catalogues are by far the best indication of this because libraries select only the most saleable shots for inclusion in them. So, ask your library if you can be put on their mailing list to receive a copy of any new catalogues they produce, or that they buy in from other agencies in their role as sub-agent. Catalogues can also be obtained from other libraries – just phone up, say you're a designer or picture researcher, and request copies of the last two or three. Accessing the websites of different picture libraries is also a good idea.

By comparing the images offered by different libraries of the things you tend to shoot, you can assess not only which subjects and locations are the most popular, but also what styles and techniques are used. Black and white is very popular in the stock world at the moment, for example, whereas five years

Scenic pictures should be kept simple and symbolic if you want them to sell and sell. Weather phenomena such as storms, cloudbursts, rainbows, mist and haze can all be put to good use here, as you can see from this picture taken in Scotland.

ago few libraries would have considered putting anything but colour photographs in their catalogues. Consequently, I now have hundreds of black and white images on file with my library, several of which have appeared in catalogues and sold well all over the world.

This analysis is particularly important if you shoot landscape and travel subjects, because you will see exactly the same subjects and scenes appearing time after time, year after year. With London it's always Big Ben, the Houses of Parliament, St Paul's Cathedral, Piccadilly Circus, a black taxi cab and perhaps a big red London bus. Paris is always represented by shots of the Eiffel Tower, the Louvre,

the Arc de Triomphe, and so on.

These are the instantly recognizable, generic subjects that all picture libraries seek, and they should be given priority before you think about shooting anything else. If you don't know what the generic subjects are in a place you're planning to visit, simply look through some stock catalogues to get an idea.

Communication

Communicating with your library is also very important if you specialize in landscape and travel photography. They will receive new picture requests literally every day of the week, some of which can't be satisfied because they simply don't have suitable shots on file. So, if you are planning a trip away, phone the library and ask if there's anything you can shoot that they don't already have covered, or what the main requests from that particular destination tend to be.

Many libraries also produce regular 'wants lists' of specific shots they have received requests for but couldn't satisfy, or popular subjects that need updating. These lists may contain everything from well known locations to pictures of schoolkids smoking in the playground. It's unlikely that you will be able to tackle everything, but wants lists are worth following as much as you can.

Giving the library what they want should be the ultimate goal of any stock photographer.

Widening the net

Another important lesson I have learned over the years is that picture sales through a library can be increased significantly by diversifying and shooting other subjects – if only on a small scale.

At heart I am a landscape and travel photographer, so the majority of pictures I take for the library are scenics. However, financing trips away from home to shoot

new pictures is both costly and complicated, especially if that trip involves travelling overseas, so there is a limit to how many trips I can plan each year.

The periods between trips are therefore spent shooting other subjects – flowers, food and drink, financial concepts, backgrounds, local generic scenic pictures, skies, occasional portraits of family and friends. Good pictures of children can sell really well, so at every opportunity I photograph my young son. By the time you read this book I will also be the proud father of a little girl, and she will no doubt become the subject of hundreds of new pictures over the coming months and years.

This is where stock catalogues come in handy again – as a source of ideas and inspiration for new shots. I've lost count of the number of evenings I've sat with a glass of wine, a notepad and a pen, wading through piles of catalogues and scribbling down ideas for shots as they come into my head. Most never come to fruition, but I find it useful always to have a 'pictures pending' list which can be referred to whenever I have some spare time.

The benefit of diversifying in this way is that you end up with pictures spread throughout the library's files, instead of being limited to one or two subject areas, so the chances of making sales, or of pictures being selected for a catalogue, will be increased.

Consider the financial outlay, too. Travel and landscape photography is expensive, because more often than not it involves staying away from home for days or weeks at a time. However, as you will discover in later chapters, you can also take many saleable pictures in the comfort of your own home, with only the cost of film and processing to consider.

I'm not suggesting that you stop shooting the things you enjoy just because they involve greater financial outlay, but I

cannot stress enough the importance of turning your hand to other subjects that are closer to home and less costly to photograph, if only so that the sales from those pictures help to cover the cost of future travels – ultimately, it doesn't matter which pictures sell, as long as you make sales.

It's a lottery

To put this in perspective, the library I supply has recently selected 60 of my pictures for use in its next general stock catalogue. Around 15 per cent of them are landscape and travel shots, taken in places such as Venice and Provence. Another 15 per cent are portraits of my son. The remaining 70 per cent are close-ups, concepts, financial still-lifes and food pictures, all taken in my home using windowlight and a 35mm SLR.

It's ironic that despite thinking of myself as a landscape photographer, only a small proportion of these pictures are landscapes. Also, the concepts and still-lifes cost virtually nothing to take compared to a trip to, say, Venice, and the set chosen for the catalogue were shot over a period of just two weeks. Nevertheless, they will almost certainly gross far more in sales than the other pictures chosen for the catalogue.

To me, this is one of the fascinating things about stock photography: it's a lottery. You invest time, money and energy in creating new, interesting photographs and at the end of the day it's impossible to know whether or not they will sell.

But if you work hard, study the market and listen to advice that's offered by your library, sales will come, and over time it's surprising just how much money you can earn in your spare time, pursuing something that you love.

What could be more satisfying than that?

Expert view:
Robert Harding Picture Library

The Robert Harding Picture Library, based in central London, was founded in 1975 by its namesake and over the years has carved out a formidable reputation as a supplier of quality stock images to a diverse range of editorial and advertising clients worldwide. Nelly Boyd is the library's chief picture editor.

'We currently represent over 600 photographers, of whom around 500 are active, and 200 are core contributors, sending in large number of pictures on a regular basis. I'd say we have around two million images on file here, and the numbers supplied by individual photographers vary from perhaps a few hundred to over 40,000.

'Our main markets are editorial – books, magazines, calendar publishers, tour operators, as well as radio and TV, but more and more now we're pushing into

the advertising markets, and we have people on the team who concentrate solely on that side of the business.

'The stock industry has changed significantly in recent years. Many of the bigger picture libraries have been bought out by huge corporations such as Corbis and Getty, so in order to maintain market share and not get swamped, you need to keep up with the times.

'Within the next five years, a huge proportion of stock sales will be conducted on-line, so with this in mind we've just got

our own website up and running, and so far have around 35,000 images available to clients.

'It took two years and a lot of money to get to this point, but long term the investment will be well worth it. Paper catalogues and personal visits to the library will continue – some of our regular clients don't even have a computer – but on-line catalogues are much more cost-effective and quicker to produce.

'When new submissions come in to me now, I edit them, then pass the accepted material on to the web-team who re-edit it for the Internet. This means that within a couple of weeks of sending new work in, you could see your work on-line where it's available to a global market. The feedback we've had from clients and photographers has so far been very positive.

'In terms of taking on photographers, I am always happy to see new material from both professionals and amateurs, but it has to be of the highest quality. To make a decent amount of money from stock sales you also need to have a lot of pictures. This varies depending on the subject, but for general travel and landscape stock, which we're well known for, I still advise photographers to work on an average of £1 per picture per year. So, if you want to make £10,000 per year you need to have around 10,000 pictures with the library.

'This doesn't always apply – a really good photographer who studies the

Robert Harding Picture Library has recently gone on-line with a sophisticated website; at the time of writing it contains 35,000 images, but it is set to grow and grow.

BREAKING IN

Here are Nelly's top tips for photographers thinking of joining a picture library.

• Choose a format that suits the subject – we wouldn't expect you to shoot lifestyle images on 5x4in, but equally, landscapes shot on 35mm will always be neglected by a buyer if there's a suitable medium-format shot available of the same quality.

• Do not send dupes, only originals, unless you have made prior arrangements with us.

• Fuji or Kodak colour transparency films are generally the preferred medium.

• Model releases for people pictures are essential if the subjects are prominently positioned in your pictures and recognizable. Never indicate on the slide mount that the image is released unless you have the written permission of the subject(s) – we prefer copies of model releases to be submitted with the pictures. Similarly, pictures of private property must be accompanied by the property release signed by the owner.

• Don't over-edit your work or try to outguess us. We need a wide variety of images, so let us see everything that you feel has market potential and edit mainly to remove technically inferior images.

market carefully and produces top-class work could make that amount with far fewer pictures if his work sells for advertising use – but editorial sales average less than £100.

'It's also important to make regular submissions, and to edit your work closely. I would expect to receive at least four submissions per year from contributors, and I accept around 80 per cent of the pictures submitted. We used to be more flexible about this, taking two shots from 1,000 sent in, but it takes too much time to weed

• All slides must be mounted in card or plastic with caption information ideally typed on white labels.

• Each slide must have a © symbol, the year it was created, and your name on the left or bottom thin side – ©2000 Lee Frost, for example.

• Captions must be on the bottom thick side of the mount and must be clear and comprehensive. For example, 'Pleasure boat on the shores of Derwentwater, near Keswick, Lake District, Cumbria, England'. Where necessary, use the abbreviation 'MR' to indicate that a picture is model released and 'PR' for property releases. Indicate 'NMR' or 'NPR' if no release exists.

• When sending digital images, submit them on CD written to ISO9660 format, with files a minimum size of 20Mb, non-interpolated. Files may be TIFF, PSD or JPEG.

• Keep the library informed of travel plans – there may be library needs that you can satisfy while away.

• Don't delay making a submission of new material because you can't be bothered to edit or caption it. I'm aware that these tasks aren't much fun, but every extra day your work sits in your files is another day in which you have lost the chance of making sales.

out good shots from average submissions.

'Saying that, I don't like our photographers to be too ruthless, and to decide that we wouldn't be interested in something. If the quality is high enough, let *us* decide if the image itself is suitable – but don't send in poor quality work. It's commonsense really.'

For more detailed information on how to join the Robert Harding Picture Library, and to get an idea of the kind of picture quality you will need to achieve, check out the library's website at www.robertharding.com

Expert view: Kathy Collins

Kathy Collins began her professional career a decade ago taking pictures for hotels, playgroups and other businesses in Scotland. After winning a photographic competition organized by the British Institute of Professional Photographers (BIPP), she then started to build up her own library of landscapes before joining one of the UK's biggest general picture libraries.

'My initial experiences of picture libraries weren't very good. On the advice of another photographer I joined a small library and made very few sales, so after a couple of years I decided to find a bigger, more established one.

'Initially I wrote to the main players – Tony Stone, the Image Bank, the Telegraph Colour Library etc – asking for their requirements. I also made submissions to them all to see if they liked my work. Some of the libraries were ruled out from the start because they wanted total exclusivity, which I wasn't happy with, but one of them got back to me saying that although the subject matter of my work wasn't saleable to them, they loved it and would I come down for a meeting so they could talk to me about what they needed. On the strength of that meeting I was asked to go off and shoot some new pictures on spec, and if they were okay I would be offered a contract.

'The subject list they offered me was financial centres around the world, so I chose one – Paris. Instead of just hopping over to France, however, I did a lot of planning beforehand, and arranged to spend time shooting on the floor of the Stock Exchange. I then spent ten days in Paris, sent in my pictures and got the contract. That was about five years ago.

'My first editor at the library told me that if I wanted to make a lot of money from stock I should cover as many subjects as possible. So, although my work was predominantly landscape-based, I now shoot all kinds of things – abstracts, close-ups of flowers and plants, financial still-lifes and industrial subjects. I also put a lot of effort into taking pictures with the catalogues in mind, because that's where the most sales come from. My income from photography is now split roughly 50:50 between sales from the picture library and sales which I make direct to clients such as calendar and greetings card publishers. Of the income from stock, about 20 per cent comes from landscape and nature pictures and the remainder from still-life and conceptual pictures shot specifically for the library.

LEFT More recently Kathy has started to shoot concept images and finds the creative freedom it brings very satisfying. For this image she made a heart-shaped ice cube and photographed it as it slowly melted.

RIGHT Kathy is best known for her stunning landscape photographs, especially of the Scottish Highlands. This panoramic vista, shot with a Fuji GX617 6x17cm camera, shows Loch Tummel in autumn from Queen's View.

'The thing I enjoy most about stock photography is it gives me the freedom and flexibility to shoot lots of different subjects, and experiment with different photographic techniques and styles. The picture library simply suggests the subject matter, then I am left to photograph it in my own way. I much prefer this approach to shooting on commission because I don't particularly like taking pictures to order – it's a case of what happens, happens. The pictures I end up with aren't always what I intended or expected, and this is what gives stock photography the edge that I find exciting.

'Since working in stock, the market requirements have also changed quite a lot. Initially stock pictures and catalogues were quite formulaic – everyone wanted those classic shots of the Eiffel Tower and Big Ben. However, royalty-free CD-Roms have taken a large slice of that market, so the libraries are now interested in more artistic, innovative photography. It's great to have the opportunity to work in this way and sell the images.

'To succeed as a stock photographer today you need to be committed. You need to study the market, look at the way images are used, and produce the best possible work you can. Study stock catalogues from all the libraries to see what kind of trends are emerging, but also try to produce conceptual and symbolic images that no one else has thought of, or find a new way to approach a traditional best seller.

'I think it's also important to have different projects on the go so you always have something to turn to. Saying you just want to shoot landscapes is fine, but in the UK it means that you will spend a lot of time not working because of the weather. By diversifying, you can always work.

'Many photographers are put off supplying a picture library by the prospect of having to pay for everything up front with no guarantee that the pictures will ever sell. However, nothing I have ever taken has been a waste of time, and even though it might take five years or more, eventually pretty much every subject does sell. You just have to be patient.'

Grangemouth petrochemical plant is only 30 minutes' drive from Kathy's home, so it is a subject she has photographed numerous times for her picture library – and achieved many sales as a result.

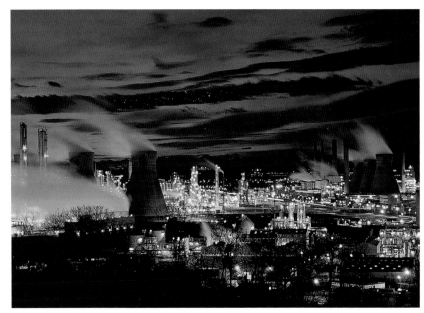

THE DIGITAL AGE

In the last few years, the photographic industry has been turned on its head by the advent of digital imaging. Since the very science of photography itself was invented, no other technological advance has had such a dramatic impact on picture-taking, and so far we have only scratched the surface of the potential benefits it can offer.

For aspiring freelance photographers, digital technology works on several different levels.

Digital cameras

First of all, there are digital cameras that allow you to capture images without the need for film. Instead, the images are stored in digital form in the camera's internal memory or a removable memory card, then downloaded to a computer.

The more you spend on a digital camera the more features, control and quality you get. At the time of writing, Nikon have just launched a new model – the D1 – which is a high-resolution digital camera that looks like any other Nikon 35mm SLR and accepts conventional Nikon autofocus lenses. In other words, you can buy the body and add it to an existing 35mm SLR's outfit. This is the way forward, and other SLR manufacturers will no doubt follow with similar cameras. For even better quality, digital backs are also available for medium- and large-format cameras.

Is it worth investing in a digital camera? Probably not – at least not yet, anyway.

If you're a globe-trotting sports or news photographer, a digital SLR is ideal because it means you can take a picture, immediately download it to a laptop computer and then e-mail it to your agency or picture desk using a mobile

phone. Consequently, pictures can be viewed on the other side of the world just minutes after they have been taken. Similarly, if you run a busy studio shooting pictures for catalogues, a camera with a digital back will save time and money because the digital files can go straight to repro. Some portrait photographers are also using digital cameras now, so they can immediately show the clients what has been taken, and run prints off an inkjet printer.

For the average aspiring freelancer, however, there is no real need for a digital camera. At present, the vast majority of picture buyers still need to work from a transparency or print, so shooting digitally could actually hinder rather than help you. The cameras are also very expensive, and technology has a long way to go before digital cameras offer image quality on a par with film-based photography for the same amount of money.

I have certainly never considered buying one, and don't know a single freelance photographer who has. This may well change, but for now, silver-based photography is a safer bet.

Digital filing

What you should seriously consider, however, is investing in a computer system so that you can scan your photographs and store them as digital files.

Once scanned, those images can then be archived in their original form, so that if you ever lose the original you still have a digital version of it. More commonly,

The Nikon D1 is the most practical, professional-quality digital camera available to date, offering high resolution and allowing you to use existing Nikon autofocus lenses.

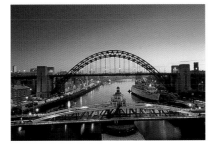
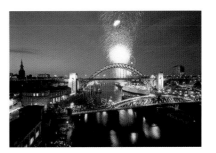

however, scanned images are enhanced and manipulated using relevant software, such as Adobe Photoshop, to remove blemishes, eliminate unwanted details, adjust colour and contrast, or otherwise create numerous weird and wonderful effects. You can combine elements from two or more different images, distort the image, add creative border effects, add filter effects, change the colours – the possibilities are endless.

The creative use of digital technology to produce seemingly impossible images is becoming increasingly popular in the stock photography industry. More photographers

are also using a computer now instead of a darkroom, scanning black and white negatives into a Mac or PC and running off prints on an inkjet printer. All the same techniques that you would use in the darkroom to manipulate the images, such as dodging and burning, can be done digitally, but the process is much quicker, and you can do it sitting at a desk. You can also play around with the image until you are completely happy with it – instead of wasting expensive photographic printing paper as you strive to produce a perfect print and make lots of mistakes along the way.

This superb image by Graham Peacock shows what can be achieved with digital technology. Asked by a calendar publisher to come up with something different, he had this digital day-to-night composite produced from a set of 15 photographs he had taken from the same location over a five-year period. It has already sold numerous times and never fails to create a stir when people see it.

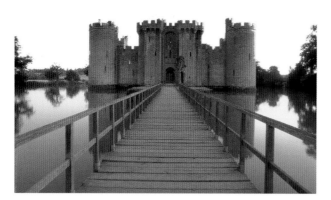
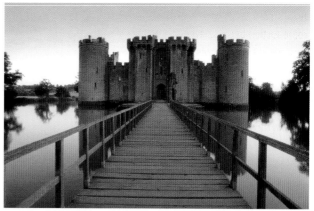

ABOVE This pair of photographs of Bodium Castle in Kent shows how an image can be dramatically improved through the considered use of imaging software such as Adobe Photoshop.

RIGHT Once you become practised at manipulating your photographs, effects can be achieved that would have been either incredibly time consuming or impossible if attempted conventionally.

Digital benefits

Digital technology also offers various other benefits. Once your photographs are scanned, for example, you can e-mail them to clients instantly, instead of sending transparencies in the post – saving time and money, and eliminating the risk of your irreplaceable originals being lost or damaged.

High-quality CD writers are also available now which allow you to copy your scanned images on to inexpensive recordable compact discs. You can then use those CDs as promotional material, sending them on spec to different clients and markets so that they can sample your work, or you can actually send out images on CD that have been specifically requested for publication.

In the UK and Europe, most publishers and picture buyers still require a transparency for reproduction purposes, but this is set to change over the next few years, and eventually there will be no

need to send transparencies for reproduction because everyone will be working from digital files. It therefore makes sense to become familiar with the technology now, rather than waiting until you have no choice.

And then, of course, there is the Internet, which allows people in all corners of the globe to communicate and exchange information. Many thousands of photographers around the world have already realized the benefits the Internet has to offer, and have websites on which they can display their talents to a global audience – hopefully attracting work in the process.

Picture libraries are also following suit, placing thousands of images on websites so that they can be browsed by picture buyers. Not only does this mean that the images are seen by a much wider, international audience, but it also gets new work into the marketplace almost immediately, whereas traditionally there is often a wait of months, even years, before a new stock catalogue is published. The long-term benefits of this to both the libraries and their contributing photographers is clear to see.

Setting up a digital workstation

Putting together a computer system which allows you to scan, store, manipulate and transport images is no longer a horrifyingly expensive prospect. Thanks to the huge global demand for home computers, and amazing advances in technology in recent years, hardware prices are actually falling rather than rising, and the level of sophistication you now get for your money is staggering. For the price of a decent 35mm SLR system, you can now equip yourself with all the hardware and software needed to set up a capable digital workstation that will meet the greatest demands.

If you are starting from scratch, here's what you need.

Computer

The first decision that you need to make here is whether to buy a PC or an Apple Macintosh computer.

PC is basically a generic term for a personal computer and there are literally hundreds of different brands available. Many computer enthusiasts even buy the components and build their own to save money. PCs are also modular, so you can adapt them as your needs change by fitting a faster processor and so on. Apple

Macs, on the other hand, are a specific brand and they are less modular. With the exception of adding additional memory, what you see is pretty much what you get.

Taken at face value, PCs seem the better option as they generally cost less and there are far more accessories and software packages available for them on the high street. However, Apple Macs are universally recognized as the standard tool of the design and publishing industry, so they tend to be chosen by photographers instead of PCs to ensure compatibility. Many would argue that they are also quicker and easier to use for imaging purposes than PCs. In my case, I have only ever used Apple Macs, so I couldn't say.

Once you have made that decision, you need to consider the following:

Memory

Every imaging task, whether it's viewing, storing or manipulating, uses your computer's memory, so the bigger it is, the better.

The most important type of memory is known as RAM (Rapid Access Memory). This is what your computer needs in order to open and run software, and to carry out tasks such as retouching or manipulating images – the more complicated the task, the more memory it uses.

For general use – scanning, retouching

A computer forms the heart of any digital workstation, so be sure to buy the right one for you. Most professional photographers prefer Apple Macs, but PCs are equally capable, and are more versatile when you need to upgrade the system.

and storing images – you could manage with, say, 64 Megabytes (Mb) of RAM. However, if you intend working with high-resolution files and want to carry out complicated manipulations, you will need more, otherwise your computer will work very slowly. It therefore pays to have as much as you can afford – 128Mb, perhaps 256Mb or more. Fortunately, RAM only costs about 10 per cent per Mb of what it did a few years ago, so this isn't an unrealistic proposition. RAM upgrades are also possible if you find that you need more, but only if there are spare 'slots' available in your computer to accept the new memory.

The images you end up with after scanning are stored on your computer's hard drive. High-resolution scans eat up a lot of hard-drive space, so you will need lots of memory if you intend storing a lot

With a little imagination and lots of practice, it is possible to produce literally any creative effect using a powerful computer system and the latest imaging software – so don't get left behind by the digital revolution.

of images. Modern computers tend to come with internal hard drives of anything from 1 to 8 Gigabytes (1 Gigabyte = 1,000Mb), but over time these will become full and you will need to provide extra space, either by investing in an external hard drive or by using external storage media.

Of the latter, Zip drives are by far the most popular, with over 40 million users worldwide. The basic Zip drive accepts 100Mb Zip disks, though more recently a 250Mb version has been launched. A 100Mb Zip drive will not accept 250Mb Zip disks. However, the 250Mb Zip drive will accept older 100Mb Zip disks. These disks have a life expectancy of around five years, and many computers now come with a Zip drive built in – or you can specify one when buying a new computer.

Another option is the Magnito Optical drive, which accepts special disks that are basically like mini CDs inside a hard shell. There are disks available with 230Mb, 640Mb or 1.3Gb of storage and they have a life expectancy of 30 years or more, making them ideal for the long-term storage of images. The only drawback is

that Magnito Optical drives aren't that popular yet, so there's always the risk that if you send one out the recipient may not be able to access it.

The most practical way to store images is by investing in a CD writer and downloading images from your computer onto inexpensive recordable CDs. Each CD offers up to 650Mb of storage, and as they are so small and slim you can store thousands of images very easily. Also, all modern computers have a CD Rom drive, so there should never be any problems with people not being able to access your work.

Processor

A computer's Central Processing Unit (CPU) controls how fast the computer operates. This is measured in megahertz (Mhz). Many photographers are still working with 100Mhz processors, but technology is moving fast and 300–450Mhz processors are now commonplace with 850–1,000 Mhz not too far away. It's worth buying the latest and fastest processor available as it makes computer operation speedier and therefore more productive.

Zip disks are widely used for the storage and transportation of digital images, though with a storage capacity of 650Mb, CDs are the most practical system of image storage.

Monitor

The monitor (screen) you buy for digital imaging is vitally important because it will determine how clearly images are seen, how accurately colours appear on the screen and so on. A poor quality screen will not give you a true and accurate representation of what the image you are viewing really looks like, and this can lead to all sorts of problems.

In terms of size, a 17in model will be sufficient. Anything smaller will be too small, but if you can afford a 20in or 21in model, so much the better. Make sure it can also display a resolution of 1024x768 pixels and has 24-bit colour depth to give millions of colours.

CD-Rom

Modern computers come with a CD-Rom drive as standard today, allowing you to load software that is supplied on CD, and to look at images that are stored on CD. Make sure that the CD-Rom offers at least 24x speed.

Expansion slots

These are sockets inside the computer which allow you to add further accessories such as graphics cards, video capture cards, sound cards and so on. You may never need them, but it's worth having at least three slots available, just in case.

Cache

This is the part of a computer's memory which makes a program run faster – 512Kb is acceptable for digital imaging.

Graphics card

This is a circuit board which ensures you get a high quality screen image and allows you to use effects such as filters more quickly – thus making it ideal for photographers. A graphics card's memory is stated as VRAM. As a minimum you will need 4Mb, but 8Mb or more is better.

There are literally hundreds of different software packages available today to help you to manipulate your photographs.

Software

To manipulate digital images you will need a suitable software package, and there are literally hundreds to choose from. Many computer systems and scanners come with bundles of free software, of which some may be useful. Long term, however, it pays to buy the right stuff for the job, and if you are serious the main software system used by photographers is Adobe Photoshop, which is regularly upgraded and offers endless creative potential.

Scanner

If you want to make digital copies of existing photographs, for storage or manipulation, a scanner will be required to convert the photographic image into a digital file.

Two basic types of scanner are available – flatbed and film. A flatbed

Buy the best scanner you can afford – film scanners are a better choice than flatbeds if you scan mainly slides or negatives.

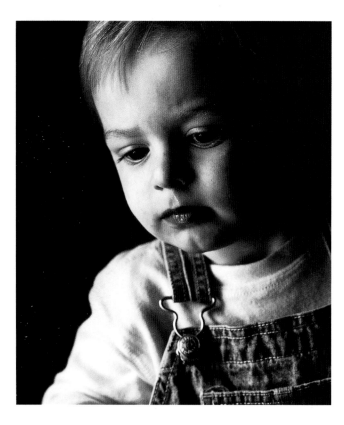

Why bother with conventional printing when you can simply scan a black and white negative into your computer, convert it to a positive image, manipulate it as you would in the darkroom, and then run off a high quality inkjet print – without ever getting your hands wet!

The latest colour printers offer superb quality – buy one that will print up to A3 if you can afford it as it will be more versatile.

scanner is similar to a photocopier, in that flat artwork such as a print is placed on its glass bed, then a charge-coupled device (CCD) scans over it to create the digital file. If you want to scan negatives or slides, an optional hood will be required, but where available these often cost more than the scanner itself. Optical resolution is also lower, so they don't work well with film.

If you are more likely to be scanning negatives and slides, a film scanner is a better proposition, offering higher resolution and much better performance. Most models accept 35mm film only, and although there are scanners available for medium and, in a few cases, large format, they cost considerably more.

To ensure high quality results, consider models offering 2700dpi resolution or more.

CD-writer

As explained earlier, this piece of equipment allows you to copy digital files on to writable compact discs, for storage or transportation of your work. In some cases it's possible to have one built into a computer system when you buy it, but separate writers are also available. As a minimum, go for a model that offers 4x write, 12x read capability.

Modem

Necessary to allow Internet access and use of e-mail facilities, a modem can either be bought separately, or built in to many modern computer systems. Whichever option you go for, make sure it has a minimum operating speed of 33.6bps (bits per second).

A CD writer will enable you to copy your digital files on to compact disc for storage or sending away.

Printer

If you want to make prints from pictures taken with a digital camera, or images that have been manipulated on your computer, you will need a colour printer – this will need to be an inkjet, dye-sublimation or Micro-Dry model. The first and last options are the most economical, though inkjet printers are by far the most popular, and you need a model offering at least 600dpi resolution, and preferably 720dpi or higher for photo-quality prints.

A wide range of photo-quality printing papers is available with different surface finishes, but digital images can also be printed on normal paper, or on textured and hand-made paper or canvas for subtle, artistic effects.

At the time of writing there is a big question mark hanging over the lifespan of printer inks, which you need to consider if you intend selling inkjet prints to clients – as more and more social photographers are now doing. The good news is that archival inks are likely to be launched very soon, making prints generated by your computer printer more stable.

Designing your own website

As well as offering benefits in terms of the storage, protection, manipulation and transportation of photographic images, going digital also gives you the opportunity to design your very own website and post it on the Internet. By doing this, anyone in the world with Internet access will be able to view your pictures at the click of a mouse.

An increasing number of picture libraries now have highly complex websites which enable users to browse hundreds, often thousands of images, and to place orders. Many photographers are now also following suit and are producing websites with which they can promote their talents and hopefully find new clients.

Websites can be designed on your own computer using software such as Adobe PageMill – suitable software often comes free with digital cameras, computers, or even taped to the cover of computer magazines. Alternatively, you could pay someone else to produce a more polished job.

Building the site

The key is to make your site as easy to navigate as possible, so plan it carefully and try to visualize how visitors can work through the different layers.

Websites start with a home page which shows the contents and contains icons that visitors click on to access different pages. Initially you may have just a single gallery of images on the site, but over time this can be developed so that you have different subjects or locations, and by clicking on the relevant icon, visitors can then get to see a gallery of images on a specific subject, place or theme. If you specialize in travel, then the

A well designed website should look good, be easy and relatively quick to navigate, and contain your very best work. These pages were designed by the photographer himself and show what can be achieved with a little effort.

categories could be organized by country. If you specialize in shooting your home country, the categories could be regions or counties – Yorkshire Dales, Lake District, Cotswolds, Scottish Highlands and so on. On each web page it also helps to have a command which allows visitors to go back to the home page or back to the previous page, as this speeds up navigation.

When designing web pages you need to balance image size, resolution and compression so that the pages can be downloaded as quickly as possible – if it takes too long, people will lose interest. The images should also have individual reference numbers so they can be ordered if you're trying to make stock sales.

Many photographers post biographical information on their website, so that potential clients can see what their background is, if they have won awards, where their work has been published, the type of clients they serve, and so on. You will also need to include contact details: phone and fax numbers, mobile phone number if you have one, plus e-mail address, especially if you design the website with a view to attracting commissions or requests for stock images.

Choosing a server

With the basic site designed, you then have the option to get creative – adding sound effects, graphics, backgrounds, animations and so on. These can all be obtained free from graphics websites and software packages, and will give your site that extra touch of class – though don't overdo it.

With the website designed and ready, you need to find an Internet provider – preferably one offering free web space initially. It's quite commonplace now to be offered 10–25Mb of free web space, but you would need a pretty complex web site to get through all that; 3–5Mb is all that you need usually, and with that you would

get well over 100 images on to the site.

All that remains then is to upload the pages to the server, send your details to as many search engines as possible so that people can find your site in photographic directories, and away you go. It's important to keep regular tabs on your site so that you can assess how many people have accessed it. Images should be changed every few weeks or months as well, or at least new ones added, otherwise visitors will get bored.

There are no guarantees that having a website will lead to increased sales, but designing one is a worthwhile exercise because, with digital technology advancing at such a pace, there will eventually come a time when far more photographers do make use of the Internet than don't, and by ignoring its advantages you will merely fall further behind.

If nothing else, it means that the whole world can admire your pictures, and this can be a huge morale booster – especially if you get positive feedback from visitors to the site.

Licence-free CD-Roms

In addition to the benefits digital technology can offer today's freelance photographer, a completely new market has also emerged from the digital age in which you could make sales – that of the licence-free or copyright-free CD-Rom.

Put simply, licence-free CD-Roms are photographic CDs (compact discs) containing dozens, sometimes hundreds, of images. Businesses such as publishers and design agencies purchase the CDs and can then use the images on them for pretty much whatever application they choose, completely free of charge. Photographers supplying work for use on these CDs are then paid either a one-off flat fee per image, or royalties that are based on how

many copies of the CD are sold.

How you view this market will be down to personal opinion. In its favour is the fact that you can sell a large number of pictures at once and therefore receive a very welcome cheque for your efforts, or a steady return if payment is royalty-based. All you have to do, literally, is package up your photographs and send them off to a relevant publisher.

The downside is that if images are selected you have relinquished digital copyright on them, usually worldwide and for all time. This means that you cannot offer the same images to another publisher of licence-free CD-Roms, or any market that will require electronic or digital rights to them such as an Internet-based picture library. That said, you can continue to sell the same images to markets that won't be using them digitally – which is still the case with the vast majority of magazine, book, calendar and card publishers.

Another important consideration is the moral implication of these products. Businesses and organizations that would once buy the use of photographs from a picture library are now finding that they can save a lot of money by purchasing licence-free CD-Roms instead – even if the quality perhaps isn't as good. This is having a noticeable effect on many picture libraries, particularly smaller ones, so, while it is possible to make a 'quick kill' by supplying images for use on CD-Rom, do think about the long-term implications – especially if you intend supplying a picture library with your work as well. You could be cutting your nose off to spite your face.

Breaking in

The type of pictures required varies. You can buy a whole CD-Rom of fireworks, backgrounds, textures, flames, skies, beaches, trees, water images and so on, as well as CDs that cover a particular city or

country. Then there are CDs full of corporate and business images, and others that cover topics such as religion, health or beauty.

If you are interested in supplying work yourself to this market, get in touch with various publishers – they often advertise in photographic magazines or freelance directories – and ask for information on

Publishers of licence-free CD-Roms are always on the lookout for high quality photographs covering all manner of subjects – from famous monuments, to food and drink, to finance.

their terms, also their fees, and any current subject requirements.

Once you have decided whom to target, put together an initial submission. There may be a stipulation about the maximum number of images you can supply initially, though some publishers are happy for you to send hundreds, even thousands.

As usual, only colour transparencies will be accepted, and although a growing number of publishers demand medium format as a minimum, there are some who are still happy to work with 35mm.

Opportunities in this market aren't as good as they were a few years ago, because more publishers are now commissioning photographers to shoot complete CDs which will contain higher-resolution scans and cost much more to buy. Nevertheless, it's still an option well worth exploring.

In terms of payment, at the bottom end of the scale you may be offered a one-off fee of £40 to £50 per image, while at the very top, photographers who have been commissioned to provide all the images for a high quality CD could make £40,000 or more in a year if it sells well – usually for just a few weeks' work.

Expert view: Paul Cooper

Paul Cooper set himself up as a commercial photographer after he was made redundant from the computer industry. He now runs a thriving studio in the north of England, has won a number of prestigious awards, and in recent years has become heavily involved in digital imaging.

Paul makes full use of his digital equipment to produce eye-catching conceptual images. With a little imagination and a lot of patience, literally anything is possible.

'Working in the computer industry, it was relatively easy for me to start using digital technology in my photography – in fact, the computer I'm using at the moment is a home-built PC.

'I started dabbling with Adobe Photoshop about two years ago, just playing around with personal work and seeing what I could achieve. It took about three months of long hours and late nights at the computer to learn the ropes, but at the end of it I felt I knew what I was doing, enough to offer digital manipulation to clients. Today, a computer is as important to me as a camera, and I can't ever imagine not using it as an integral part of my work.

'My PC system isn't particularly glamorous – a 300Mhz Pentium II processor with 128Mb RAM and Photoshop 4 – but it serves my needs. I also use an Epson Photo printer and an Agfa Dua scan flatbed with a transparency tray to scan images into the computer.

'I have to admit, I'm beginning to reach its limits. When you're working with a 20x16in image at 300dpi you can literally go off and have your tea while the computer's saving it, but for most applications it's adequate. The key is to make the most of what you have.

'One of the greatest benefits digital imaging offers me is speed. I can achieve things on a computer such as multiple exposures far quicker than I could conventionally, thus saving time and money. This has opened up a whole new market for me, because I can now offer services to clients that, if done conventionally, would take too much time and therefore cost too much money. This not only benefits the client, but also allows me to be more ambitious in my work.

'Often, for example, I will take a number of different photographs on colour negative film, print up the chosen shots, scan them, then take elements from the different shots and create a multiple image. Other uses for digital technology include removing scaffolding and cars from architectural shots, and, because I don't have a large-format camera or a shift lens, correcting converging verticals when I'm shooting buildings.

'It can cost a fortune to have these things done by an outside retouching bureau, so being able to do it myself helps to keep costs down. Also, I don't like sending pictures to clients if I'm not completely happy with them, so I'd rather do the computer work myself and earn less money from a job, knowing the end result is as good as it can possibly be. In the long term this pays because it leads to more work.

'More recently, this equipment and knowledge has been put to good use by offering a short-run printing service for

businesses that need small quantities of leaflets. This means that I get to take the pictures, then I produce the final artwork, thus earning more money while saving the client money in the process.

Portraits or proof prints can also be printed out for clients on an inkjet printer, and instead of spending hours in the darkroom, I can scan black and white negatives into the computer, turn them into positive images, retouch as necessary and produce high quality black and white prints both quickly and easily.

'I have a website up and running which promotes my services on a global scale. There are sections for portraiture, weddings, editorial, PR, advertising, a picture library and so on, and each category contains a number of striking images for clients to study.

'Having the website has definitely led to more work because it's so easy for people to see what I can do. Often, a potential new client will ring up having never seen my photography, so I get them to visit the website while we're on the phone and talk about it there and then. Weddings tend to be booked well in advance too, so I advise the prospective bride and groom to check the site regularly for ideas of what they want.

'For this reason, I update the site with new images on a regular basis – perhaps every three months, though I should do it more frequently really. At the moment I have about 100 images on the site, which I designed myself. The total site only uses about 3Mb of memory so sometimes I'll copy it on to a CD and send that out to clients as a kind of portfolio. It means they can view the contents of the website without having to go on-line.'

ABOVE Paul created this superb still life using several different photographs. First he took various pictures of the cello, enlarging the negatives to 10x8in. Next, the prints were scanned, then he selected different elements from each print and pasted them on to a new background using Adobe Photoshop software.

LEFT You can make simple images far more saleable by adding interesting effects. Here, Paul selectively coloured some of the keys on this mobile phone and introduced the creative border to frame the image.

COMMISSIONED PHOTOGRAPHY

Essentially, this book is about taking pictures under your own direction, then finding markets for them. However, the more you become involved in this and the more your work is published, the greater the chance that one day, completely out of the blue, you will be asked to take on a commissioned photographic assignment.

You may get a phone call from the editor of a magazine you have been supplying for a while, for example, asking if you could take the pictures for a forthcoming feature, or if you could photograph something close to where you live because stock pictures of it aren't available.

This is particularly common on specialist-interest magazines. Many's the time during my days as a photographic magazine journalist that I got in touch with a regular contributor and commissioned them to shoot something specific. Equally, over the years I have been on the receiving end of these requests myself.

Remember also that magazines, books, calendars and cards are seen by many thousands of people, so if your work is featured there's always the chance that it may be noticed by someone who happens to need the services of a photographer –

Some commissions are more relaxed and enjoyable than others. For this brochure promoting a new property development in Torquay, Devon, I was simply asked by the client to shoot popular local scenes.

such as a designer, or someone running a business. The chances of this happening are increased considerably if you are known for specializing in a particular type of photography, or if you live in an area with a thriving tourist industry.

Word of mouth can also bring work your way. Enthusiast photographers are often asked to take the pictures at a relative's wedding – you have probably already done this yourself. But if you do a good job it rarely stops there, because the happy couple will then mention your name to their friends, or friends of friends, and so it goes on, until you find that without even trying you have suddenly built up a little sideline in weekend wedding photography.

The question is, when that phone call does come, how should you react and, more importantly, what do you do next?

Know your limitations

First of all, you need to decide whether or not you actually want to take on the job,

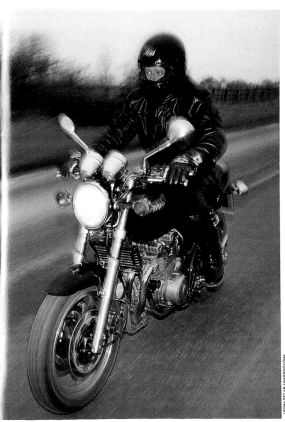

and that will depend what the job being offered is.

Commercial commissions

Magazine commissions tend to be fairly straightforward: you will be given a detailed brief about exactly what's required, and if the job involves other people or visiting private property you will be put in touch with the relevant individuals and a date for the shoot will be set. Often, a journalist will also accompany you to gather material for the feature or simply to make sure that you take the right pictures.

The hardest part of doing jobs like this is getting used to the lack of control you have. Stock photography is easy in comparison because you don't have anyone breathing down your neck, and you can photograph what you want when you want; so if the weather's bad you simply wait until the next day, or if the subject matter is uninspiring you don't bother getting your camera out. More importantly, if the pictures you take aren't up to much, no one has to see them but you.

Commissioned photography is rarely, if ever, like this. More often than not the shoot is booked for a specific day, and unless the weather is so appalling that it makes photography impossible, or related activities are cancelled because of the weather, you basically have to turn up and get on with it.

Often the job will involve taking pictures of subjects you have never tackled before, or you will be expected to make something incredibly boring look amazing. And you have to do it at short notice, often with no pre-planning, and no option to return later. Worse still, you may not even get the chance to see the processed films and edit your work, because many magazines have accounts with processing labs and like to take the exposed film away at the end of the job. Arghhhh!

These pictures were taken during a commission from a motorcycle magazine – the main shot from the back of a jeep while the bike followed, to create blur in the background and increase the feeling of speed. When the weather is as dull and grey as it was on that day, you will try anything once!

For photographers who do this kind of thing day in, day out, it's par for the course. They're used to the deadlines and the pressure to perform, and actually revel in it, relishing the challenge of taking high quality pictures when the odds are stacked against them. But if you're invited into this arena after only ever taking pictures for yourself, it can come as something of a shock – and if you mess up, it's unlikely you will be approached again. There's a saying in photography that you're only as good as your last job. It's true.

Weddings

Wedding photography should be approached with even greater caution. Messing up a magazine assignment or a commercial job for a local business is bad enough, but the worst thing that can happen is that you don't get paid and are never asked again.

With weddings, you have to add to this the fact that it's the most important day in the lives of the bride and groom and their respective families and it can never be repeated, so if you forget to load your camera with film, your camera breaks down halfway through the shoot, the films get mangled at the processing lab or any other catastrophe occurs, you will also have broken hearts to deal with – as well as the prospect of a legal bill when you are sued for professional misconduct which can happen if the client is a total stranger.

Planning

One way to reduce the risk of problems is by getting yourself organized. That means making sure you have everything with you that you are likely to need, that all your equipment works properly, and that you are completely familiar with it.

Don't use a camera that you have just bought and aren't completely at home with – you will simply be inviting trouble. Equally, don't borrow an unfamiliar

camera from a friend to do the job, because you'll have to spend too much time just thinking about how to use it instead of concentrating on the pictures.

Pack spare batteries for everything that needs them – cameras, meter, flashgun. Check that your handheld meter is giving accurate readings. Pack a spare tripod – I didn't on one job, only to find that a leg joint snapped while I was miles away from home photographing a trout fishery for a magazine. I managed to get the shots handheld, but with difficulty once the light began to fade. A spare camera body is essential, too, just in case.

Make sure you have full details of the shoot from the client, especially if you're working away from home. If you're covering a wedding, visit the church and reception venue well in advance so you can establish where the best spots for pictures are – and where you can work in the event of rain. It's also essential to meet the bride and groom before the fateful day and discuss their needs. Do they only require formal shots? Would they like you to shoot some candids as well? Are you expected to attend the reception after the ceremony? Do they require some black and white pictures as well as colour?

With magazine commissions, establish who is supplying the film. Many magazines will provide it, but others will expect you to – so then bill them for it. If it's the latter, take at least double what you expect to use.

The more planning you do, the easier your life will be on the day. As your experience grows you will do this automatically, but in the early days you need to cover every possible eventuality, good and bad.

Wedding photography isn't for the faint-hearted, but with practice and experience, high quality results such as this are well within reach – and good wedding photographers are never out of work.

Money matters

One of the great benefits of commissioned photography is that you are agreeing to do a specific job for a specific financial reward, and unless you make a complete mess of things, then the payment will be automatically forthcoming.

Pricing

As to the amount you are paid, magazines tend to have fixed rates for editorial photography. In the UK, this varies enormously depending on how successful the magazine is, though an average for most specialist titles is £200 per day pro rata: £100 for half a day, £25 per hour. Some will offer more but, equally, small circulation titles will probably offer less – down to £100 per day.

Weddings are trickier to price because much depends on how many pictures you are expected to take and what the bride and groom expect at the end of it all. If it's a simple case of turning up, taking the pictures, getting the films processed and handing over a few packs of prints, you can work out what it will cost for film and processing, add, say, a 20 per cent surcharge for running around, add any travelling costs incurred, and then a fee for your time – £200 plus costs is reasonable for a basic wedding package.

If the couple expect a proper album of enlargements, then you need to build in the cost of buying the album and having enlargements made from the chosen negatives, plus the extra time you will spend organizing this, making trips to the lab and so on. Reprints for friends and relatives are also popular, so work out a price structure for different-sized prints, based on what it will cost to have them made plus your profit on top.

With commercial jobs you can apply a similar formula, quoting a fee for your time plus all costs. Film should be charged per roll for the film itself, and for processing,

with a surcharge added for your trouble: 50 per cent of the actual cost isn't unreasonable. So, if you pay £3 for the film and £2.50 for processing, the cost to the client would be perhaps £8.25 per roll. Travelling costs tend to be charged per mile: 40p per mile is a good average to work to in the UK, though if you are travelling long distances, some magazines will hire a car for you as it works out cheaper for them.

It's tempting to under-price a job when you first start receiving commissions, for fear of losing the work. But resist this, because if you start out cheap, those clients will expect you to remain cheap. Under-pricing also makes it difficult for other freelance photographers to charge decent rates, and while to you it may be pocket money that is earned during your spare time, to many it is their only source of income.

Invoicing

Once the job has been done and the client is satisfied with the pictures, you will need to issue an invoice for payment. This should include the following:

• Your name and address.
• The date the invoice was issued.
• A description of the job undertaken and the name of the person who commissioned it.
• The date the job was undertaken.
• A breakdown of costs – your rate, the number of films exposed and processed, any mileage you are claiming for travelling, and any other expenses.
• The total amount owing.

A clause at the bottom of the invoice saying 'Payment due within 30 days of invoice date' or something to that effect is advisable, though in reality it rarely makes much difference as to how quickly you are paid. Some clients will settle an invoice

within a few days – some even on the spot. Others will take a month, though some will leave payment as late as possible – up to 60 or 90 days after receiving the invoice.

Legalities

There are copyright implications to consider when taking on commissioned work, both in your favour and in the client's favour.

In the UK, these are covered in detail by the Copyright, Design and Patents Act 1988, plus subsequent amendment to the Act, while other Acts apply in countries outside the UK. There isn't space in this book to cover copyright in detail, so you are advised to get hold of a copy of the Act. A handy booklet, *The ABC of UK Photographic Copyright*, produced by the British Photographers' Liaison Committee (see page 191), is well worth buying.

In the meantime, here's a brief look at the main factors you should consider.

Moral rights

All photographers working in the UK can assert the moral right to be recognized as the 'author' of the photographs they take. In practice, this means you have the right not to have your work subjected to derogatory treatment, and you have the right to be identified as the author of your work – in the form of credits or 'by-lines' when your pictures are published.

Photographer copyright

When you accept a commission, the client usually expects to keep the photographs you take. This is perfectly normal. However, you still own the copyright to

One thing about commissioned photography you will either love or hate is the unpredictability of the business – when the phone rings, you never know what someone is going to ask you to shoot.

those pictures, so if the client decides to use them for any purpose other than that for which they were originally taken, by law you have the right to additional payment for repeat use – and the client should seek your permission and negotiate suitable remuneration for any additional use of the pictures.

For example, if you are commissioned by a magazine to take the pictures to illustrate a feature, the fee you are being paid only covers one-time use of those pictures, unless the commission says otherwise. Therefore, if the publisher decides to re-use some of those pictures at a later date, in a different issue of the magazine, another magazine, in promotional material, a yearbook, free supplement, advertisement or anything else, you should be paid an additional fee over and above what you were paid initially.

The same applies if you are commissioned by, say, a local business to take pictures for a brochure or report and a few months later those pictures are used for something else.

Most buyers of photography are open and honest about this. However, not all

The specialist magazine market is one area where aspiring freelancers can tout for commissions. I was approached to take these pictures several years ago by a gardening magazine because its usual photographer was away on holiday.

are. The problem lies in keeping tabs on your work: how would you know if pictures you took three years ago were re-used unless you saw them in print?

Unfortunately there is no real answer to this, so the best you can do is make it clear on your original invoice that the pictures you have taken are for a specific purpose, and any further use will be subject to additional payment.

Relinquishing copyright

In an attempt to bypass the above problem, many regular buyers of photography – such as magazine publishers – now have a policy that all freelancers working for them sign a contract relinquishing copyright on all the pictures taken on commission. In doing so, this means that the client can use the pictures again and again, free of charge.

Few photographers are happy about

doing this, but most also realize that by refusing they could be 'blacklisted' and lose work. If you have already taken on commissions from a client and are then faced with the same dilemma, the best solution is to try to negotiate a higher payment rate: if the normal day rate is £200, say, then offer to sign the contract if the rate is increased to £300 per day. It is unlikely that such a big jump will be accepted, but at least it's a starting point and you may finally agree on a fee that is acceptable to both parties.

If a rate increase is turned down, then you have to weigh up the pros and cons of compromising your rights as a photographer against losing work – remembering while you do so that the more photographers sign away copyright on their work, the harder it gets for us all to assert our rights and be suitably rewarded for the services we offer.

Legal action

If you do suspect that unauthorized use of your work is taking place, then you should take legal advice from a solicitor who has knowledge of copyright – professional photographic bodies may be able to help here (see page 191). He or she will then contact the client concerned and seek damages for copyright infringement.

You could contact the client directly and demand payment for the unauthorized use, but unless you feel this action will resolve the situation, it is better to rely on a legal expert. Either way, you should ensure the payment claimed is high, in order to deter the client from doing the same thing again.

UK law gives you six years to act upon copyright infringement such as this, though if you can prove that the user of the work intentionally prevented you from knowing that the infringement had taken place, this constitutes fraud, and then there is no time limit.

Social photography

With social photography – portraiture, PR, weddings – there are two extremes that should be considered.

Firstly, although you own copyright on the pictures you take, you cannot sell the rights to them, or use them yourself, without first seeking the permission of the people depicted. In other words, if you photograph a wedding on commission and want to use some of the pictures to promote your services – by placing prints in a shop window or letting a local newspaper publish them, perhaps – or if you want to submit the pictures you take to a picture library, you must seek approval from the client first. If they refuse, there's little you can do about it. If they agree, get them to sign a model release form so there can be no legal comeback in the future.

The second point concerns copyright infringement by the client. Many portrait photographers offer a sitting service, for example, where for a relatively small fee they take a selection of portraits and pass on a set of proof prints to the customer. The idea is that the customer will then order reprints from these proofs, and that's where the photographer makes the bulk of his profits.

A similar situation exists with wedding packages, where small proof prints of the event are given to the happy couple so that they and their families can choose which pictures they would like to have enlarged and perhaps put in a special wedding album.

Unfortunately, in both cases it is not uncommon for the customer to take the proof prints along to a copy shop or processing lab and have enlargements made themselves for a nominal cost – thus bypassing the photographer and saving a lot of money.

This is blatant copyright infringement, and if you suspect a customer is exploiting you in this way you should seek legal advice, claiming damages from them well beyond what it would have cost had they made legitimate orders, so as to deter them, and other people, from doing the same thing again.

Holding on to the negatives would have prevented this not too many years ago, but it is now possible to have prints made directly from prints at high street processing labs. And with the advent of digital technology, scanning a small print into a computer and then producing enlargements from an inkjet printer is also both easy and inexpensive.

Insurance

If your professional photographic activities involve people, you will need to take out some kind of public liability insurance so that you are covered in the event of someone being injured, or worse, as a result of your presence.

Imagine you are photographing a wedding, for example, and one of the guests trips over your gadget bag, breaking a leg, which means that they can't work for six months. Or you go to someone's house to shoot some commercial portraits and a light falls on to one of your customers, causing an injury which requires hospital treatment.

In this litigious society we all live in, few people are going to dust themselves down and tell you not to worry – not if they think there's money to be made by pursuing the matter. Law firms even advertise their services on TV today, offering to represent people who have had accidents and claim compensation for them from the person responsible.

Once word gets around that you're a decent photographer, all kinds of requests may be received. This drummer from a rock band wanted something a little different, so I obliged and shot him on Konica 750 infrared film.

Expert view: Malc Birkett

Fifteen years ago, Malc Birkitt turned his back on a successful career editing photographic magazines to pursue an unpredictable future as a freelance photographer. He needn't have worried, however, because since then his skills have been in constant demand by magazine and book publishers, advertising agencies and a wide range of commercial clients.

'Say "Yes", then worry about it later, is the motto I have always applied to my photography. When the phone rings, you never quite know what you're going to be asked to photograph, but for me that has always been part of the challenge.

'I thrive on the variety. One day I could be asked to shoot a boring lump of plastic, the next a control room for a water authority, but whatever the subject and whatever the brief, I always give it my all because if you are not doing your best, then you're not doing your job properly.

'Carving out a career as a commercial photographer takes a lot of effort, hard work and perseverance. When I decided to go freelance I didn't just jump; I walked the streets of London, Birmingham and other cities, showing my portfolio to publishers and agencies and trying to get projects on the go ready for when I left my job. As it turned out, most of those projects failed to materialize once I was freelance, but one or two came to fruition and it got me started.

'One of my luckiest breaks came when some guy peered over my shoulder while I was showing my portfolio to a publishing house, saw a shot of a motorbike, and asked me if I would be interested in taking the pictures for a book on Harley Davidsons. That was a magical assignment, bombing around the USA

attending bike rallies, and other book projects came out of it.

'I also made use of connections in the publishing industry and ever since going freelance I have done a lot of editorial work for gardening magazines, travelling all over the UK photographing wonderful gardens. I now have a large collection of garden stock shots which I'm starting to sell through an on-line picture library.

'After a few years I decided to advertise my services in the local *Yellow Pages*, and this has led to all sorts of work – commercial, industrial, advertising, PR, corporate portraiture. The only thing I don't do is weddings. Despite working for some very high-profile clients, weddings still freak me out, so if someone asks me I always put them on to another photographer.

'Most of my photography is done with a Mamiya RB67 medium-format camera and lenses from 45mm to 180mm. I also have a 35mm kit based on Canon EOS5s, plus a large-format system which gets dusted down occasionally. The majority of jobs involve working on location, though I have a studio set-up in my garage at home. Recently I have also invested in digital equipment so I can supply images on CD-Rom, and this in itself has led to more work – I'm helping someone put together a website at the moment.

Malc is regularly commissioned by gardening magazines to illustrate editorial features and always tries to come up with something a little different – in this case, using differential focusing to lead the viewer's eye into the picture.

This picture was taken on commission for a regional water authority and shows the high level of technical skill – developed partly by studying for a degree in photography – that Malc puts into his work, no matter what the subject.

PART 2
SUBJECTS
THAT SELL

PEOPLE AND LIFESTYLE

Of all the subjects you can shoot for stock – especially if you intend submitting your work to a picture library – people are probably the most lucrative.

Lifestyle images are used by the thousand for advertising campaigns, generating huge amounts of money for the photographers who took them. Unfortunately, they're also one of the most difficult to photograph well, so if you are to succeed you will need both determination and skill. It's not that people are an inaccessible subject, or technically more demanding than any other subject – far from it. No, the difficulty lies in taking pictures that have the right style.

When you see pictures of loving couples walking hand in hand along a deserted beach, or happy families having a barbecue in their garden, it's tempting to think that any photographer could take pictures equally as good. In reality, however, those pictures take a lot of planning, and what often looks like a casual snapshot is usually a carefully timed and executed photograph. Consequently, many aspiring freelancers try, and fail, in this most competitive of markets because their pictures haven't quite got that special something.

If you look closely at the majority of people and lifestyle pictures you will also notice that the subjects are perfect in every way, whether man, woman or child. They have perfect bodies, flawless skin, sparkling eyes, well groomed hair and immaculate clothes.

Again, this is no mistake. Advertisers don't want ordinary folk like you or me, they want beautiful people who can sell the dream and give us something to aspire to. Lifestyle photographers almost always hire professional models, who not only look the part but can also act the part because they have confidence and presence in front of the camera. Other specialists, such as make-up artists and

hair stylists, may also be brought in to make sure everything is just right. Then there are locations to find, travel arrangements to make, clothes to buy.

Needless to say, if you want to get involved in this type of photography at the upper end of the market, you need to be willing to invest a lot of money and be confident that you will get it all back again through sales of your work.

Realistic aims

If reading this has shattered your illusions, don't let it. There is money to be made from people pictures, it's just that you need to be realistic about your aims and perhaps set your sights a little lower – at least until you've got a foot on the lifestyle ladder.

Finding models

One option, initially, is to work with amateur models who are looking for opportunities to practise their skills and will usually pose for free in return for a few prints for their portfolio. I know several photographers who have established careers in this way, and although it may take longer to get there, the financial risks are much smaller.

The easiest way to find suitable models is by getting in touch with local modelling agencies, who recruit new faces on a regular basis. Most newcomers can't afford to pay for glossy portfolios, so they are usually willing to do a contra-deal with photographers – they model for free and you take pictures for their 'book' for free.

Another option is to approach anyone you see who looks promising and ask if they would be interested in modelling for you.

The key is to be polite and tactful. Explain that you are a photographer who

Simple head-and-shoulders portraits with strong eye contact make good stock shots, whether the subject is male or female. This photograph features a friend of mine, and was shot in a temporary studio which I set up at home.

Camera: *Pentax 67* **Lens:** *165mm*
Film: *Ilford HP5 Plus* **Lighting**: *2 flash heads on background, single flash head with softbox on subject*
Exposure: *1/10 second at f/16*

takes people and lifestyle pictures for a stock library and that you are always looking for models. A strange man confronting a young woman in this way can easily be misinterpreted, so if you are male, it helps to have your wife or girlfriend present, to add credibility. Give the person you approach a business card and suggest that they think it over, then give you a call if they're interested. If the person is, or appears to be, a minor (in the UK, under 18 years), insist that they bring a parent or friend along initially if they do like the idea of modelling for you. Nine times out of ten, you will never hear from that person again, but some people will respond, and over time it's possible to establish a useful network of suitable models.

Another option is to recruit people you already know – friends, relatives, neighbours, work colleagues – and use them as models. In recent years there has been a gradual shift in the stock industry

towards pictures of ordinary people, young and old, tall and short, fat and thin, and although the market is small compared to that already discussed, it does exist and can be very lucrative.

Hardware

In terms of equipment, a basic 35mm SLR system is all you need to produce saleable people pictures. Unlike with scenic and travel subjects, most picture libraries will accept 35mm, so you don't have to work in larger formats.

By far the most useful focal length for people photography is a short telephoto around 85–105mm, particularly for

Stylish, informal photographs of pretty girls enjoying life can be big sellers for both advertising and editorial use, though you need to get every aspect of the shot right if it's going to stand out from the crowd.

Camera: *Canon EOS1n* **Lens:** *200mm f/1.8*
Film: *Kodak Ektachrome E100S*
Exposure: *1/500 second at f/2.8*

head-and-shoulders portraits, as its slight foreshortening of perspective flatters facial features. Shorter lenses – around 50mm – are equally useful for half- or full-length shots and environmental portraits, while focal lengths around 200mm allow you to throw distracting backgrounds well out of focus so that

Once you find a set-up that works well, make the most of it. Both these pictures were shot in the same corner of the photographer's studio, using the same lighting, same film and same angled composition.
Camera: *Hasselblad* **Lens:** *80mm (boy), 50mm (girl)*
Film: *Fujichrome Provia 400 cross-processed*
Lighting: *Softbox to right of camera and silver/gold reflector to left*
Exposure: *1/500 second at f/11*

your subject is prominent in the frame.

Film choice for people pictures is important if you're shooting colour, as some emulsions are better at rendering skin tones than others. Fujichrome Velvia, for example, the most popular choice for scenic photography, is shunned by portrait photographers as it makes skin tones look far too warm. Fujichrome Provia 100F is the current favourite, offering sharpness and grain close to that of Velvia, but with far more realistic skin tones and a stop extra speed.

Black and white is popular. If you don't have access to a darkroom, use Agfa Scala, which is an ISO200 black and white transparency film, or Ilford XP2 Plus, which is C-41 process. If you do process and print your own black and white, films such as Ilford HP5 Plus and Ilford 400 Delta are ideal, along with Kodak T-Max 400.

Other essentials include one or two

reflectors, so that you can bounce light into the shadows when working indoors or out (white folding Lastolite reflectors are ideal), an 81B or 81C warm-up to enhance skin tones, and perhaps a flashgun to provide fill-in when shooting outdoors in bright sunlight.

Pictures taken indoors tend to look far more natural and spontaneous if they're shot in windowlight, whereas studio lighting clearly suggests that the pictures are set up. Both approaches have their place, of course, so it's worth buying and using a basic lighting system, too.

I picked up a couple of inexpensive flash heads on the secondhand market, along with stands and softboxes. That's all you really need – I often use just a single light fitted with a softbox, as it gives a form of illumination similar to windowlight. The only time more lights are a benefit is when you need to light the background separately. One light

on the background may be sufficient to do this, but for a clean, white background a pair of flash heads will be necessary to provide even illumination.

Ideas count

If you're serious about people and lifestyle photography, get in touch with your picture library and discuss ideas with them. Stock catalogues are also a must for checking out current trends and getting ideas for pictures of your own, as are fashion and lifestyle magazines.

When you do start your investigations you will see that there's a great demand for simple head-and-shoulders portraits in both black and white and colour, so this is always a good place to start.

These can be shot indoors or out, in available light or artificial. The most important thing is to have strong eye contact so that your subject communicates something to the viewer, and attractive,

flattering light. Experiment with jaunty angles, take some pictures with your subject smiling, others with them looking more thoughtful or serious. Introducing props such as a wine glass, coffee cup or telephone is worth considering, as is shooting in different locations.

The key is to come up with a whole list of variations on the same basic theme, then gradually work through them all so that your library has a range of images from which to choose.

Anything to do with health and beauty is worth shooting and you could take a range of shots with a single model in a short space of time. Just think about the daily rituals that men and women go through, or the issues that people take seriously today, for example:

- Applying make-up
- Massaging the temples to relieve stress
- Washing hair
- Applying moisturizing cream
- Brushing teeth
- Eating fresh fruit
- Munching on a bar of chocolate
- Drinking alcohol
- Drinking coffee
- Drinking mineral water
- Washing with fresh water
- Shaving (men)

All these pictures, and many more, could be taken with modest equipment, using natural light and amateur models, yet if you thumb through the pages of any stock catalogue you will see them time after time after time.

Saying that, there's little point in slavishly copying pictures you have already seen, because if you do so, the chances are that by the time your pictures get into circulation, trends will have changed. The key, therefore, is to use existing stock images as a guide to the type of subjects and ideas that sell, but then to interpret

them in a different way. Remember, also, that picture libraries will rarely select more than two or three shots of the same person for a catalogue if they cover a similar theme, unless those shots are outstanding, so vary your models, or at least vary the type of pictures you take of any one person.

Different photographic techniques are also worth experimenting with – using fast, grainy film, making Polaroid Image transfers of suitable pictures, shooting in warm tungsten light on unfiltered daylight film, introducing movement by shooting at slow shutter speeds, and so on.

Two's company

As well as pictures of individuals, there's also a huge market for couples, and with suitable models you can take a variety of saleable pictures with ease.

The key here is to come up with different themes and then work around them. Couples are normally photographed in a way that suggests love, romance, happiness, togetherness, companionship and intimacy, so be mindful of these things while you are planning pictures.

Initially you could begin by taking simple pictures of two people together outdoors – walking in the park, gazing into each other's eyes, kissing, embracing each other, chatting, relaxing on a park bench, walking their dog and so on. At different times of year this same set of pictures can be repeated – with your models wrapped up in warm clothing in winter, and wearing lighter, summer clothing in warmer weather.

You could also shoot in different locations – the park, the beach, an attractive garden somewhere, outside a country pub, in a bustling city. If you're

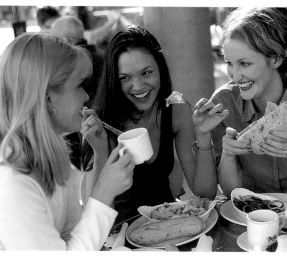

Young people having fun with friends is another popular stock theme that you should consider shooting. Make use of local cafés and restaurants to provide a suitable venue and backdrop to your pictures.
Camera: *Canon EOS-1n* **Lens:** *50mm*
Film: *Kodak Ektachrome E100SW*
Lighting: *Daylight and large white reflector*
Exposure: *1/60 second at f/4*

lucky enough to live by the sea, a whole range of other opportunities will be at your disposal – individuals and couples strolling on the beach, paddling in the sea, relaxing in the sunshine. Indoors, how about finding a local restaurant, coffee shop or cocktail bar where you can take pictures out of hours so that you have the place to yourself.

The older generation

In your search for suitable models, don't ignore older people, either. There is a growing market for pictures of middle-aged and elderly people enjoying active lives – driving sportscars, riding bicycles, playing tennis, golf and other sports, exercising, eating healthy food, painting, gardening, walking and generally enjoying themselves. Any of the picture ideas already mentioned can be applied to models who are getting on in life, from simple head-and-shoulders portraits

With imagination and planning it's possible to come up with a range of different stock shots during a single session. Couples depicted in various scenarios are especially popular for general-interest and women's magazines that run articles on relationships.

Camera: *Canon EOS1n* **Lens:** *50mm*

Film: *Kodak Ektachrome E100SW*

Lighting: *Windowlight with reflector*

Exposure: *1/60 second at f/2.8*

of individuals to happy couples.

Then there are the more negative sides of old age to consider – disabilities, loneliness, poverty, isolation and so on. These things need not actually apply to your models, but they can be implied in the pictures you take.

Kids' stuff

And then there are children and babies, the most accessible subjects for people and lifestyle photography. If you don't have children of your own, you'll have friends or relatives that do, so there should be suitable models on hand. Even better, you don't need 'beautiful' children to take saleable pictures – big, small, fat, thin, ugly, attractive, blond, brunette, blue-eyed, brown-eyed... Whatever the physical attributes of your subjects, it's possible to take saleable pictures of them because

children are just children: funny, lovable, cute, cuddly, mischievous.

Babies

Let's start right at the very beginning, with newborn babies. The birth itself tends to be a rather chaotic, emotional event, and it's unlikely your partner, sister or friend will appreciate being photographed at her most vulnerable. However, immediately after the birth there are great pictures to be taken – the first tender moments when the newborn baby is being held by its proud mother, its first feed, those big, searching eyes wondering what the hell is going on, those tiny, wrinkly hands and feet, the name tag on the baby's wrist. These simple detail shots are especially popular because they're highly symbolic, generic images of childbirth that have universal appeal, so don't feel you always

have to include the baby's face.

The first weeks and months of a baby's life can be equally productive from a photographic point of view. Shoot more close-ups of those delicate hands and feet when the baby is sleeping, using a macro lens so that you can focus nice and close – or place one hand on the much larger hand of an adult to symbolize the fragility of childhood. Capture tight shots of the baby's gentle face as it sleeps, close-ups of it being breastfed, and so on.

The great thing about babies is that they're relatively immobile, so you can position them to take advantage of attractive windowlight, or for shots of feeds you can ask the mother to sit in a specific place. Interesting facial expressions, especially smiles and wide-eyed stares, can be great sellers, so keep a camera handy at all times. You may have to waste a lot of film to get a few great shots, but at the end of the day you only need one to make a lot of money.

BELOW Taken when my baby daughter was just a few weeks old, this simple image is symbolic of babies and childbirth. Such shots are very popular with picture libraries.
Camera: *Nikon F5* **Lens:** *105mm macro*
Film: *Fujichrome Provia 400 rated at ISO1600 and push-processed 2 stops*
Lighting: *window light*
Exposure: *¹⁄₂₅ second at f/4*

As your baby gets older, so the photo opportunities change. The baby becomes more expressive, facially, and begins to crawl around. So take pictures at every opportunity – bath time, feeding time, baby clothed and naked, awake and asleep. Try lying on your stomach and take pictures as your subject crawls towards the camera, or use a wide-angle lens and go in really close – doing this often results in wonderful expressions.

Toddlers

Toddlers can be difficult to photograph, simply because they have such a short attention span – they also want to take an active interest in what you're doing instead of doing as you tell them, and picture-taking can become a very frustrating activity where tempers often fray and tears are shed.

The easiest way around this is to keep your shoots brief, and, more importantly, to keep your subject occupied. So base the pictures around some kind of activity – searching for bugs or picking flowers in the garden, dressing up in silly adult clothes or fancy costumes, washing the car with a hose, playing in the park on climbing frames, roundabout and swings, having fun with family pets, splashing in puddles, playing with colourful balloons and

so on. Holidays can be equally productive, with ice creams to eat, the sea to paddle in, sand castles to build, fish to catch. Anything that takes your subject's mind off the camera will make your life easier – and provide lots of opportunities to take interesting pictures that capture your subjects doing what all kids do.

ABOVE This gentle portrait of my son, Noah, was taken when he was only a few months old and contains all the elements of a successful stock shot – simple composition, strong eye contact, soft lighting and that all-important 'ahhhh' factor. It has already featured on the cover of a photographic magazine, and looks set to sell many more times over the coming years.
Camera: *Pentax 67* **Lens:** *135mm macro*
Film: *Fujichrome Provia 100* **Filters:** *Soft focus*
Lighting: *Single studio flash fitted with softbox and positioned to left of camera*
Exposure: *¹⁄₆₀ second at f/11*

Social issues

As well as depicting the more attractive sides of life, there is also a growing market for images covering less desirable topics.

Drug abuse, violence, child neglect, poverty, burglary and theft, alcohol abuse, smoking, depression – all these subjects are part and parcel of daily life, more so now than ever before, and any stock photographer looking to make money would be silly to ignore them.

Another reason for shooting pictures that depict social issues is you don't need beautiful people – quite the opposite, in fact – so you don't have to be quite so choosy about whom you ask to model. Often you will need to make your subject look unattractive intentionally in order to get the point across. Heroin addicts rarely have flawless skin, and burglars usually prefer to hide their faces rather than show them off.

All you need to do is set yourself a brief, then take as many different pictures as you can which satisfy it. If you decide

to work on the idea of car-related crime, for example, you could photograph a teenage boy apparently trying to force his way into a car – shot from inside and outside the car, plus a close-up of the door or window being forced. Your subject could also be depicted loitering around a busy carpark looking suspicious, reaching into an open car window and snatching a handbag, pulling a car radio from its mounting, and so on. Once you start to think about it, it's surprising how many different ideas spring to mind.

This dramatic photograph was set up using friends as models, to symbolize the kind of situation paparazzi photographers often find themselves in. It has since been selected for publication in my picture library's next stock catalogue to illustrate invasion of privacy.
Camera: *Nikon F90x* ***Lens:*** *28mm*
Film: *Agfa Scala 200* ***Lighting:*** *Electronic flash*
Exposure: *⅛ second at f/5.6*

The techniques you use can make or break a great picture. Shooting from unusual angles, using slow shutter speeds to introduce blur, loading up with fast, grainy film, cross-processing film and working from close range with a wide-angle lens – all these things will add a gritty realism to your work.

A quite moment in secretly captured on film and the result is an image that captures the contemplative side of childhood. Noah was mesmerized by a flickering candle flame, so I grabbed a quick shot with his face bathed in golden light.
Camera: *Nikon F90x* ***Lens::*** *50mm*
Film: *Fujichrome 400 rated at ISO1600 and pushed 2 stops*
Exposure: *1/15 second at f/1.8*

MODEL RELEASES

Once you start photographing people with a view to selling your pictures, either directly to clients or through a picture library, it is vitally important that your models sign a release form. The vast majority of picture libraries won't accept people pictures unless they're accompanied by a model release signed by all the people depicted – but even if they did, you would be foolish to proceed without one.

By signing a model release, your subject is basically agreeing to let you sell the pictures taken of them, without there being any demands for payment if you happen to make a lot of money from those pictures, or any legal comeback if the pictures are used in a way with which the model is unhappy .

If you take a picture of someone drinking alcohol, for example, and that picture ends up being used to illustrate a magazine article on alcoholism, it could be assumed that the person in the picture is an alcoholic, even though the picture was innocently set up and normally they are teetotal.

If you have a signed model release for those pictures, your model can do nothing about it. However, if you don't, that person could sue you for defamation of character. This doesn't only apply to professional or amateur models, either, but also to family, friends, husbands, wives, boyfriends, girlfriends, neighbours, work colleagues, total strangers – anyone you ask to pose for pictures that may eventually be published or used in a commercial way must sign a model release form, no matter how well you know that person. In the case of minors – in the UK, people under 18 years of age – a parent or legal guardian must sign the model release.

You can buy pads of model release forms from professional photographic organizations and freelance bodies (see page 191). These contain the standard contract and wording and come in duplicate form so that both you and the model have a copy.

Alternatively, you could formulate your own release form and print off copies from a computer as and when required, which is what I do. This method also allows you to vary the wording of the contract, if necessary.

Territorial limits are usually worldwide, but your model may request that they be limited to a specific country, such as the UK, or a continent, such as Europe.

As for specific exclusions, this clause allows your model to specify any areas they do not want the picture to be used for – such as anything to do with drug abuse or sex, for example. Clearly, the more exclusions there are, the more limited the use of the picture(s) will be.

Here's what a basic model release should say and include:

I permit the photographer referred to above, and his licensees or assignees, to use the photograph/s referred to above and/or drawings therefrom and any other reproductions or adaptations thereof, either complete or in part, alone or in conjunction with any wording and/or drawings, solely and exclusively for:
- Editorial
- Experimental
- PR
- Press advertising
- Display material
- Packaging

Territorial limits:

Specific exclusions:

- I understand that such copyright material shall be deemed to represent an imaginary person.
- I understand that I do not own copyright of the photograph/s referred to above.

Name of model (in capitals):

Signature of model:

Date:

Witness:

- Models who are under 18 years of age must produce evidence of consent by their parent or guardian.
- In accepting the above model release, the photographer and client undertake that the copyright material shall only be used in accordance with the terms of the release.

Depressed, suicidal, or just following the photographer's instructions? If your subject signs a model release form, it won't matter because by doing so they relinquish all rights to the image, and a say in what it's used for, with the exception of any limitations stated in the contract. **Camera:** *Olympus OM4-Ti* **Lens:** *85mm* **Film:** *Kodak 2481 high speed mono infrared* **Exposure:** *1/60 second at f/11*

Expert view: Chris Rout

A commercial diver by trade, Chris Rout started selling his pictures to photographic magazines while still an enthusiast. Today he is carving out a lucrative niche as a talented beauty and lifestyle photographer, and is represented by two leading picture libraries.

'My photographic career began out of necessity more than anything else. During the early 1990s there wasn't much diving work around, so with a growing family to support I enrolled on a freelance photography course, and then decided to become a photographer.

'That's really how I got into people photography. Up until that point I used to photograph all kinds of things, but one of the projects on the course was to take some glamour pictures, so I contacted a local model agency and organized a shoot. The agency liked the pictures I took, and things just went from there.

'One of the things I enjoy about people photography is working as part of a team. Being a diver, I'm used to being part of a small team where everyone relies on each other, and it's the same when you're photographing people. I also enjoy chatting and having a laugh. Going off alone shooting landscapes has never really appealed.

'In the early years I got in touch with models through local agencies. Aspiring models can rarely afford to pay to have a portfolio shot for them, so they come to an arrangement with a photographer – modelling for free in return for some shots for their portfolio. This gave me the chance to improve my skills, and work on new ideas.

'The only drawback with using up-and-coming models is that they aren't always that confident in front of the camera, so you spend a lot of time encouraging them and don't always get the shots you want. Saying that, I sold a lot of pictures to photographic magazines that I'd taken on model test shoots, and even now I take stock shots for the picture libraries during test shoots. The main thing is that you're up front about everything. Model agencies won't be too pleased if they think you're exploiting new models and not giving anything in return.

'More and more now I hire professional models that are confident and experienced, so I know that I will get something good from the shoot. This is expensive – usually around £180 per model for a three-hour session – so you need to have a very clear idea about the pictures you want to take, otherwise you're simply wasting money.

'For example, I might set up a shot with a model sitting on a window seat, then take a happy, smiley shot, a sad shot, get the model to hold a coffee cup, a chocolate biscuit or a pack of headache pills and so on. I also vary the viewpoint and shooting angle, and a three-hour shoot may involve up to four changes of clothing because you need to keep the shots looking different.

'The key is to study the market. My work tends to be used in women's magazines and national newspapers, so I'm constantly looking at them to see if

Typical family situations such as a visit to the local doctor are often requested by magazines and national newspapers. To maximize sales, Chris always listens to advice offered by his picture library.

the style of photography has changed. At the moment, everyone wants minimal depth-of-field, for instance, so I spend most of my time shooting at maximum aperture – my most useful lens is a 50mm standard. I also shoot the same themes using different models. Libraries often receive similar requests – for couples chatting, arguing, kissing and so on – so you need to keep supplying them with new pictures showing the same things.

'I use 35mm equipment most of the time because it's versatile, quick to use, and medium format is rarely expected. I've got a Canon EOS-1n system with 20–35mm f/2.8 and 70–200mm f/2.8 zooms, a 50mm f/1.8 standard and a 200mm f/1.8. Fast lenses are ideal because at maximum aperture you can really throw the background out – the 200mm f/1.8 is superb for this. They also allow me to work at decent shutter speeds even when the light is relatively low, so I can work handheld without worrying about camera shake. My favourite film is Kodak Ektachrome E100SW, which has a slight warmth similar to using an 81A filter. This makes skin tones look more attractive.

'Another accessory I couldn't live without is my California Sunbounce reflector. It's huge – about 6x4ft [2x1.2m] – with white on one side and gold on the other, and it's invaluable for controlling the light – you can see the effect on models 20ft [6m] away in bright sunlight, so I can still use it even for walking and running shots.

'In terms of locations, I make the most of the places in my home town of Middlesbrough. Big parks and gardens are ideal for outdoor work because you can use the trees and hedges to provide a neutral background, then shoot at a wide aperture to throw it out of focus. I also shoot in local cafés and restaurants – if you find out when the quiet times are you can work without getting in the way of the

customers. I use ones that are well lit by daylight. Natural lighting is more fashionable now anyway, but having to set up lights just gives me more to think about and I'd rather concentrate on the model.

'If you want to succeed as a people and lifestyle photographer you've got to be willing to work hard and keep at it. You also need to be a good listener and accept criticism from those who know better.

Pictures that depict themes such as healthy eating are popular for magazines, so Chris regularly updates his stock collection with new images.

I would also advise any photographer to find a good picture library – my work now sells all over the world, and to markets that I couldn't reach as a photographer working independently.'

LIVE PICTURES
LIFESTYLE SHOOT

Despite the fact that one of my best-selling stock shots is a portrait (see page 86), I actually take very few people pictures. It's not that I find the process difficult, but more that I prefer to take pictures on the spur of the moment, and good people shots require planning.

Recently, however, I have been trying to change all that by setting up the occasional shoot with family and friends, and the pictures you see here are the result of one such foray.

My subject, Alison, is a good friend and didn't hesitate when I casually enquired if she fancied doing a little modelling, though being the mother of three young children her time is precious and trying to pin her down for a set time on a set day wasn't easy.

Eventually we managed to find a 'window' in our diaries where she had an hour to spare between leaving the office for the afternoon and picking up her children from their minder.

Planning a shoot

My aim was to produce a set of lifestyle portraits depicting Alison in a variety of situations and poses. Had there been more time available I would have suggested that she brought at least one extra change of clothes, to give the shots variety, but there's a limit to what you can achieve in an hour, so I decided against this and to keep everything as simple as possible. I also planned to shoot everything indoors, in my home, using windowlight rather than studio flash as it's more spontaneous.

On the day the weather was cloudy and dull, so the quality of light was perfect for flattering portraits. At the same time,

however, light levels indoors were relatively low, so in order to achieve manageable shutter speeds I had to load up with ISO400 film instead of ISO100 and shoot at maximum lens aperture. Most of the shots here were taken in the same room, close to a set of double-glazed doors to make best use of the light flooding in.

The shoot kicked off with a quick sequence of portraits of Alison peering through the doors while holding a cup of coffee – clichéd I admit, but a popular stock pose nonetheless. Next, I asked her to lie flat out on the floor facing the window and cup her face in her hands, while I fired away with my camera mounted on a tripod at its lowest setting.

From there I introduced a chair to the room so that Alison could sit a couple of metres from the window, and while she chatted to my wife I took pictures standing upright and looking down, shooting with a 105mm macro lens set to maximum aperture and focusing carefully on her eyelashes, knowing pretty much everything else in frame would be thrown out of focus by the shallow depth-of-field. Variations on this pose were taken, with my subject looking sombre, smiling, and sipping from a coffee cup.

With Alison still seated,

I then proceeded to shoot a sequence of head-on portraits, again making the most of diffuse windowlight to flatter her skin tones. We then moved our activities to the living room, where I asked Alison to relax on a comfy sofa and pretend to be chatting on her mobile phone while I snapped away – a task she performed with ease.

Finally, with half a dozen frames left on a roll of film, I decided to use them up by shooting portraits of Alison resting on the arm of the sofa and looking away from the window. By exposing for her face, which was in shadow, this produced an attractive high-key effect and proved to be one of my favourite pictures from the session.

TECHNIQUE TIPS

• Establish a game plan well in advance of the shoot so that you have some picture ideas to work on, and factors such as lighting and equipment have been considered.

• Discuss your ideas with your model so that he/she knows roughly what you have in mind.

• If time permits, ask your model to bring along at least one change of clothes to add variety to your pictures.

• Shoot variations on each idea or theme so that your picture library has a choice of shots.

I'm the first to admit that people photography isn't my strong point, and that I'm never likely to be a threat to some of the specialists who contribute lifestyle pictures to my library. Nevertheless, in the space of just one hour I managed to put together a decent set of shots which cost me nothing but the price of a few rolls of film.

Alison was a great model – confident and fun in front of the camera, responsive to my instructions, and able to change her expression at will. She was also more than happy to sign a model release, giving me the necessary clearance to submit the shots to my library, and I feel confident that over the next couple of years these pictures will achieve at least a few sales.

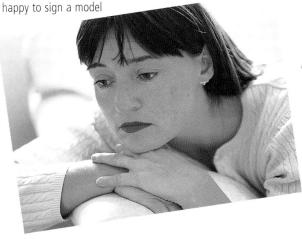

Here are just a handful of the pictures I took of Alison during our brief indoor lifestyle shoot. All were taken in windowlight on a dull, rainy day, using either an 85mm f/1.8 or a 105mm f/2.8 lens at maximum aperture.

EQUIPMENT AND TECHNIQUE

Camera: Nikon F90x 35mm SLR
Lenses: Nikkor 105mm f/2.8 macro and 85mm f/1.8
Tripod: Manfrotto 190 with ball-and-socket head
Film: Fujichrome Sensia 100 rated at ISO400 and pushed 2 stops
Filters: None
Lighting: Windowlight

BEST SELLERS

I do not take many pictures of people and my subjects are mainly family and friends and tend to be taken for pleasure rather than profit. That said, some have sold through both my picture library and from on-spec submissions, generating healthy returns. Here are a few examples, with details of how they were taken and a record of their performance to date.

DAMON

I took these portraits of a friend several years ago while experimenting with cross-processing colour slide film – they were nothing more than test shots and the shoot lasted no longer than ten minutes. Two or three years later, almost as an afterthought, I decided to submit them to my picture library, not realizing that they would eventually sell all over the world and become two of my best-selling photographs.

What makes it sell?

Undoubtedly the subject's relaxed expression – they're very happy, refreshing images. The bright colours and high contrast, courtesy of cross-processing, also help, as does the clean, white background which makes the images easy to work with because text can be dropped on to them.

Over all, they're stylish, contemporary images symbolic of today's young generation, making them perfect for many different uses.

FACTS & FIGURES

Equipment *Pentax 67, 165mm lens*

Lighting *3 studio flash heads – 1 with softbox on subject, 2 with dishes on background*

Film *Fujichrome Provia 100 cross-processed in C–41 chemistry*

Number of sales to date *43*

Catalogue image? *Yes, both*

Where sold *UK, France, Germany, Switzerland, Austria, Belgium, Finland, Norway, Holland, Ireland, Ecuador, Portugal, Sweden, Spain, USA*

To make regular sales from stock images today, you really need to get them in the library's catalogue. In this case, both shots were selected for catalogue use and have sold equally well.

Used for *Audio-visual presentation, brochure, photographic magazine, banking leaflet, book illustration, advertising campaign, promotional poster. Most uses unknown*

Total sales to date *£5,500*

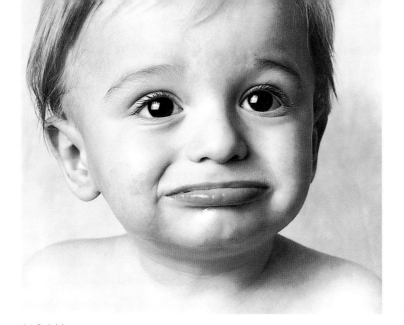

Character Study

FISHERMAN

I photographed this retired fisherman in the Scottish port of Tarbert. My companions and I struck up a conversation with him, and after a while I politely asked if I could take his picture. He agreed, so while he continued to chat and laugh I fired away, exposing two rolls of film.

What makes it sell?

The subject's expression, the beautiful soft light of a bright overcast day, the tight composition and the simple, uncluttered background — handy for dropping text on to the image.

FACTS & FIGURES

Equipment *Olympus OM4-Ti, 85mm lens*
Lighting *Daylight* **Film** *Fujichrome RDP100*
Number of sales to date *9*
Catalogue image? *No* **Where sold** *UK, France*
Used for *Photographic books and magazines, general book illustration*
Total sales to date *£325*

NOAH

Noah is my young son, and like all parents, I can't resist the urge to take pictures of him at every opportunity. On this occasion I had set up a temporary studio in a spare room at home and managed to persuade him to pose for the camera. After only a few minutes he lost interest — like most two-year-olds do — and, completely unprovoked, pulled this funny face which I instinctively captured.

What makes it sell?

Those lovely big eyes, his cute face and unusual expression. Imagine it being used to sell pensions, investments, or anything else that tends to cause confusion. Again, the composition is simple and the background plain, to focus all attention on my subject's face. Shooting in black and white also simplifies the image further.

FACTS & FIGURES

Equipment *Pentax 67, 165mm lens*
Lighting *Single studio flash head with softbox at 45 degrees to camera*
Film *Ilford XP2 Plus*
Number of sales to date *2*
Catalogue image? *Planned for late 2000*
Where sold *UK*
Used for *Magazine illustration, mailer*
Total sales to date *£450*

STEVE

This portrait is of my brother Steve, taken a decade ago during a weekend visit to my family home. I simply posed him next to a window on a dull, overcast day so that his face was sidelit and exposed half a dozen frames of fast black and white film, shooting handheld.

What makes it sell?

Photographically, it illustrates portrait and darkroom technique, use of windowlight and the power of black and white — making it ideal for photographic books and magazines. As a stock image, the moody expression and strong eye contact are suitable for illustrating social issues.

FACTS & FIGURES

Equipment *Olympus OM4-Ti, 85mm lens*
Lighting *Windowlight*
Film *Fuji Neopan 1600*
Number of sales to date *8*
Catalogue image? *Yes*
Where sold *UK, France, USA, Colombia*
Used for *Photographic magazines and books. Library uses unknown*
Total sales to date *£450*

NATURE AND SCENICS

The vast majority of scenic photographs taken are location specific – in other words, they are intended to show what a particular place looks like, be it a pretty Cornish fishing village or a Scottish castle.

Atmospheric misty scenes make ideal generic stock images as they have such great symbolic strength, as well as being highly evocative. This shot was taken in Provence, using a telephoto lens to emphasize the effects of atmospheric haze on the receding hills.
Camera: *Nikon F90x* **Lens:** *80–200mm*
Film: *Fuji Velvia* **Filters:** *81C warm-up*
Exposure: *¹⁄₂₅ second at f/11*

Chapter 6

However, different markets tend to favour different styles of photography, so bear this in mind while shooting landscapes.

Traditional markets for landscape photography, such as calendar, postcard, book and magazine publishers, tend to rely mainly on 'record' shots – pictures that are taken in ideal weather conditions and use straightforward photographic technique to show a place at its best.

If you thumb through a scenic calendar, for example, you will find that the majority of the photographs were taken in bright sunshine, often with cottonwool clouds drifting across vivid blue sky. There will also be the token snow scene for winter, and perhaps a sunrise or sunset – but rarely does it get more dramatic than that. The racks of postcards in tourist locations tell a similar story, as do travel brochures or regional features in country and outdoor magazines.

The main exception to this rule is when you are photographing areas where the

ABOVE Here's a classic example of a high quality 'record' shot that would appeal to traditional markets such as calendar publishers and tourist authorities. The subject, Bamburgh Castle in Northumberland, has been captured in perfect weather conditions, while use of a wide-angle lens allowed me to show the castle in its stunning natural environment and include strong foreground interest.
Camera: Woodman 5x4in **Lens:** 90mm
Film: Fuji Velvia **Filters:** Polarizer and 81B warm-up
Exposure: 1 second at f/32

LEFT Air freshener, toilet cleaner, mineral water, outdoor clothing – mountain scenes are used to promote all kinds of things due to the way they symbolize freshness and purity.
Camera: Olympus OM4-Ti **Lens:** 300mm
Film: Fuji Velvia **Filters:** None
Exposure: 1/125 second at f/16

scenery and weather is more dramatic. The Scottish Highlands and Lake District are two obvious regions in the UK where you expect stormy light, dark threatening skies and harsh winters, so you would be foolish to ignore these things.

Some markets – such as photographic magazines, advertising agencies and calendar publishers that produce bespoke calendars for individual clients – also prefer more photographically challenging and creative work. Equally, if you were ever lucky enough to be asked to take the pictures for a book on a specific area – such as the two I have illustrated in recent years on Dartmoor and Northumbria in the UK – you would be expected to work in all seasons and all weathers in order to create a realistic portrait of that place.

Beyond this type of illustrative scenic photography you enter the world of the generic image, where photographs are taken not to illustrate a specific place – though some shots can be both specific and generic – but for symbolic purposes.

If you check out the bottles of mineral water in your local supermarket, for example, you will often find a picture of a river or waterfall used on the packaging. Similarly, lush green foliage or beautiful skies are often used to promote anything to do with good health, while tropical beach scenes are favoured in promotions for bank loans, pension schemes, investments and anything else that's saying 'do this and make your dreams come true'.

Atmospheric misty scenes, sunrise and

sunset shots, sand dunes, rainbows, lightning, storms and many other types of subject or weather phenomena are also used. My scenic pictures are often published in brochures and 'mailers' – I have even sold shots for use on bakery packaging, a label in a waterproof jacket and an advertisement for carpets!

This is the great thing about generic scenics. Because they're anonymous, their use is almost limitless and you can find the same shot being used for all kinds of things – especially if you market your work through a picture library.

The need for anonymity also means you can take saleable pictures anywhere, instead of investing time and money travelling to popular areas. Some of my best-selling scenic pictures have been taken near my home, despite the fact that I live in an area that's renowned for its featureless landscape.

Quality counts

Whichever market you are targeting, it's the quality of light that will make or break a great landscape picture, so this factor should always be given priority.

In clear weather, the best times of day to shoot are during early morning and late afternoon, when the sun is low in the sky, the light has a pleasant warmth, and long shadows reveal texture and depth in a scene. Make the most of this by using a polarizing filter to deepen blue sky and increase colour saturation.

I tend to rise before sun-up so that I can be on location in time to shoot the sunrise, then take advantage of the beautiful morning light – without having to worry about people or traffic spoiling the view, as most sensible folk will still be tucked up in bed!

During summer, the sun has reached

its zenith (highest point in the sky) and the light its maximum intensity by late morning. The next few hours are less productive because the light is too harsh, washing out colour, while the overhead sun casts short, dense shadows and modelling is minimal. I use this time to recce new locations or move on to my next destination, then resume shooting during mid-afternoon and continue beyond sunset.

Season

Spring and autumn are the most attractive seasons in which to shoot saleable landscapes – spring for the fresh, lush foliage and autumn for the beautiful fiery colours. In both seasons the weather is unpredictable. Mist and heavy dew is common in the morning, while sudden storms and heavy downpours followed by crisp, refreshing sunshine allow you to

This panoramic photograph is a good example of a generic scenic – the rolling hills, green pasture and whitewashed farmhouse typify the beauty of the English landscape perfectly, aided more than a little by warm, early morning sunlight.

Camera: *Fuji G617*
Lens: *105mm* **Film:** *Fuji Velvia*
Filters: *81B warm-up*
Exposure: *1 second at f/22*

Dramatic sunsets are ideal both for illustrating a specific location and as generic stock images. I took this picture on the Caribbean island of St Lucia.

Camera: *Pentax 67*
Lens: *55mm wide-angle*
Film: *Fuji Velvia* **Filters:** *None*
Exposure: *¹⁄₆₀ second at f/11*

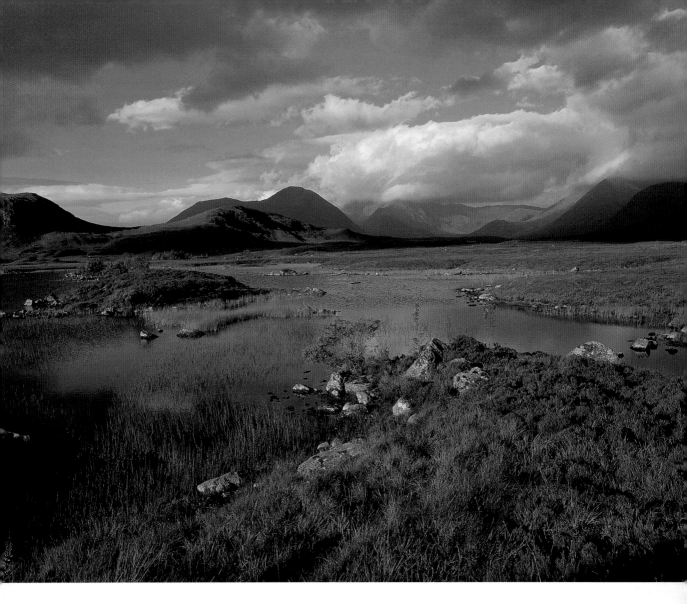

take a variety of different pictures in a short space of time.

During stormy weather, watch for rainbows. Use a wide-angle lens to capture the rainbow arching across the landscape, then home in on the bow with a telephoto or telezoom lens. To enhance the drama of stormy light, use a neutral-density (grey) graduated filter to darken the sky, and take your meter reading from the sunlit foreground.

Winter is less productive simply because the landscape is laid bare and the weather tends to be less favourable. That said, snow and frost can transform a scene overnight, so you should always keep an eye on the weather and be ready to make the most of sudden changes.

Composition

After light, the next factor you need to consider is composition. A well composed landscape photograph should lead the viewer into and through the image, transporting them from the comfort of their armchair to the place depicted.

Wide-angle lenses are ideal for this because they allow you to capture a broad sweep of landscape on a single frame of film — much more than the naked eye can appreciate. More useful, however, is the way they exaggerate perspective, so that nearby elements loom large in the frame while everything else seems to rush away into the distance. This allows you to use nearby features as foreground interest, and by doing so not only create a logical

If you're planning photographic trips, it pays to visit areas that are known to be popular among picture buyers – then make an effort to capture them in the best light. This shot, taken on Rannoch Moor in Scotland, has been used in numerous calendars, a book, on the cover of an outdoor magazine and across a double-page spread in a photographic magazine – with sales to date more than covering the cost of the whole ten-day trip.

Camera: *Pentax 67* ***Lens:*** *55mm wide-angle*
Film: *Fuji Velvia*
Filters: *0.6 density ND grad and 81B warm-up*
Exposure: *½ second at f/16*

entry point into the scene but also add a strong sense of depth and scale, giving the impression of three dimensions in a two-dimensional image. All manner of natural and manmade features can be used as foreground interest – a river or stream, a path, moss-covered rock, boats at the edge of a picturesque harbour and so on.

Front-to-back sharpness is also vital for most landscape pictures, so make sure you stop your lens down to f/16 or f/22 and use the depth-of-field scale on the lens barrel to check what the zone of sharp focus will be. I use the hyperfocal focusing technique to maximize depth-of-field. To do this, focus the lens on infinity, then check the depth-of-field scale to see what

the nearest point of sharp focus will be at the aperture set. By refocusing the lens on this distance – known as the hyperfocal distance – depth-of-field will extend from half the hyperfocal distance to infinity.

Telephoto lenses are more selective in what they see, allowing you to isolate interesting parts of a scene – such as the sun's golden orb at sunset, the patterns created by dry stone walls, or the receding effect of mist and haze on the landscape. Telephotos also compress perspective, so that the elements of a scene appear closer together. This effect, known as 'foreshortening', can be put to good use when photographing mountains and hills, avenues of trees, and other repeated features in the landscape.

Hardware

You actually need very little equipment to produce saleable landscape pictures. I use a moderate wide-angle lens at least 80 per cent of the time – a 28mm in 35mm format, 55mm for 6x7cm and 90mm for

Sometimes a lucky combination of beautiful light and eye-catching features creates an unmissable opportunity. This is Alnmouth in Northumberland, but the location is irrelevant – it's the symbolic power of the image that counts: the gentle ripples in the sand, the warm light, the moored fishing boat, and the feeling of tranquillity you get just by looking at it.
Camera: *Walker Titan 5x4in* **Lens:** *90mm*
Film: *Fuji Velvia* **Filters:** *Polarizer and 81B warm-up*
Exposure: *2 seconds at f/32*

5x4in. Either a standard or short telephoto lens copes with the remaining 20 per cent of situations.

Film format

More important than the actual cameras and lenses you use is the film format, and my advice is that if you want to make your work attractive to as many markets as possible, you will need to shoot medium format rather than 35mm. Many picture libraries now insist on it for scenic photography, as do the main players in markets such as calendar and book publishing. But even in markets where 35mm is still acceptable, by shooting a larger format your work will stand out, because a bigger original on the lightbox always looks more impressive – as well as offering superior image quality.

My preferred system is a Pentax 67 with 45mm and 55mm wide-angle lenses, a 105mm standard, 135mm macro, 165mm short telephoto and 2x teleconverter. These lenses cover a range that roughly equates to 24mm, 28mm, 50mm, 70mm and 85mm in 35mm format.

If you can't afford to buy a full medium-format system in one fell swoop, build it up over time. Initially I would advise investing in a camera body and moderate wide-angle lens which you can use alongside your 35mm kit – as I did for a couple of years – then add other lenses as funds allow.

As for which medium format to go for, that's up to you. The smallest, 6x4.5cm, is the most economical, offering 15 frames on a 120 roll of film compared to 12 on 6x6cm and 10 on 6x7cm. The cameras and lenses are also compact and lightweight. However, to my mind the increase in image size over 35mm just isn't enough, which is why I favour 6x7cm – almost an industry standard today among stock photographers. As for 6x6cm, I personally find it difficult to compose square pictures,

whereas users of the format clearly don't. More importantly, pictures tend to be reproduced as rectangles, so if you do use the square 6x6cm format, more often than not your work will be cropped, which kind of defeats the object.

Large format – 5x4in and bigger – is more of an indulgence really. The camera movements available do make it invaluable for controlling perspective and depth-of-field, and for eliminating converging verticals when shooting buildings, but the cost per shot is very high, the cameras are slow and cumbersome to use, and with the exception of some upmarket calendar publishers, you will find few picture buyers today who *insist* on large format.

In recent years panoramic film formats – especially 6 x 17cm – have become very popular for landscapes in the calendar, postcard and magazine market. Many picture libraries are also actively encouraging their contributors to supply 'pans' because they can sell for large sums in the advertising world.

I personally use a Fuji GX 617 body

which produces 6 x 17cm originals on 120 or 220 roll film, with 90mm, 180mm and 300mm lenses. Though expensive – around £7,500 for the body and three lenses – it's a superb system and is now regarded as the industry standard. The Japanese Art 617 is a less expensive option but can only be used with a 90mm lens, while Linhof also produces a 6 x 17cm camera which accepts interchangeable lenses. If you can't afford to invest in such equipment at this stage, you can always hire it as and when required from pro dealer centres.

Other essentials

Other essential items are a sturdy tripod to aid composition and keep your camera steady when using long exposures, a reliable lightmeter if your camera doesn't have one built in, a cable release to trip the camera's shutter and a selection of filters.

A polarizing filter is essential for deepening blue sky, reducing reflections on water and cutting through glare so that colour saturation is increased. Buy the best

one you can afford – preferably made from glass. Warm-up filters are also ideal for enhancing the light – I carry 81B, C, D and EF.

The only other filters you need for landscape photography are neutral-density (grey) graduates, which allow you to tone down the sky so that it doesn't burn out when you expose for the landscape . I carry 0.45, 0.6 and 0.9 density grads which reduce the brightness of the sky by 1.5, 2 and 3 stops. As a rule of thumb, if you're not using a polarizer, the chances are you will need a grad – and, occasionally, you will need both.

In terms of film, keep it slow. By far the most popular film among landscape and nature photographers is Fujichrome Velvia (ISO50) for its superb sharpness, fine grain and vibrant colours. I use this almost exclusively for scenic photography, switching occasionally to Fujichrome Provia 100F (ISO100) if I need a little extra speed – when shooting at night to keep exposure times down, or in windy weather so that a faster shutter speed can be set.

ABOVE Panoramic landscape pictures are becoming increasingly popular in all kinds of markets, from book publishing to big-budget advertising. The 'narrative' format is highly versatile, and pictures can be cropped to a number of different shapes.
Camera: *Art 617* **Lens:** *Nikkor 90mm*
Film: *Fuji Velvia* **Filters:** *Polarizer and 81B warm-up*
Exposure: *2 seconds at f/32*

BELOW Think of a property cliché and this simple shot fits the bill every time, making it an ideal generic stock image. Taken a couple of miles from home, I composed the scene so that the cottage was small in the frame to give potential users plenty of cropping options.
Camera: *Walker Titan* **Lens:** *65mm wide-angle*
Film: *Fuji Velvia* **Filters:** *Polarizer and 81B warm-up*
Exposure: *¼ second at f/22*

Life's a beach

Ask any successful picture library what their biggest-selling scenic pictures are, and nine times out of ten they will point you in the direction of an idyllic beach scene.

Swaying palm trees and pristine white sand against perfect blue sky and crystal-clear seas are used to sell everything from pension plans and investments to bank loans and insurance schemes. You will also see them published in travel brochures, books, magazines and calendars, used on postcards, posters, product packaging, and so on. It's not uncommon for the right shot, published in a picture library stock catalogue, to sell a hundred times or more over two or three years and generate thousands of pounds in reproduction fees.

Getting the right shot isn't as easy as it might sound, however. It's not that beach scenes are difficult to photograph well – nothing could be easier – it's finding the right location that counts, and then capturing it in perfect weather.

You might think that simply flying off to a Caribbean island with a suitcase full of film will do the trick, but not every island in the Caribbean boasts such scenes: I failed to find a single one on St Lucia. Also, if you visit at the wrong time of year – during the monsoon season, say – you may find the perfect scene but have cloudy skies to contend with, which will reduce the sales potential of your pictures to zero.

Nothing but perfect blue sky will do.

Stock photographers have even been known to chop down palm trees in places like the Maldives after photographing a perfect scene – to prevent anyone else from getting decent shots! I doubt this happens very often, but with such large

RIGHT Abstract shots of the sea and sky are popular with picture libraries as they potentially have many uses, especially as background images. When you're in the right location it therefore makes sense to shoot a selection with both wide-angle (as here) and telephoto lenses.
Camera: *Pentax 67* **Lens:** *55mm*
Film: *Fuji Velvia* **Filters:** *Polarizer and 81B warm-up*
Exposure: *⅛ second at f/16*

LEFT The most saleable beach scenes aren't always the most interesting photographically. An empty foreground like this would normally be avoided, for example, but here it gives the impression of open space and tempts the viewer to step into the scene
Camera: *Pentax 67* **Lens:** *45mm*
Film: *Fuji Velvia* **Filters:** *Polarizer and 81B warm-up*
Exposure: *¼ second at f/22.*

BELOW Perfect beach scenes complete with palm trees, crystal-clear sea and deep blue sky can be huge sellers in the advertising and promotions industry, so it's well worth the effort and expense of visiting suitable locations. This panoramic was shot in the Maldives.
Camera: *Art 617 panoramic* **Lens:** *Nikkor 90mm*
Film: *Fuji Velvia* **Filters:** *Polarizer and 81B warm-up*
Exposure: *1 second at f/22*

amounts of money at stake, some people will go to the most extreme lengths.

The most popular places are the Seychelles, Maldives, Pacific islands such as Tonga, Fiji, Samoa, the Solomons, Tahiti and the Cook Islands, Tobago and Antigua in the Caribbean. Islands off Thailand, Sri-Lanka, Zanzibar and Northern Queensland in Australia are also worth considering. Generally, the further off the beaten track that you go, the better are your chances.

Wherever you go, it's going to cost you a lot of money to get there. So, if you intend planning a trip to shoot beach scenes, you should get advice from your picture library and look through as many books, brochures and magazines as you can lay your hands on to get an idea of the best locations.

Equipment and composition

In terms of equipment, medium format is going to sell much better than 35mm – many picture libraries won't even accept 35mm shots of this type of subject. Panoramic beach scenes shot on 6x12cm or 6x17cm cameras can also be big sellers, so if you don't own such a camera, consider hiring one for the trip.

The best-selling beach scenes are the ones that look as if they were taken on a desert island, so if you want your pictures to fall into this category avoid litter, people, boats and anything else that shows signs of life. You should also include a reasonable amount of beach so that the viewer feels they could literally step right into the scene – palm trees

occupying one third to one half of the image, and sand/sea/sky taking up the rest is a good average to work to.

A polarizing filter is invaluable for enhancing the sea and sky and boosting colour saturation, and you should ideally shoot during the morning or afternoon when the sun isn't directly overhead and the light is more attractive – morning tends to be better if you're in a touristy area as there will be less chance of sun worshippers spoiling the view.

Once you have got these all-important shots 'in the bag' you can then concentrate on others – palm trees swaying in the breeze, the patterns created by ripples on the sea, perfect footprints in the sand, sea washing up the beach, palm trees in silhouette at sunset and other things that typify life in paradise.

Simple, empty pictures showing nothing but sea and sky can also be good sellers, as can wide-angle shots looking out to other nearby islands or showing a solitary boat bobbing on the ocean. The main factor here seems to be to capture not only a feeling of paradise – perfect weather, perfect scenery – but also space and isolation and a complete sense of getting away from it all. In other words, your pictures need to sell a dream.

Tree-mendous

Generic pictures of woodland and trees are well worth shooting, both for picture libraries and your own files.

Autumn and spring are the best times of year to do this – autumn for those beautiful colours, and spring for the fresh green foliage that's so symbolic of life, nature, good health and the great outdoors. In midsummer foliage tends to look scorched and dull, while in winter deciduous trees are stripped bare, making them less desirable in most markets.

A good area of woodland can be the source of many different pictures, so it's worth seeking out the right location, either locally or by travelling to a more suitable area – town and city parks and the grounds of country estates or stately homes can be surprisingly productive.

For general shots, head into the heart of the wood and find a clearing where all you can see, literally, are trees. Ideally, do this on an overcast day when the light is soft and contrast low, so you can record a

Woodland scenes are at their best during autumn, when dying foliage creates a kaleidoscope of colours. I captured this beautiful scene on the banks of the River Dart in Devon, shooting in overcast conditions to keep contrast low.
Camera: *Woodman 5x4in* **Lens:** *90mm*
Film: *Fuji Velvia* **Filters:** *Polarizer and 81B warm-up*
Exposure: *2 seconds at f/22*

full range of detail and capture the beautiful foliage colours. If I'm on a landscape shoot and the weather turns

dull I always head for woodland – or waterfalls (see page 100) – because I know I can still take saleable pictures there, no matter how flat and dull it gets. Weak backlighting can work well too, adding a beautiful glow to the translucent leaves, or misty mornings with the first rays of sunlight exploding through the trees to create a stunning effect.

Spend time composing the shot – I find a wide-angle lens equivalent to 24mm or 28mm on 35mm format to be the most effective for capturing a broad sweep of woodland, and for shots looking straight up so that surrounding trees converge towards the centre of the frame to create dynamic compositions.

I also use a polarizer to increase colour saturation. Foliage tends to pick up a lot of glare, especially in damp weather, but a polarizer will cut through this and boost the colours significantly. An 81C or 81D warm-up is used, too, to enhance the naturally warm colours of the foliage.

Selecting subjects

Of course, you don't need dense woodland to produce saleable pictures. Small groups and individual trees can be just as photogenic if they're naturally beautiful or the light is interesting. Think of a mature beech tree backlit by autumn sunlight, the fiery red leaves of a Japanese maple or a fruit tree covered in colourful blossom against a deep blue sky. Seasonal pictures of the same scene photographed in spring, summer, autumn

and winter are popular with picture libraries, and the biggest sellers tend to be simple scenes, perhaps containing a single deciduous tree to illustrate clearly the seasonal changes to the landscape.

Avenues of trees with a country road or path running between them can also produce good stock shots, and are well worth looking for. Shoot straight down the middle with a 200–300mm telephoto lens to compress perspective and crowd the trees together, or use a wide-angle lens to emphasize the strong lines created by the trees and road stretching off into the distance. Spring and autumn are prime times to take such pictures, but winter shots with the trees and road covered in snow or fading into mist can also work well.

Then there are countless detail shots to consider – the patterns and textures of tree bark, groups of backlit leaves or branches thick with autumnal foliage, fallen leaves carpeting the ground in autumn or on a frosty winter's morning, a single tree in silhouette on the horizon, and so on.

Many pictures could potentially be

Close-ups of fallen autumnal leaves make great background images for picture libraries, or to illustrate patterns and textures in photographic magazines. This shot was taken in my garden on a sunny autumnal day.
Camera: *Pentax 67* **Lens:** *135mm macro*
Film: *Fuji Velvia* **Filters:** *None*
Exposure: *⅕ second at f/16*

A single tree in the middle of a field – not exactly exciting. However, I photographed this scene in spring, summer, autumn and winter, and the set of four images has sold numerous times through my picture library to illustrate seasonal changes on the landscape.
Camera: *Olympus OM4-Ti* **Lens:** *28mm*
Film: *Fuji RFP50* **Filters:** *Polarizer*
Exposure: *⅕ second at f/11*

taken in your own back garden, especially the smaller details. Failing that, local parks and public gardens are well worth checking out. The great thing about trees and woodland is that you can take saleable pictures pretty much anywhere.

In terms of equipment, medium-format tends to be preferred for general woodland scenes, but details and close-ups can be shot on 35mm. Panoramic woodland scenes are also becoming popular.

Water world

Of all the 'scenic' subjects you can photograph, water is by far the most powerful from a symbolic point of view. It's used to represent life, good health, vitality, energy, freshness, clean living, purity and much more, so as an advertising tool, pictures of water are in great demand. This is good news for the aspiring stock photographer, because water is also a highly accessible subject and can be depicted in any number of ways.

In the flow

Rivers and streams are an obvious starting point – you can include them as part of wider views, capture vivid reflections in their surface, use a slow shutter to record the moving water as a graceful blur flowing around rocks, shoot glistening highlights from the sun and so on. Flick through any good stock catalogue and the chances are you will see all these images gracing the pages – and making money for the photographers who took them.

Waterfalls are another big seller because the power and energy of falling water is so emotive (see pages 108–9). You needn't visit Niagara Falls to take saleable pictures, either – modest waterfalls just a few metres high are more than adequate.

The key is to photograph them in as many different ways as you can, from wide views showing the falls in their natural environment to details of water cascading over rocks. Experiment with filters, too – blue filters will give your pictures a cold feel – and return to the same falls in different seasons, as the volume of water running in winter will be much greater than during summer, allowing you to take completely different pictures.

Seascapes

Then there's the sea, where powerful waves pound the shore and pristine surf rolls up smooth, sandy beaches. Wave shots are popular among picture libraries, though only the best will do – that means using a long lens of 300mm or more to fill the frame, and being in the right location. The coast of western Europe and America are the best areas for dramatic seas, but elsewhere the wave action tends to be rather low-key in all but the stormiest weather.

ABOVE As well as rivers and waterfalls, water can be photographed in other forms – like these droplets of rain hanging from a piece of grass. Sometimes you have to look beyond the obvious to come up with unusual images.
Camera: *Nikon F90x* **Lens:** *105mm macro*
Film: *Fuji Velvia* **Filters:** *None*
Exposure: *1/30 second at f/8*

LEFT Water is a big seller in the stock photography market, especially shots of waterfalls that are used widely in advertising and can attract high fees.
Camera: *Pentax 67* **Lens:** *165mm telephoto*
Film: *Fuji Velvia* **Filters:** *None*
Exposure: *4 seconds at f/22*

Dawn and dusk are great times to photograph the sea, especially as the sun's golden orb is rising or setting and the surface of the ocean reflects the warm colours in the sky. Use a telephoto lens to home in on the sun and its shimmering golden reflection, or simply photograph the surface of the sea with a telephoto lens, excluding all signs of land and sky from your pictures. Once the sun has set and twilight approaches, you can take beautiful photographs by using a long exposure of 30 seconds or more to blur the motion of the sea as it crashes against the shore or washes gently over rocks.

The key with pictures like this is not necessarily to look at them as classic landscapes, but more as tools for designers that can be used as visual icons. Looking at how scenic photographs are used, particularly in advertising, will help steer you in the right direction.

Other shots

Water can also be photographed in other ways. The dappled pattern you get on the surface of a swimming pool in bright sunlight is popular for use as background images, as are pictures of the concentric circles created when a droplet of water hits the surface of still water or a pebble is dropped into a pond. Bubbles in water, condensation running down a window, the patterns in ice, and droplets of water are other shots to consider.

ABOVE The sea can be photographed in many ways – my favourite is to wait until dusk and then use a long exposure to record its gentle ebbing and flowing as a graceful blur.
Camera: *Pentax 67* **Lens:** *55mm (image cropped)*
Film: *Fuji Velvia*
Filters: *None*
Exposure: *30 seconds at f/16*

BELOW Though not particularly exciting, this sea and sky detail taken in Turkey has sold several times already and more than covered the cost of the whole trip – which just goes to show that you should never ignore the simple details in favour of breathtaking scenics.
Camera: *Pentax 67* **Lens:** *165mm*
Film: *Fuji Velvia* **Filters:** *Polarizer*
Exposure: *⅟₆₀ second at f/5.6*

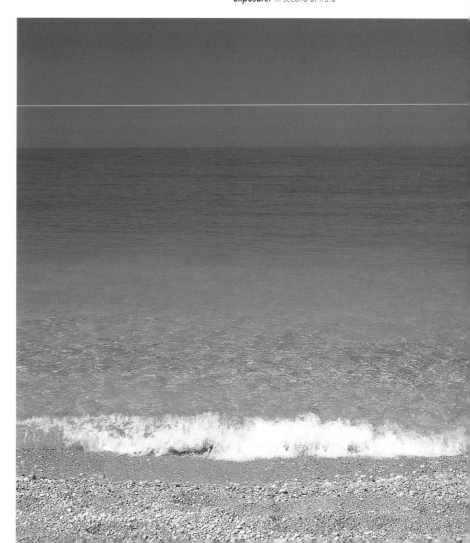

Flower power

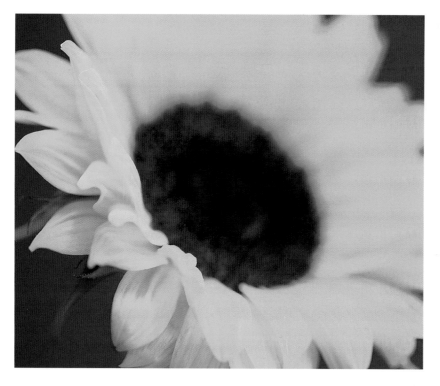

This is the kind of effect you can achieve by using a macro lens at its widest aperture setting. Notice how just the edges of the petals nearest the camera are in focus while everything else is blurred due to lack of depth-of-field. Images of this type are popular for advertising use.

Camera: *Pentax 67* **Lens:** *135mm macro and extension tube* **Film:** *Fuji Velvia* **Filters:** *None* **Exposure:** *¹⁄₂₅ second at f/4*

Flowers make great subjects for stock pictures, simply because by varying your approach you can produce a wide variety of different images that will appeal to all kinds of markets. Even better, you can shoot them all year round, indoors or out, and the financial outlay required is very small – often nothing.

I go through a flower phase periodically, and usually satisfy it by visiting local florists, buying up any interesting specimens I see, taking them home, and experimenting to see what I can come up with. I have also sold pictures of flowers taken in my back garden, in the gardens of friends and neighbours, or simply while out and about – woodland, hedgerows, farmland, meadows and parks can all be a source of great pictures, both in your home country and overseas. I have even been known to grow flowers such as sunflowers and various herbaceous perennials in my

garden specifically to photograph – and my knowledge of gardening can be written on the back of a postage stamp.

The kinds of markets you can sell your flower shots to will depend mainly on how you photograph them.

Flower 'portraits'

Fairly straight shots, whether they're of individual blooms, flower arrangements or wildflower meadows, are ideal for calendars and greetings cards. These can be shot indoors or out – I favour windowlight when I'm working indoors, and bright overcast weather for outdoor shots – and a standard or short telephoto lens will usually be ideal for the job.

Try to keep the background simple. Outdoors, the natural colours of foliage and other flowers are ideal, and by shooting at a wide lens view aperture you can throw the background out of focus. Shooting from a low viewpoint so that sky

becomes the background is another option, or you could use a telephoto lens to home in on the flowers and keep everything in the frame in sharp focus.

Indoors, a sheet of coloured card can work wonders. I have various colours, bought from an artists' supply shop, and use them to produce vibrant, graphic images, where the colour of the background contrasts strongly with the colour of the flowers – such as yellow flowers against blue card, or red flowers against green (see pages 188–9).

Alternatively, you could go for something more textural. I used to live in an old thatched cottage which had exposed stone walls and an old pine fireplace surround in the breakfast room. I used these features as a background to many flower shots. The pastel colours of a crumbling plaster wall in the utility room also worked well – until the room was decorated!

Getting in close

After shooting some flower portraits I usually move on to close-ups, using a 105mm macro lens on a 35mm SLR to fill the frame with colours, patterns and textures. These pictures are almost always taken indoors, using windowlight for illumination – I usually place the flowers in a vase on my kitchen windowsill. The

benefit of working indoors is that you have more control over the light and you don't have to worry about wind moving the flowers.

A popular technique when shooting close-ups, and one I use a lot, is to set the lens to its widest aperture so that depth-of-field is reduced almost to nothing – a millimetre perhaps. This means that only a tiny part of the flower will be recorded in sharp focus while everything else is reduced to an indistinguishable blur.

The effect can work brilliantly, producing eye-catching abstract images with a strong graphic quality if you shoot a colourful flower against a contrasting background, or, more commonly, a wonderful dreamy feel due to all the colours and shapes merging and any hard edges being softened. By making just minor changes to camera position or slightly shifting focus you can also completely transform the image, so that lots of different pictures can be taken of a single flower – and it's possible to put together a hundred or more new shots in the space of an afternoon.

Which flowers should you choose? Well, that depends on the type of pictures you intend to take. Perennial favourites include tulips, daffodils, bluebells, red poppies, sunflowers (possibly the most commercial of all), roses (especially red), gerbera and lilies. However, if you're shooting wide-aperture close-ups where the flower is unrecognizable in your pictures, any flower will do.

LEFT The same technique has been used for this shot of a Stargazer lily, focusing on a selected area of the flower and leaving everything else to fade increasingly to a blur of soft colours. Picture libraries welcome pictures like this as they potentially have many different uses.
Camera: *Nikon F90x* **Lens:** *105mm macro*
Film: *Kodak Elite Chrome 100* **Filters:** *None*
Exposure: *⅕₀ second at f/2.8*

ABOVE Your back garden can be the source of saleable flower pictures – I noticed these attractive dandelions growing all over my lawn when I returned from a trip away and the grass was in dire need of a trim. Before doing that, I made sure I took a few photographs!
Camera: *Nikon F90x* **Lens:** *105mm macro*
Film: *Fuji Sensia 100* **Filters:** *None*
Exposure: *⅟₆₀₀ second at f/2.8*

Patterns, textures and backgrounds

Here are just three of the hundreds of background pictures I have taken over the years, the vast majority on 35mm – larger formats aren't essential.

LEFT Detail of a backlit leaf shot on my kitchen windowsill.

BELOW Frosty leaves in morning sunlight, shot in my garden.

BOTTOM Frozen condensation on the side of my car.

Camera: Nikon F90x **Lens:** 105mm macro

Film: Fuji Velvia **Filters:** None

Exposure: Various

When putting together brochures, advertisements, catalogues, books, leaflets and a wide range of other products, designers often place images behind text or other photographs and illustrations as a background. This is usually done for no other reason than that it looks effective, but it does mean there's a useful market for suitable images, despite the fact that copyright-free CDs (see page 60) have taken a big bite out of it in recent years.

If you check out the background section or pages in a picture library stock catalogue you will see that all manner of natural subjects are featured. Perennial favourites have always been detail shots of marble, granite and other rocks showing the beautiful colours and patterns, but the list of possibilities is endless: pebbles, seashells, fallen autumnal leaves, moss-covered stones in an old wall, the regimented pattern in brick walls, flower petals, backlit close-ups of leaves, tree bark, a field of sunflowers, droplets of dew on a spider's web, the ripples on a sandy beach or swimming pool, icy patterns on a frozen window and frozen condensation on the side of a car ...

Subtle colours and patterns tend to be more saleable than bold, graphic images, simply because when they are used as a background they don't compete with whatever is placed in front of them. You should also try to cut out any extraneous details so that the image is very simple and defined. This usually means working from close range with a standard or macro lens – the most interesting background subjects tend to be small – or homing in on more distant details with a telephoto lens.

Reach for the skies

Sky shots can be yet another big seller when they are marketed through a picture library – especially if they appear in a stock catalogue.

I know of one photographer who took a few pictures from an aeroplane window while he was going on holiday, and over a three-year period the sales from one of them topped £5,000. Such returns are possible because sky shots tend to be used for advertising purposes, where the fees paid are high.

The most popular sky images usually show interesting cloud formations against blue sky. Perfect cottonwool clouds on a velvety blue backdrop work well, as do single clouds sitting in the sky, or rays of light radiating from behind a cloud that has obscured the sun.

The lens you use will depend on what's up there – a wide-angle lens is ideal when the sky is full of interesting clouds, though on some occasions you will need a 200–300mm telephoto to home-in on the best 'bits'. A polarizing filter can also be useful for deepening blue sky so that the clouds stand out more prominently.

Dawn and dusk are good times to shoot the sky. On some days you will find the clouds tinged with pastel shades, but on others the sky will be alive with fiery reds and oranges, all of which can make for great shots.

It's impossible to predict if a sky picture will sell or not, so shoot them at every opportunity – stock photography is a numbers game.
Camera: *Nikon F90x*
Lens: *28mm, 80–200mm* **Film:** *Fuji Velvia*
Filters: *None* **Exposure:** *Various*

Expert view: Tom Mackie

American-born Tom Mackie started his career as an industrial photographer working out of Los Angeles. Ready for a change, he then decided to settle in the UK, and for the last 15 years he has been working as a full-time landscape photographer.

Tom is well known for capturing breathtaking scenes like this, showing petrified sand dunes in Arizona, and he returns to the USA at every opportunity to build his files.

Tom always checks the location of waterfalls when he visits a new location, so that he has a commercial subject to hand in the event of dull weather.

'I started shooting landscapes as an antidote to being bored with studios and factories, exploring the western states of the USA, and things just grew from there,' says Tom. 'The turning point was moving to England – I'd never even set foot in the country before, but it gave me the perfect opportunity to make a fresh start. We literally just sold everything and moved.'

These days, Tom makes an income in various ways – by taking on commissions from publishers and travel companies, supplying magazines with images both in the UK and the USA, and shooting stock for picture libraries in England, Germany and Japan. He's also in the process of designing a website to attract new clients via the Internet, and is producing a brochure plus some sample photo CDs of his work to send out to designers, agencies and publishers.

'To make a decent living from landscape photography today you need to make your pictures work hard. That means getting them seen by as many different people as possible, and shooting to suit different markets. Some picture libraries only want big-selling generic images, for example, while others have a more editorial base, so I put different shots with different libraries.

'An average repro fee from magazines, travel brochures and similar markets is £40 to £50, but much bigger sales are possible. My biggest-selling shot from a single sale is a 35mm picture showing patterns in sand dunes, which sold for £5,000 through a picture library – I got half that.'

Tom uses various camera systems depending on where he's going and the type of pictures he intends to take. In the UK he still favours a 5x4in large-format system with 75mm, 90mm, 150mm and 210mm lenses, plus a Fuji GX617 panoramic camera with 90mm and 180mm lenses. For overseas trips he now uses a Pentax 67 kit with 45mm, 75mm

shift, 135mm macro and 200mm lenses.

'You don't really need to shoot large format these days, though some upmarket calendar publishers do prefer it,' he explains. 'However, I like it for the movements which allow me to control depth-of-field and perspective – and the image quality is superb.'

The only other items you'll find in Tom's backpack are polarizer, warm-up and neutral-density graduate filters, plus lots of Fujichrome Velvia, his preferred choice of film.

'I usually make two or three overseas trips each year to places like the USA and Canada, staying away for two or three

weeks. My favourite UK locations are Scotland and the Lake District – I make an annual pilgrimage each autumn. I have a VW camper van which is ideal because I can drive to the next location, sleep in the van, and be exactly where I need to be.

'When I'm on location I have this kind of ritual – I'm out before sunrise, I spend all day shooting until the evening, plan the next day, grab something to eat, get some sleep, then repeat the whole thing again the next day.

'You have to be dedicated to succeed, so working hard on location is vital. You can't just switch off at 5pm. Also, taking pictures is only one aspect of the business

The Giant's Causeway in Northern Ireland is a much-photographed subject, but Tom's beautiful sunset rendition of the scene is still a popular choice among picture buyers.

– there's marketing, admin, chasing up overdue payments, editing, filing and captioning new work, and all the other hassles that running a business entails. In fact, it's these other things that can make or break you, to the point that a mediocre landscape photographer can make a lot of money if they're a good businessman, but the best photographer in the world will go hungry if he doesn't know how to market his work.'

LIVE PICTURES
WATERFALLS

These pictures were all taken during a single day in the Yorkshire Dales at just two locations – West Burton Falls near Aysgarth, and Kisdon Force/East Gill Force near the village of Keld.

My brief was simple; to take as many different pictures as I could – everything from scenic shots showing the falls in their natural surroundings to close-ups of water bouncing off rocks at the base of the falls and the patterns created by the rivulets of falling water.

The weather on the day was dull and overcast, with light rainfall every now and then – just right for waterfall pictures, as contrast tends to be too high in bright sunlight. There had also been a lot of rain over previous days, so the rivers in the area were in full spate and the waterfalls very active – in summer they can sometimes be reduced to nothing more than a gentle trickle.

Technique

The most effective way of photographing waterfalls is by using a long exposure – anything from $1/2$ second upwards – so the moving water records as graceful streaks as it plummets towards the ground. The longer the exposure is, the more gaseous this effect tends to be – I have worked at exposures of 2 minutes or more in situations where light levels are really low.

Shooting in dull weather usually makes it easy to achieve suitably long exposures because light levels are much lower than in bright, sunny conditions. Many waterfalls are also tucked away in shady valleys, so even if the sun is shining you may find that direct light never hits the falls and light levels are always several

stops lower than out in the open.

Stopping your lens down to f/16 or f/22 and using slow-speed film (ISO50–100) will further increase the exposure. One to ten seconds is the optimum working range; beyond that you won't see a great difference in the effect, so unless you have no choice but to use longer exposures, there's no point.

If you're still struggling to get an exposure that's long enough, a neutral-density (ND) filter can be used to force an exposure increase. A 0.6 density ND requires an exposure increase of 2 stops, while a 0.9 density ND requires a 3 stop increase. Alternatively, I use my polarizing filter as it reduces the light by 2 stops, plus an 81B warm-up filter to balance the slight cool cast that polarizers often introduce. The advantage of a polarizer over an ND filter is that you can also use it to reduce glare on wet rocks, and increase the colour saturation of any foliage you may be including in the shot, so it serves two useful purposes.

I use a handheld lightmeter and take incident light readings to determine correct exposure. This is more accurate than using your camera's integral metering as the brightness of the water may fool it into causing underexposure.

The first shot of the day, showing a side view of West Burton Falls. The weather was still rather damp and foggy, but this would clear in an hour or two.

These are the same falls, but from a completely different viewpoint, using the river and rocks as foreground interest. A cloudy sky meant the light was soft and contrast low – perfect for this type of shot.

On this occasion, I started off at West Burton Falls which are located at one end of a natural amphitheatre and spent the whole morning there shooting the falls from different angles and through different lenses. When I first arrived the atmosphere was misty and damp, more like the Pacific

EQUIPMENT AND TECHNIQUE

Cameras: Pentax 67, Nikon F90x, Art 617 panoramic

Lenses: 55mm, 105mm, 165mm for Pentax, 80–200mm for Nikon, 90mm for panoramic

Tripod: Gitzo Studex

Film: Fujichrome Velvia

Filters: Polarizer, 81B warm-up

Exposure: Various from 2 to 60 seconds

TECHNIQUE TIPS

• When you're planning to visit an area to shoot landscapes, check your maps to see if there are any waterfalls nearby – the best ones aren't always well known.

• Spring and autumn tend to be the best seasons for waterfall photography – in summer they may run almost dry.

• Return to waterfalls in the winter and shoot icicle details.

• Dull days are better for waterfall photography than bright sunshine, as the light is softer and the contrast lower.

• Mount your camera on a sturdy tripod and trip the shutter with a cable release to avoid shaky pictures.

• Take a variety of different shots using wide-angle and telephoto lenses.

ABOVE Details of rivers, streams and waterfalls can be good sellers, so I made a point of shooting some – in this case water spilling over the rocky shelves in the river. Trapped autumn leaves add interest.

BELOW My favourite shot of the day – the natural structure of the waterfall is attractive, so I concentrated on this by using a telephoto lens to cut out extraneous details.

rain forest of Northern America than the north of England, but slowly the mist cleared. I then spent the afternoon at Kisdon Force near Keld until the light faded, doing exactly the same thing – shooting scenics and panoramics before closing in on smaller details.

This approach gave me a wide range of both specific and generic shots that are ideal for numerous different markets, from photographic magazines and calendar publishers to advertising agencies.

BEST SELLERS

SKY DETAIL

I started shooting sky images like this after seeing them in picture library catalogues and realizing there was a big demand for suitable shots, mainly as backgrounds.

 This picture was taken from my back garden on a perfect summer's day and, luckily for me, was chosen for a stock catalogue a couple of years later, which is where all sales have come from.

What makes it sell?
Hard to say. It's a simple photograph of an attractive sky, but nothing spectacular. The thing about these images is that you never know if what you've taken will sell, though exposure in a stock catalogue is essential.

FACTS & FIGURES

Equipment *Olympus OM4-Ti, 28mm lens, polarizer*
Film *Fujichrome Velvia*
Number of sales to date *14*
Catalogue image? *Yes*
Where sold *UK, Singapore, Japan, Ireland, Turkey, Finland*
Used for *Brochure cover and inside illustration, advertising poster, corporate audio-visual/video rights. Uses for overseas sales unknown*
Total sales to date *£447*

COMBESTONE TOR

I have been photographing the wild landscape of Dartmoor in Devon for many years now, and recently had a book on the region published. This shot, used on the cover of the book, was taken quite early in my freelance career and on my first ever visit to the location. I remember the day vividly – late autumn, an hour or so before sunset, with winds so strong I could hardly keep my tripod steady. At the time I had no idea it would be such a big seller, though it has always been one of my favourite landscape photographs, and the memory of that day on the moor comes flooding back whenever I look at it.

What makes it sell?
Strong composition, dramatic light, attractive colours – this shot bears all the hallmarks of a classic landscape. As well as capturing the character of Dartmoor, it also works well as a generic landscape, and most of the sales have been for that purpose rather than because it depicts a specific location.

FACTS & FIGURES

Equipment *Pentax 67, 55mm lens, tripod, 0.6 density ND graduate and 81C warm-up filters*
Film *Fujichrome Velvia*
Number of sales to date *20*
Catalogue image? *Yes*
Where sold *UK, Switzerland, France, Mexico, Colombia, Argentina, USA, Ireland, India*
Used for *Poster, audio CD, record and cassette covers, book cover, various magazines, audio-visual, book illustration, advertisement for photographic filters, mailer, brochure cover and inside illustration, tourist board, calendar*
Total sales to date *£4,240*

MARBLE CLOSE-UPS

This picture, along with dozens of others, was shot specifically for my picture library – marble and granite details tend to be well featured in stock catalogues, so I decided to get in on the action. The actual subject matter came from a manufacturer of fireplace surrounds – I contacted them and asked if I could borrow some granite and marble samples for the day. I then photographed them in turn at home, and in the space of a single afternoon produced around 150 new stock images, which my picture library willingly accepted.

What makes it sell?

No two pieces of marble or granite are the same – the colours and patterns are infinitely variable. This makes them ideal as background images for both editorial and advertising use.

FACTS & FIGURES

Equipment *Nikon F90x, 105mm macro lens, tripod, 2 studio flash heads fitted with softboxes*
Film *Fujichrome Velvia*
Number of sales to date *7*
Catalogue image? *Yes*
Where sold *UK, Germany, Canada, Slovenia*
Used for *Photographic equipment supplement and brochure*
Total sales to date *£1000*

WANSFORD-IN-ENGLAND

Just to prove that you needn't travel to the ends of the earth to find saleable scenery, this picture was taken just a few miles from my home. I actually visited the village for a Sunday afternoon stroll with my family, and only took a camera as an afterthought on the off-chance I might get a nice shot. This is one of a dozen or so I took, in typical summer sunshine, from a bridge overlooking the river and cottages. All in all, a ten-minute task – and the picture's still selling.

What makes it sell?

The scene is naturally very pretty, with old stone cottages lining the river, and the light, though not particularly exciting, makes the most of this. Shooting from the bridge allowed me to use the river as foreground interest so that it carries the eye through the scene, and the end result is a picture ideal for traditional markets such as calendar and postcard publishers, travel companies and magazines.

FACTS & FIGURES

Equipment *Pentax 67, 55mm wide-angle lens, tripod, polarizer and 81B warm-up filter*
Film *Fujichrome Velvia*
Number of sales to date *14*
Catalogue image? *Yes*
Where sold *UK, Norway, USA, Taiwan, France, Argentina*
Used for *Travel brochures, newspaper editorial, calendar, photographic magazine, display exhibition, packaging, magazine feature*
Total sales to date *£1,100*

HOLIDAYS AND TRAVEL

Last month it was Venice. Next month it's Spain and the Maldives. Then on to Greece, Morocco, Mali, Prague, Tuscany ...

At the time of writing, this was my proposed itinerary for the next few months. Exciting? Glamorous? Exotic? You bet. Travel photography is all these things and more. It's the ultimate way to earn a living – flying off to some beautiful, far-flung destination with a cartload of camera gear, spending a week or two taking lots of breathtaking photographs and being paid for the privilege.

However, despite the obvious attractions of travel photography, you also need to be aware of the drawbacks.

For a start, it's an overcrowded market where competition is intense – simply because there are so many photographers doing it, on both a part-time and full-time basis.

Then there's the cost. Few markets for travel pictures actually commission

The quality of light is vital when shooting travel. I prefer early morning or late afternoon, when the sun is low and the light has a pleasant warmth – especially for architectural subjects such as the Louvre in Paris.
Camera: *Olympus OM4-Ti* **Lens:** *28mm*
Film: *Fuji Velvia* **Filters:** *Polarizer and 81B warm-up*
Exposure: *⅛ second at f/11*

photographers to take pictures for a specific reason these days, simply because they have found that it's cheaper and more reliable to use stock images from a picture library. Therefore, you will generally have to underwrite the cost of these trips yourself, hoping to recoup them and turn a profit through future sales of the pictures you take. And that's assuming you don't encounter bad weather or any other problems that could hinder your photography once you're there – such as delays at airports or luggage going missing.

All things considered, this makes travel photography a risky business – probably more so than any other subject. Nevertheless, if you come up with the right pictures, it is possible to make sales and, believe it or not, some sort of living from globe-trotting, so don't let these minor pitfalls put you off.

Location finder

You can't become a travel photographer without travelling, of course, so first you need to decide where to go.

Initially, this decision will probably be dictated by the amount of free time you

The most successful travel photographs are those that can be used to symbolize a whole city, region or even country, like this shot of Fira on the Greek island of Santorini. Pick up a travel brochure for holidays in Greece and the chances are that there will be a shot of Santorini, even if the island isn't included on the list of destinations, simply because it's such a beautiful place and symbollic of all that's great about the Greek islands.

Camera: *Pentax 67* **Lens:** *55mm wide-angle*
Film: *Fuji Velvia* **Exposure:** *30 seconds at f/16*

have and how much money you can afford to spend. The chances are that you have another career outside photography, so most of your pictures will be taken during holidays or the odd weekend away. This isn't ideal, especially if you have children, because you won't be able to disappear with your camera from dawn to dusk every day, and picture-taking will have to be integrated with other activities. But it needn't be a problem, either. This is exactly how I became involved in travel photography – taking pictures during holidays in Europe and sending them off to a picture library.

Family holidays can also provide photographic opportunities that you wouldn't get while travelling alone – such as using your kids as models down on the beach, or taking shots of your family sightseeing at famous monuments, eating in restaurants and so on. The key is to milk every situation for everything you can. Once sales from these initial trips begin to come in, you can then start to plan more serious photographic expeditions and concentrate 100 per cent on picture-taking.

Again, much here will depend on your financial situation. If you can afford to spend lots of money on trips, then the

world really is your oyster. Most of us have to count every penny, however, so cost will be the biggest obstacle.

Keeping costs down

The easiest way around this is to concentrate initially on saleable locations that are close to home and cheap to visit, then look further afield once sales increase. For photographers living in the UK, for example, London should be top of your list. Okay, you're not actually leaving the country, but London is a major international centre, on a par with New York, Paris, Tokyo and other capital cities, so good pictures have a huge global market.

The next step is to visit locations in neighbouring countries – from the UK you can choose from the whole of mainland Europe, with cultural and financial centres such as Paris, Rome, Milan, Florence, Venice, Amsterdam, Barcelona, Madrid, Prague and Budapest close to hand. The opening of the Channel Tunnel, reduced cross-channel ferry prices, and the advent of budget airlines now make it easy and cheap to travel in Europe – city breaks lasting a few days can also be picked up for next to nothing, especially outside the main tourist season when hotels are eager for trade. By travelling off-season you can also avoid teeming crowds of tourists – and blazing heat in many places.

Another way to save money is by booking package holidays, so for an all-in price you get return flights, airport transfers and accommodation. This can work out cheaper than booking flights and accommodation separately, especially if you book last-minute discounted holidays – something that's becoming easier, thanks to the Internet. Also, you will often find that staying for two weeks costs only a fraction more than staying for one, so if you have the time this is worth considering.

The downside of package tours, you might think, is that you're stuck in one place for the duration. However, this needn't be the case and you could use the accommodation you have booked merely as a base from which to travel further afield. I often do this in Europe – taking ferries to other Greek Islands, for example, or hiring a car to explore other parts of the country and staying in cheap hotels for the odd night here and there to avoid long drives back to base.

In the picture

Wherever you go, and however long you stay for, the key to successful stock travel photography is coming up with the right pictures, and that in turn depends on the market/s you intend to supply.

Generic images

The vast majority of the travel pictures I take are sold through my picture library, so first and foremost I contact the library to see if they have any specific requirements for the location I intend visiting. I also have a collection of stock catalogues from different picture libraries that I flick through to see which scenes or subjects come up time after time. Inevitably, the

subjects published in these catalogues are the ones most frequently requested, so they are always given priority – Big Ben in London, the Eiffel Tower in Paris, the Statue of Liberty in New York and so on.

The label often applied to these pictures is 'generic' because they are instantly recognizable the world over and almost without exception are the first choice of picture buyers, whether they are a tour operator looking for travel brochure illustrations, a book publisher putting together a travel guide, or an advertising agency working on a major campaign.

Wherever you go in the world, generic images exist and they should be the ones you put the most effort into taking. Often, you will also find that they are photographed in a certain way or from a certain viewpoint, and although it's a good

Capturing the colour and character of a place is the key to successful travel photography. This picture, taken in Marrakech from the roof of a hotel, shows evening crowds gathering in the city's bustling Djemma el Fna (Place of the Dead).
Camera: *Nikon F90x* **Lens:** *80–200mm*
Film: *Fuji Velvia* **Exposure:** *⅛ second at f/5.6*

idea to look for new angles or try different photographic treatments such as film choice, experimenting with filters, and so on, it pays to get the obvious shots first.

Surprisingly, the best-selling travel pictures tend to be the easiest to take. Bright sunshine and blue sky is often favoured for famous landmarks or views. Certain buildings and monuments such as the Eiffel Tower and Big Ben also photograph well at night, when they are floodlit. Perfection is what most picture buyers want. They need to show scenes and subjects at their best, so while dramatic stormy light and unusual camera angles may make for exciting photographs, don't naturally assume that they will sell.

Getting creative

Once you have taken those all-important generic shots you can then start concentrating on secondary images. Initially that could – and really should – mean taking some alternative pictures of the same generic subjects, so you have something different to offer. So try unusual viewpoints, use different lenses, experiment with film and filters, and so on. Secondary images could also be the sights that are popular among picture buyers but not their first choice – anything well

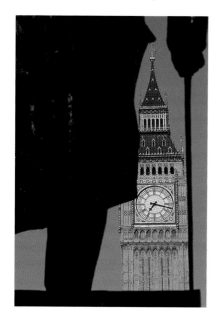

LEFT Looking for unusual viewpoints from which to photograph popular scenes and subjects is a good way to increase sales. Here, London's Big Ben has been framed by a nearby statue of Winston Churchill.
Camera: Olympus OM4-Ti **Lens:** 85mm
Film: Fuji Velvia **Filters:** Polarizer and 81C warm-up
Exposure: ⅛₀ second at f/4

ABOVE You don't always need to capture sweeping views in order to produce saleable travel pictures – smaller details can be just as powerful. This colourful shot says 'Greece' the second you look at it.
Camera: Olympus OM4-Ti **Lens:** 24mm
Film: Fuji RD100 **Filters:** Polarizer
Exposure: ⅛₀ second at f/11

known in London after Big Ben and Parliament, Piccadilly Circus and St Paul's Cathedral, for example.

Next, you can get really alternative, perhaps shooting tell-tale details – a fire hydrant against a yellow cab in New York, a red telephone box in London, masks in a Venice shop window, that kind of thing. I recently spoke to the marketing director of a leading picture library who reckoned that one in every 15 requests for travel pictures is a detail like this – a 'thinking man's' travel shot as he put it, something that's symbolic but not too obvious.

The stock photography industry is also using a lot more black and white work today, so I often keep a camera body loaded with mono film, be it fast conventional film for grainy images or infrared for something different. Black and white is particularly useful if the weather's not too great – colour pictures taken on a dull, grey day are unlikely to sell, but such conditions are ideal for black and white.

You can also tone the final prints to add colour – sepia, blue and selenium are the most popular.

Other shots

Other markets that you can supply direct should also be considered. A publisher of travel guidebooks will usually require pictures of any major tourist attractions, for example, so you should buy a current guide yourself and then make an effort to photograph those subjects – buildings with an interesting history, art galleries and museums, street scenes, local transport (especially if it's unusual), statues and monuments, popular restaurants, cafés, markets and anything else on the tourist trail. These pictures needn't be particularly special – in fact, fairly straight illustrative shots are more likely to sell than creative images.

The same applies if you're visiting a coastal location where people throng to

Beach scenes can be good sellers, but only if they're shot early in the day before crowds of sunseekers arrive. Holidaymakers like to think they will have the place to themselves, rather than having to battle through hoards of prone bodies to find a vacant patch of sand!
Camera: *Pentax 67* **Lens:** *55mm* **Film:** *Fuji Velvia*
Filters: *Polarizer and 81B warm-up*
Exposure: *⅛ second at f/16*

soak up the sun. After shooting any generic subjects or scenes, take pictures of the local beaches, gift shops, postcard stands, street vendors, bars, harbours, fishermen mending nets on the quayside, and any other subjects or details that tend to paint an overall picture of what the place is like.

Shots of local people are worth taking, too, especially if the place is known for its traditional dress. These shots are often snapped up for travel brochures.

The magazine market is different again. General-interest titles that run travel features tend to require the same generic images as most markets, but specialist travel magazines often prefer to take a

Good quality sunsets are always in demand by travel companies either to illustrate a specific location or, more commonly, for the feelings of romance and atmosphere they portray. This picture was taken on the southern coast of Turkey.
Camera: *Pentax 67* **Lens:** *55mm wide-angle*
Film: *Fuji Velvia* **Filters:** *81C warm-up and soft focus*
Exposure: *¼ second at f/11*

different view, looking beyond the obvious and concentrating instead on the cultural or historical significance of a place rather than the popular tourist attractions, environmental issues such as traffic and industrial pollution, or even the negative side of tourism such as overcrowding, continual building work, litter-strewn beaches and streets, local unrest and so on. There's also scope to sell pictures of lesser-known regions in the country or area you are visiting – such as traditional villages where life goes on as normal, despite being just a few miles from bustling tourist resorts. Business-travel magazines, on the other hand, favour pictures of financial districts, new industries, big new hotels and so on.

Finally, many overseas locations are ideal for generic nature and scenic images such as perfect skies, beach scenes, sea views, rivers, waterfalls, weather phenomena, and sunrise and sunset shots.

Ultimately, the type of pictures you take will depend on where you're travelling to. However, wherever you go, it pays to photograph that place in as many different ways and with as many different markets in mind as you possibly can.

Equipment for travel

The type of cameras and lenses you take on your travels will depend mainly on the markets you intend to supply, and to a lesser extent on where you are going.

Most picture libraries today prefer to see medium-format images simply because image quality is much higher than 35mm so they tend to have greater appeal – especially for advertising use, or on the covers of books, magazines and travel brochures.

My main camera for travel is a Pentax 67, which produces 6x7cm images on rollfilm. I prefer this format over 6x6cm

because I find it easier to compose rectangular rather than square images. The other main option is 6x4.5cm, which gives 15 frames on a roll of 120 film compared to 10 on 6x7cm and 12 on 6x6cm.

The cameras and lenses for 645 systems are smaller and lighter than other medium formats, cutting down the total weight of the kit and making them easier to use for handheld pictures, but I have stuck with 6x7cm for over a decade now because image quality is so good, and the Pentax 67 in particular is ideal for travel due to its unique design – it looks like an oversized 35mm SLR.

The lenses I usually carry with this camera are 45mm and 55mm wide-angles, a 105mm standard, 135mm macro, 165mm short telephoto and 2x teleconverter. This covers the same focal lengths as 24mm, 28mm, 50mm, 70mm and 85mm in 35mm format, with the 2x teleconverter turning the 165mm into a 330mm telephoto, similar to 180mm in 35mm format.

In addition to the Pentax 67 system, I also pack a 617 panoramic camera which produces stunning 6x17cm images on rollfilm. I have three lenses for this camera – 90mm, 180mm and 300mm.

Panoramic images are becoming more and more popular with picture libraries – the library I supply publishes panoramic-only stock catalogues. Sales of panoramic images also tend to be in markets that generate high returns, such as advertising, so even though the equipment is expensive and the cost per shot high – you only get four frames on a roll of 120 film – good panoramic images can reap handsome rewards.

Both of these systems fit snugly into a Lowe-Pro Photo Trekker backpack, along with filters and film, lightmeter, and other useful accessories.

The filters I always carry are a glass polarizer, warm-ups from 81B–81EF, 0.45,

TOP DESTINATIONS

If you're going to invest money in travelling to different locations, it makes sense to start with the most popular ones. Here's a list of the top locations for which picture libraries receive requests:

- London
- Paris
- Rome
- New York
- Boston
- San Francisco
- Los Angeles
- Prague
- Tuscany
- Provence
- Florida
- Mexico

It's also worth considering up-and-coming travel destinations. If you pre-empt the rush and photograph them early, you stand to make more sales because there will be fewer pictures available. These places change all the time, but reading travel magazines and the travel sections of national newspapers can give you advance warning of exactly where is becoming fashionable.

At the moment, it's:
- Iceland
- Morocco
- Zanzibar
- The Baltic States
- Vietnam

0.6 and 0.9 density ND (grey) graduates, a couple of soft-focus filters, and a blue 80A which comes in handy occasionally for adding a cold colour cast to pictures taken in misty weather or at night. A sturdy Gitzo tripod and solid head also go on every trip.

In terms of film, I use Fujichrome Velvia almost exclusively for its superb image quality and vibrant colours. I also choose Fujichrome Provia 100F in certain situations, such as windy weather or at dusk, because at ISO100 it's a stop faster and allows briefer exposures to be used. Though not quite as colourful as Velvia, this film is almost as sharp and the grain is just as fine. The alternative is to uprate Velvia to ISO100 and have it push-processed 1 stop, which can be done with no noticeable loss of image quality and only a marginal rise in contrast.

Depending on where I'm travelling to, I may also take a 35mm system comprising a Nikon F90x SLR body with 18–35mm, 50mm, 85mm and 80–200mm lenses. This is mainly to shoot black and white pictures, or for handheld shots – candids, action, that kind of thing. The 80–200mm zoom lens is also handy for long-lens pictures that are beyond the limits of my Pentax 67 kit.

Day to day I carry only medium format or 35mm, and would always shoot generic stock images on the larger format – or I'll rationalize both kits and carry a bit of each in one backpack. The key is to try to take only what you will need each day, rather than carrying everything.

Although rare, there are also some trips I make with just 35mm equipment – usually to countries where the going is rough and pictures tend to be taken 'on the hoof'. In addition to the basic Nikon kit mentioned above, I add a second SLR body to this, plus, more recently, a Hasselblad X-Pan panoramic camera with 45mm and 90mm lens – this produces 24x65mm images on 35mm film.

The benefit of 35mm equipment is that it's much quicker to use than medium format – often with no need for a tripod – so pictures can be grabbed in crowded places such as markets and souks, and you don't have to spend too much time in one spot, which could end up attracting unwanted attention.

Commercially this makes little or no difference to picture sales because destinations that are situated off the main tourist trail aren't photographed in as much depth, and competition is less intense – 35mm will therefore be accepted by most markets.

Final thoughts

Whatever equipment I am taking on a trip, all essential items are carried on board the aircraft as hand luggage so that I know they are safe and sound. My tripod and any back-up gear such as a spare camera body are packed with my main luggage. My main luggage did go astray once, on a trip to Paris, which meant I was without a tripod initially, but it did turn up the next day and I could still take some pictures without it.

Film is also carried as hand luggage – anything up to 100 rolls. I take all film out of its original packaging, leaving just the sealed foil wraps on rollfilm, and place it in large plastic zip-lock bags. Just before the hand luggage is X-rayed, I remove the film bags from my backpack and put them through the machine separately so that they're clearly visible.

Modern X-ray machines are said to be safe – I've never experienced any problems – but this small precaution makes me feel a little more reassured. I would never pack film, exposed or not, in my main luggage as the X-ray doses received are often much higher and the risk of damage increased.

Incidentally, the weight limit on hand luggage is 5kg (11lb) on most airlines. My photographic backpack, complete with film, must weigh at least double this, but to date I have never been challenged and asked to put it on those dreaded weighing scales.

Pictures of local people can say as much about a place as the scenery, so always be on the lookout for opportunities to photograph them – I captured this smiling face on the Caribbean island of St Lucia.
Camera: *Nikon F90x* **Lens:** *80–200mm zoom* **Film:** *Kodak Elite 50* **Exposure:** *⅟₆₀₀ second at f/4*

Filters can be used to help you overcome less-than-perfect conditions, but don't overdo it. I used a combination of warm and soft-focus filters to enhance this shot of the Plaza De Espana in Seville, Spain, which would otherwise have looked rather grey and washed out due to hazy weather conditions.
Camera: *Olympus OM4-Ti* **Lens:** *28mm* **Film:** *Fuji Velvia* **Filters:** *Orange 85C and Cokin Diffuser 1* **Exposure:** *⅟₆₀ second at f/16*

Expert view: Peter Adams

India, Sri Lanka, Cuba, Mexico, Australia, USA, Canada, Greenland, Indonesia – over the last decade, Peter Adams has travelled to all corners of the globe and photographed almost 30 countries. The bulk of the pictures he takes are marketed by one of the UK's top picture libraries, but he also sells pictures direct to clients such as calendar publishers and design agencies.

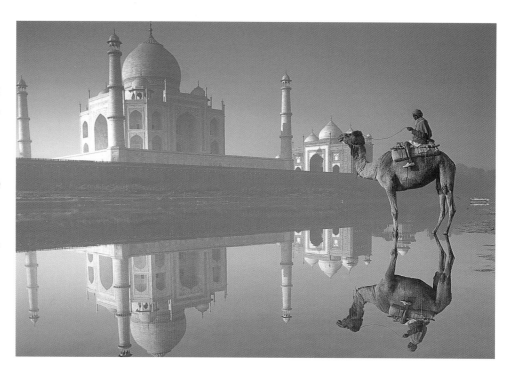

Peter puts a lot of effort into producing high quality generic images, like this picture of the Taj Mahal in India, shot in misty early morning light. Including human interest adds to its appeal.

'I did a lot of travelling in my early twenties and decided to become more involved in photography because I saw it as a way of financing further trips,' he recalls. 'These days I spend about 20 per cent of each year overseas, though I've got children now, so I rarely go away for more than three weeks at once.

'My most recent trip was to Sri Lanka, stopping off in the Maldives *en route* for a week. Very soon I'm off to Trinidad, Tobago and Barbados, then Andalucia in Spain after that. I like to try and plan trips well in advance because once something is booked I can work towards it and plan where I want to go – it also gives my wife plenty of warning that I'm going to be away.'

The decision about where to go is based partly on Peter's desire to see different countries, but also on the pictures his library needs. Consequently, he always liaises with the library and they send him lists of specific subjects they want. He also reads books and magazines, and looks through stock library catalogues to get an idea of what's out there.

'Because travelling is expensive I try to get as much out of each trip as possible, and have different aims while I'm away. My trip to Trinidad coincides with the carnival there, for example, so as well as shooting beach scenes and palm trees I can also take lots of people pictures which the library are particularly keen on. Similarly, while I was in Mexico I hopped over to Cuba for three days – ironically, the Cuba pictures have sold better than those from Mexico.'

Peter almost always travels alone, and prefers to book just a flight to somewhere rather than a complete package. This means he's not restricted and can travel wherever

Cigars and big old American cars are classic symbols of Cuba. Peter has combined both in this shot, along with the smiling face of a local inhabitant, to produce an image that has sold the world over.

he chooses to go. He readily admits it can be tough and lonely at times, especially now he has children, but he's equally aware that it's hard to concentrate if you're having to worry about someone else.

'To make best use of the light I start shooting early in the morning, then rest through the middle of the day and go out again in the evening. If I'm somewhere important, like the Taj Mahal in India, then I'll stay until I've got the shots before moving on. That might mean hanging around for several days, but my first priority is always to get good pictures of the main scenes and subjects because they're the ones that tend to sell the best.'

People feature highly in Peter's work, so whenever he's in a different country he puts a lot of effort into taking pictures of the locals.

'Whenever I can, I spend time with potential subjects, getting to know them before suggesting I take their pictures. I also try to show a good sense of humour and get them laughing because better pictures tend to result. This isn't always possible – sometimes you just have to respond to a situation – but generally I find that involvement is more productive.'

Peter uses 35mm Olympus equipment on his travels because it allows him to be flexible and carry a good range of lenses – 21mm, 28mm, 35mm shift, 65–200mm and 300mm – without being bogged down, plus plenty of film: typically, about 60 rolls for a three-week trip. He also has an Art 6x17cm panoramic camera which he takes on some trips, with another 50 rolls of 120 film for that as well.

Most big picture libraries prefer medium-format images these days, but Peter has never found 35mm to be a limitation and reckons his work is more successful by using it because he can be more spontaneous. Ultimately, this depends upon the library you supply.

'People think travel photography is

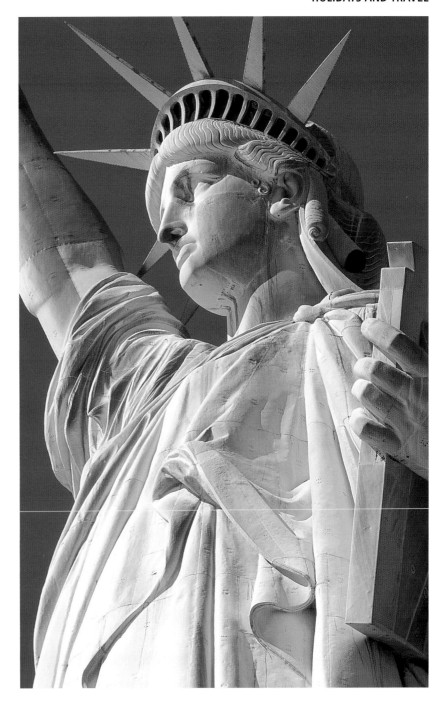

glamorous,' he says. 'In reality, about 10 per cent of it is absolutely fantastic, but it's also hard work and there are lots of hassles such as delays at airports to contend with. I actually hate leaving home and tend to spend most of the journey and the first day or two wondering what the hell I'm doing there, but once I've got some good pictures and start living like the natives, I begin to enjoy it.'

The Statue of Liberty is the first choice among picture buyers requiring images that symbolize New York, so when Peter visited the city he made sure this was his primary subject, and that he got perfect pictures of it. This shot, though photographically very straightforward, illustrates why Peter's work is in such great demand.

LIVE PICTURES
VENICE

Renowned for its stunning architecture and maze of narrow canals, Venice is one of the world's most romantic cities – a place where superlatives only hint at its natural beauty, and where saleable pictures can be taken pretty much in all weathers and seasons.

I travelled there recently with the primary intention of adding some new images to my own and my picture library's stock files, booking a four-night off-season city break and staying in a small hotel situated close to the famous Rialto Bridge.

Although I had been to Venice before and knew my way around pretty well, I still did some homework before embarking on this trip, checking picture library catalogues and travel brochures to see which scenes and subjects tend to be in most demand. I also thought long and hard about which equipment to take so that I could make the most of whatever I encountered, and packed a range of different films, both black and white and colour, to cope with different weather conditions and light.

I decided to go during the winter (early February) because there are far fewer tourists around to spoil the views and the light tends to be more atmospheric – even though the weather is less predictable and temperatures often hover around freezing. It's also cheaper to travel off-season. During the summer, Venice is hot and overcrowded and the light tends to be very hazy.

To give you an idea of what a typical photographic trip entails, here are some highlights – and lowlights – from my five days in Venice.

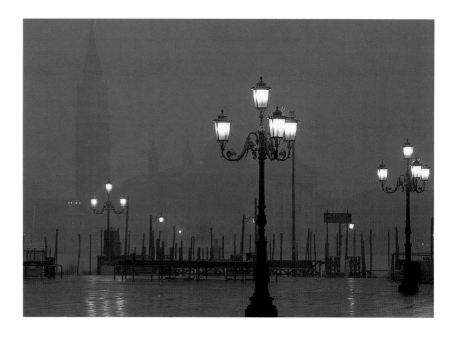

Day 1

Leave home at 5am for two-hour drive to Heathrow Airport. Departure due at 8.55am, but delayed due to fog over Venice. Not a good start. Finally arrive at Venice Marco Polo Airport an hour late. It's damp, grey, foggy and 1°C (34°F). Take bus to Piazzalle Roma, then waterbus to Rialto Bridge. Baggage is heavy – a drawback of carrying photographic equipment – and I'm glad to reach the hotel. Half an hour later I head off with tripod and camera gear for my first wander. Don't expect to take many pictures today. Fog is dense and visibility down to about 50m [150ft], but at least I'm out. Dark by 6pm so I return to the hotel and get gear ready for early start tomorrow.

Day 2

Rise to the alarm at 6.30am, shower, and head for St Mark's Square. It's still cold and foggy, but magical and I feel excited

The first shot of the trip, taken with a Nikon F90x and 80–200mm zoom. I enhanced the cold, foggy feel of the scene using a blue 80A filter.

to be here. Take my first shots – always a big moment – looking across St Mark's towards San Giorgio Maggiore.

The ornate street lights are still on, adding a splash of warmth to the pre-dawn gloom, and I use a blue 80A filter to give the shots a cold colour cast, shooting with the 80–200mm zoom to compress perspective so that the Campanile on San Giorgio Maggiore looms dramatically in the background.

Fog is less dense away from the lagoon so I spend the rest of the morning shooting the pretty side canals, gondolas and interesting details such as Venetian masks in shop windows. Grab a pizza for lunch, then check views from Academia Bridge and take a trip up the Campanile in St Mark's for panoramic views and shoot some black and white film. I feel like I'm

taking some good pictures, but progress is slow and I really need a break in the weather. Maybe tomorrow.

Day 3

Rise at 6.30am and head for St Mark's again – one of the best places in Venice for those all-important 'generics'. Fog has lifted and a pastel-coloured dawn sky creates a beautiful backdrop to the scene. Perfect. I excitedly set up the Pentax 67 with 165mm lens and use an 81C warm-up filter to enhance the light.

Shooting is interrupted periodically as passengers pour off arriving ferries and flood across my path. I expose a few frames with people in the scene, but prefer it to be deserted so I wait impatiently.

These are the best shots so far and I look set for a productive day. Then without warning the fog rolls in, visibility is down to just a few metres and my enthusiasm drops with the temperature. Head back to hotel for breakfast – a rare treat – and

ABOVE And another classic view of Venice, looking across the lagoon towards San Giorgio Maggiore from St Mark's during late afternoon.

RIGHT The bright colours in these gondolas stand out vividly against the muted tones of the buildings, creating a simple but pleasing image.

decide what to do next.

The fog lifts a little, but conditions aren't great so I spend the afternoon exploring and marking interesting spots on my map for future reference. Venice is full of surprises. Narrow alleys open up into enormous squares full of wonderful old buildings, statues and fountains. I feel

incredibly lucky to be here – even if the photography is not going as well as I had hoped.

Day 4

Leave hotel at 6.45am to clear skies. The sun has yet to rise, but I get a good feeling, which is just as well because this is my final day. Head to St Mark's for a third time – it's the best place to be at dawn – and take similar shots to yesterday but in much stronger light. Heading back across the square I see the sky is blue. Not a hint of fog anywhere. Better make the most of it.

First stop, Rialto Bridge, where I spend a hour or so shooting from different angles. It's the first time all week that I've needed to use a polarizing filter. Next I head up onto the bridge itself to capture views along the Grand Canal. The canal is busy with work traffic – barges, cranes, police – so I have to wait patiently for them to pass and gondolas to appear. My tripod and 'big' camera attract lots of attention, but I'm used to it.

A brisk walk takes me to the Academia Bridge where the views along the Grand Canal to Santa Maria Della Salute church are wonderful – another classic Venetian scene. The light is perfect now, so I take a variety of shots with wide-angle, standard and short telephoto lenses using the Pentax 67.

Realizing that the daylight hours are passing, I head back to St Mark's Square, knowing the light on San Giorgio Maggiore and the gondolas lining the edge of the lagoon should be good. It is. More shots in the bag.

It's late afternoon now, the place buzzing with tourists and the sun dropping fast. I look for a viewpoint from which to capture the sunset and find a narrow jetty that allows me to shoot along the row of gondolas towards Santa Maria Della Salute. Perfect light, stunning scene.

With the sun down, twilight arrives quickly and I fire off a few 'night' shots before heading back to the hotel. It has been a frantic day, my feet are blistered, but I feel intensely satisfied that I have managed to get the shots I set out to take – despite the fact that at the start of the trip the odds seemed stacked against me. Now I just have to hope they sell ...

EQUIPMENT AND TECHNIQUE

Cameras: Pentax 67, Nikon F90x and Nikon F5

Lenses: 55mm, 105mm and 165mm for Pentax; 18–35mm, 50mm, 80–200mm for Nikons

Tripod: Gitzo Studex

Film: Fujichrome Velvia 120 (40 rolls) and Provia 400 (6 rolls) for Pentax; Fujichrome Sensia 100 35mm (20 rolls), Ilford HP5+ (10 rolls) and Fuji Neopan 1600 (8 rolls)

Filters: Polarizer, 81B to 81EF warm-ups, 0.45, 0.6 and 0.9 neutral-density graduates, soft focus, blue 80A

Accessories: Pentax Digital Spotmeter, cable releases, filter holders. LowePro Photo Trekker backpack to carry everything

LEFT One of my favourites from the whole trip, this scene was captured just before sunset from St Mark's, looking along the gondolas to Santa Maria Della Salute church.

BELOW The famous Rialto Bridge, captured using an 18–35mm zoom at 20mm. Shooting such a wide view enabled me to show the bridge in its environment.

ABOVE Dawn on the morning of day three provided this shot, captured in beautiful golden light. Knowing where the sun rises and sets is essential if you want to be in the right place at the right time.

BELOW Small details, such as these masks hanging in a shop window, can be highly symbolic of a place.

TECHNIQUE TIPS

• Check travel brochures, guidebooks, advertising campaigns, postcards and picture library catalogues to see which subjects and scenes are the most popular at your chosen destination.

• When you visit a popular scene or landmark, take a variety of different pictures. Shoot in both the upright and horizontal formats, use different lenses, explore different viewpoints and return at different times of day.

• Be careful not to overshoot. It's tempting to expose roll after roll of film to the same scene, but the more film you use, the more money you will have to make just to break even.

• Try to visualize how your pictures might be used and shoot accordingly. Leaving a large area of sky or other empty space in the composition will allow text to be dropped onto the image, for example.

• Famous landmarks are best photographed early in the day before crowds of tourists arrive, or during the evening when most tourists have left the area.

• Note the names of specific locations you photograph if they're not obvious or well known so that you can caption your pictures accurately. Marking a map can also help to jog your memory.

• Carry small self-adhesive labels so that you can stick messages to individual rolls of film – such as 'Push 1 stop' or location details.

BEST SELLERS

PICCADILLY CIRCUS, LONDON

This shot resulted from an experiment rather than a serious attempt to produce an unusual image. I had only ever tried the zoomburst technique once or twice before, so finding myself in Piccadilly Circus on a day trip to London to shoot some new stock images for my picture library, I decided to finish a roll of film by having another try.

In all I exposed six frames, zooming a 35–70mm lens from one focal-length range to the other during a ⅛ second exposure while also panning the camera to keep track of the passing London bus. It was rather hit and miss, and only one frame really worked – this one. Fortunately, it was chosen to appear in a general stock catalogue by my picture library a few years ago and has been selling steadily ever since.

What makes it sell?

It's a vibrant, action-packed and eye-catching image that sums up the hustle and bustle of London perfectly. It also includes instantly recognizable subjects, but shows unusual treatment of a much-photographed subject.

FACTS & FIGURES

Equipment *Olympus OM4-Ti 35mm SLR, 35–70mm zoom*

Film *Fujichrome Velvia*

Number of sales to date *23*

Catalogue image? *Yes*

Where sold *UK, Singapore, Ireland, Belgium, Luxembourg, Spain, Germany, France, USA*

Used for *Photographic book and magazines, several travel brochures, in-house magazine, single-sheet mailer. Most uses unknown*

Total sales to date *£2,200*

OIA, SANTORINI, GREECE

I took this photograph during a week's stay on the beautiful Greek island of Santorini with my wife. Oia, a village at the northern tip of the island, is famed for its stunning sunsets and views out to sea, so we headed up there one evening – to be confronted by perhaps 200 other people already gathered for the spectacle!

The shot is fairly straight, capturing the view across the village and out to sea.

What makes it sell?

The windmill and whitewashed houses tumbling down the hillside create a generic scene that sums up not only the charm of Santorini, but the Greek Islands in general. Including plenty of sky also means type can be dropped onto the image.

FACTS & FIGURES

Equipment *Pentax 67, 105mm lens, tripod, 81C warm-up filter and 0.6 neutral-density graduate to hold detail in the sky*

Film *Fujichrome Velvia*

Number of sales to date *3*

Catalogue image? *Yes*

Where sold *UK*

Used for *Travel brochures, bakery packaging by one of the UK's leading supermarket chains*

Total sales to date *£1,300*

THE LAGOON BEACH, OLU DENIZ, TURKEY

I had seen this scene in photographs many times before, so on arrival in Olu Deniz – where I went on a week's package tour to shoot stock pictures – I did a recce to find out where it was. It turned out that to get this shot you needed to paddle out to an island across the lagoon; so having worked out the best time of day to get it, I asked a local guy hiring boats to tourists if he would take me over and then pick me up an hour later, which he agreed to do – for a fee, of course.

What makes it sell?

This is a good example of a generic image. The lagoon is a naturally stunning scene, so it's always used to promote the area, and it would be foolish for any visiting photographer to miss it, despite the hassle of getting to the island. The light is also perfect, and the amazing colour of the sea just makes you want to dive straight in.

FACTS & FIGURES

Equipment *Pentax 67, 55mm lens, polarizer and 81B warm-up filter*
Film *Fujichrome Velvia*
Number of sales to date *9*
Catalogue image? *No*
Where sold *UK*
Used for *Non-exclusive advertising rights, magazine illustration, photographic magazine, travel brochures. Most uses unknown*
Total sales to date *£1,200*

THE CATHEDRAL, FLORENCE, ITALY

During a trip to Tuscany several years ago I spent a single day in Florence taking in the sights. The weather was clear and bright, though the light was rather harsh and hazy: not exactly ideal conditions. All the pictures I took were shot handheld, on 35mm equipment – I left my tripod back at the hotel, which is a very rare occurrence – as I strolled around the city; and to be honest, I left that evening doubting I had anything worth shouting about.

What makes it sell?

You tell me. This is a straight record shot taken in relatively bland light – certainly nothing remarkable. What it does illustrate, however, is the importance of putting your work with a good picture library, because you really never can tell.

FACTS & FIGURES

Equipment *Olympus OM4-Ti 35mm SLR, 180mm lens*
Film *Fujichrome Velvia*
Number of sales to date *1*
Catalogue image? *No*
Where sold *UK*
Used for *Point-of-sale cards*
Total sales to date *£1,000*

SPORT AND FITNESS

The action and drama of sport can be used to symbolize many things – competitiveness, winning, participation, facing a challenge, determination, team spirit, skill, precision, victory, endurance, strength, stamina ...

Consequently, picture libraries are crying out for good sports images, and any photographer capable of coming up with the goods stands to make a lot of money.

As few photographers have the necessary skills to achieve this, competition is also far less intense than with other more popular subjects, such as landscapes and travel – all the more reason to start practising your focusing technique.

Game plan

Literally any sport can be used as the basis of good stock shots, though it's always worth starting with the most popular. Athletics, marathons, fun runs, cycling, swimming, skiing, sailing, climbing, rowing, tennis and golf tend to be top of the list, followed by football, rugby, dog racing, horse racing, showjumping, cricket, basketball and so on.

My advice is to get hold of as many stock catalogues as you can, and then analyse them to see which sports appear most frequently – and the style of photography used, which seems to get more obscure as the years pass.

As with wildlife and nature, if you're seriously into sports photography and already have a decent body of work, it makes sense to join the ranks of both a specialized sports agency and a general library, so that you can maximize the sales potential of your work, though a general library is likely to make more money for you due to the wider range of markets it supplies.

For this reason, the key to success with shooting stock sports pictures is to keep things simple and generic.

Identity crisis
Pictures of well known sports personalities will be perfectly acceptable to a specialist sports library, for editorial use, but a general picture library is unlikely to be interested in them because famous faces bring with them all kinds of copyright problems that inhibit the use to which those pictures can be put. Big-earning advertising sales are definitely out because celebrities won't allow their faces to be used to promote or endorse a product

without prior permission – and usually a big fat cheque. That's how many of them make a living.

The same applies to team names, or the names of individual sportsmen and women. They're often splashed across sportswear, especially for team games such as rugby and football. Again, including them in your pictures will reduce the number of markets to which the pictures can be offered because it makes them too specific. It also dates the pictures because

players switch teams, sports kits and sponsors are changed, and so on.

Sometimes it's impossible to avoid including these giveaway clues, but whenever you can you should try to because they can make a big difference to the sales you achieve.

An easy way to make your pictures more generic is by using slow shutter speeds and panning the camera, so that the image is blurred. Not only will this render unwanted names or details

The best-selling sports images tend to be either action-packed or atmospheric – and this is a perfect example of the latter. The beautiful golden light, the ripples on the water and the perfectly co-ordinated action of the rowers all combine to make it a winner.
Camera: *Nikon F5* **Lens:** *500mm*
Film: *Fujichrome Velvia*
Exposure: *1/500 second at f/5.6*

This superb action shot by Simon Stafford, bears all the hallmarks of a classic generic stock image. It's colourful, exciting, and the slow shutter-speed pan has added a wonderful sense of grace and flow that makes it ideal for symbolizing anything to do with competition, dedication and winning.
Camera: Nikon F4s **Lens:** 80–200mm
Film: Fujichrome RDP100
Exposure: 1/15 second at f/16

Creative techniques are often used by sports photographers to give their stock pictures added interest. Here, Simon Stafford zoomed his lens through its focal-length range to create the explosion of colour and streaks.
Camera: Nikon F90x **Lens:** 80–200mm
Film: Fujichrome Provia
Exposure: 1/8 second at f/16

illegible, but the sense of motion introduced by the blurring can also be incredibly effective – Simon Stafford's superb shot of athletes above is a good example of this.

The shutter speed you need to use will depend on how fast your subject is moving. For motorsports, working at speeds of $1/125$ or $1/60$ second is advised, while for athletics, $1/15$ or $1/8$ second will give a pleasing effect. Much depends on the accuracy of your pan as well – if you pan smoothly at the same pace as the action then your subject will come out sharper, whereas deliberately panning at an uneven pace will increase the level of blur.

Taken to an extreme, this technique can result in impressionistic images where the subject matter is hardly identifiable and the sense of grace and flow created by excessive blurring gives the image its appeal, so experiment with different shutter speeds and see what happens.

Zooming is also an effective way of obscuring unnecessary details – and adding impact to what could otherwise be rather uninteresting shots. You can use any zoom lens for this technique: all you have to do is zoom through its focal-length

range while shooting at a slow shutter speed, so that you get an explosion of colour and streaks radiating out from your centrally placed subject.

Timing

The most crucial aspect of good sports photography is timing – trip your camera's shutter just a fraction of a second too soon or too late and you can not only miss the peak of the action, but also end up with an out-of-focus subject.

The only way to avoid this is by practising and polishing your skills. Some photographers have better hand–eye co-ordination than others, but even if you don't, the more pictures you take the better you'll become.

Sports that follow a known route, such as motor racing, horse trials, many athletics events and slalom canoeing, are easier to photograph because you can pre-focus on a predetermined spot, wait for your subject to approach, then trip the shutter – shooting momentarily before your subject snaps into sharp focus, otherwise you'll miss the moment.

Where the movement is more erratic – as is the case with field sports such as football and rugby – you need to follow-focus so that your subject is kept constantly in focus as you track it with the camera, until you're ready to shoot.

This is much more difficult to achieve, though the modern autofocus systems found in cameras such as the Nikon F5 and Canon EOS3 are virtually foolproof, and many sports photographers now use their cameras in continuous AF mode for follow-focusing so that they can concentrate more on the timing of the shot, rather than on whether their subject is in focus.

The shutter speed you need to use to freeze the action will depend on how fast your subject is moving, how big it is in the frame and the direction of travel in relation to the camera.

A person sprinting or cycling towards the camera can be frozen on $^1/125$–$^1/250$ second, but if they're moving across your path you'll need to shoot at $^1/500$ second. For a galloping horse, a tennis serve or a car travelling at 100kmph (60mph) you will need $^1/250$–$^1/500$ second to freeze a head-on shot, and $^1/1000$ second if the action is photographed side-on.

In order to work at high shutter speeds you will often be shooting with your lens at its widest aperture. The benefit of this is

Horse trials is another sport that tends to feature in stock catalogues, the colour and drama making it a popular choice for picture buyers. Simon Stafford took this shot at Blenheim Horse Trials in Oxfordshire, positioning himself close to a water jump where he knew the action would be at its most dramatic.
Camera: *Nikon F90x* ***Lens:*** *300mm*
Film: *Fujichrome Provia 100*
Exposure: *⅟₅₀₀ second at f/4*

that when using telephoto lenses, depth-of-field will be reduced significantly so that the background is thrown well out of focus. The downside is that with so little depth-of-field to play with, your focusing and timing need to be spot on otherwise you'll end up with an out-of-focus subject.

Film and lenses

The rule-of-thumb when choosing film for sport and action photography is to keep it as slow as possible for maximum image quality, so don't be tempted to load up with ISO400 film to make your life easy when you could get away with ISO100.

Generally, ISO100 film is the norm, with Fujichrome Provia 100 being the most popular emulsion used. In dull weather, this can be uprated a stop to ISO200 or 2 stops to ISO400 and then push-processed, so you only ever need carry one speed of film for outdoor work.

Indoors, where light levels are much lower, ISO400 is about the slowest you can get away with, but often you will need to uprate it to ISO800 or ISO1600. Consider the type of lighting used, too: tungsten-lit interiors will give pictures taken on daylight film a yellow/orange cast, so you will be better off using tungsten-balanced film. Kodak Ektachrome 320T is the fastest available, though it can be uprated to ISO640 or ISO1200 as and when required.

In terms of lens focal length, your needs will be dictated by the sport you're intending to photograph and how close you can get to it. Sporting events on a local or county level, at small venues, tend to offer much greater access to spectators, and if you contact the organizers beforehand they may give you permission to shoot from anywhere. Consequently, you can achieve a lot with a telezoom such as an 80–200mm or 75–300mm.

Shots taken at the start and end of a race are often used by picture buyers to symbolize winning, achievement, attaining goals, determination and success, so if you capture the perfect moment, the financial rewards can be high.
Camera: *Nikon F4s* **Lens:** *600mm* **Film:** *Fujichrome Provia* **Exposure:** *1/500 second at f/4*

At many national and international events access is more restricted. The action also tends to take place much further away from the camera, so longer lenses become necessary. Again, a 300mm telephoto may prove suitable in some cases, but you're more likely to need a 1.4x or 2x teleconverter to increase its focal length – or a 400–500mm lens. Sports such as cricket and motor racing often require even longer lenses – professional cricket photographers regularly use 600–800mm optics, and occasionally 1,200mm!

If you can't afford such exotic optics just yet, stick to local events and cover sports that offer easy access – such as canoeing, motocross and athletics. Or contact sports clubs in your area and ask to attend practice sessions – with sports such as rowing this will probably give you more photo opportunities than if you attend an actual race.

From a stock point of view, you're just as likely to take saleable pictures at a local meeting as you are at an international event – especially if you use creative techniques such as slow shutter speeds, panning and zooming to make the images more generic (see Duncan McEwan's fun run shot on page 138). Where long lenses are essential, hire them for the day as and when required, until you can afford to buy your own.

It's a set-up

The other option is to set up shots. Stock catalogues always include a selection of sport concepts such as a close-up of a golfball on the edge of the hole, a footballer's foot on a football, a dart in the bullseye on a dartboard, a relay baton being passed from one hand to another, a close-up of a basketball net, a pair of feet in well-worn running shoes or walking boots, and so on. So write a list of all the main sports, then try to think of ways in which you can symbolize them with simple set-ups.

Fitness is another important aspect of stock sports photography, and something that lends itself to being set up specially for the camera.

Why not ask a friend or relative to be your model for a few hours, then go and take various fitness shots in a local park – jogging, doing sit-ups and press-ups, riding a bicycle, sitting on a mountain bike, stopping to take a breather after a good run, drinking from a water bottle. Your local gym can also be used as a location for lots of different shots – lifting weights, walking on a treadmill, stretching and so on.

Either way, make sure your subject is suitably dressed in correct, modern sports attire – and as well as taking pictures of them looking perfect, take some that capture the sweat, tears and pain of keeping fit.

In on the action

Setting up action shots is also worth considering. Perhaps you know a mountain-bike enthusiast who would be willing to show off his skills while you take pictures, or a keen golfer who would be happy for you to accompany them during a round at the local club – or go along with you primarily to set up shots such as eyeing up a putt, taking the putt, teeing off and so on.

Friends playing tennis is another popular subject – especially shaking hands across the net at the end of a game. Another popular set-up tennis shot involves fixing a ball to the edge of a tennis racket and then shooting it with a wide-angle lens at maximum aperture, so that you get the ball big and sharp in the foreground, with the racket and player out of focus in the background.

Competitive swimming is tricky to photograph, but you can mimic the sport at your local pool if you know a keen swimmer – use a long lens to capture tightly composed head-on and side-view shots of them gulping for air while using different swimming strokes such as butterfly, breast stroke and crawl.

Finally, though not quite as popular as big sporting events, school sports days can also be the source of great pictures – the egg-and-spoon race, three-legged race, sack race and other events will all provide lots of fun photo opportunities, as will the parents' race when mums and dads compete against each other.

Childrens' sports are also worth photographing – these include junior football and rugby, tennis, swimming, athletics and cycling. Or why not simply take some pictures of your kids racing around the local park on their mountain bikes?

If you don't have the skills to shoot fast-moving action, why not set up some sport and fitness shots using models? Chris Rout took this shot in a park close to his home, using the model's own mountain bike as a prop. The golden light was given a helping hand by using two sheets of gold-coloured card as reflectors.
Camera: *Canon EOS1n* **Lens:** *70–200mm*
Film: *Fujichrome Velvia*
Exposure: *⅟₆₀ second at f/4*

Expert view: Simon Stafford

When injury forced Simon Stafford to withdraw from competitive sports back in the mid-1980s, he started photographing them instead.

Despite having a busy Civil Service career, he still manages to cover many national and international events, and his work features widely in the photographic and sports press.

'I suppose I took the traditional route into sports photography, shooting local events at small venues first, then gradually building up to the point where I was travelling all over the country pretty much every weekend.

'American football kicked things off for me. There were a couple of big games with American teams at Wembley Stadium which I attended, then gradually I diversified from open field sports to basketball, canoeing, equestrian events, athletics, hot-air ballooning and all kinds of things.

'In the early days I would scour the listings in *Time Out* magazine and newspapers to find out where and when things were happening. I also used to get an events calendar from the Sports Council and contact the sporting associations for individual sports.

'It took about two years of hard work before I got to the stage where my focusing skills and timing were good enough to produce consistently good results. I used to sit in the middle of a busy roundabout on the A3 road, practising my follow-focusing and panning skills, sometimes with black and white film in the camera so I could process it and see how I'd done, but often with no film. This really helped, and combined with photographing different sports where the pace differed, my hit rate gradually increased.

'Anticipation is also important – the more you get to know a sport, the more you can predict what is likely to happen next, based on the way the event is going. This in turn will influence where you position yourself or where you focus so you don't miss a great shot.

'The biggest problem with covering big events at major venues is obtaining press accreditation so you can get close to the action. I overcame this by submitting my work to specialist sports magazines. Once

Simon is renowned for his use of creative techniques when shooting sport. Here a slow shutter speed of ⅛ second was used to emphasize the thrills and spills of an American football game, and produce a superb generic sports image in the process.

I became known to the various editors I could then contact them to see if they would be interested in pictures of a particular event. There were no guarantees my pictures would be used, but doing this enabled me to mention specific names and magazines when I filled in application forms for press accreditation. If you just put "freelance" on the forms you get nowhere because anyone could do that – you need to have contacts in publishing who can verify who you are.

'The alternative is to cover events where you can get close to the action from public areas, such as canoeing, three-day eventing and so on. Often I prefer to shoot from public areas at such events because you get different views, and the professionals tend to be crammed into a small press enclosure.

'I also keep programmes from venues I visit for the first time as they often have a seating plan. By studying this I can decide which rows of which specific seats will give the best views of certain things – the

long-jump pit or the start of the 100m sprint, for example – then make sure I book that seat. Knowing which direction the seat faces is also important as it allows you to determine where the sun will be in relation to the action and you.

'Fast lenses are vital if you want to take sports pictures seriously for sale as they allow you to use slow film and optimize image quality – I use ISO50 Fuji Velvia when I can, or Provia 100.

'My first big investment was a 300mm f/2.8 Nikkor lens and 1.4x teleconverter. This proved to be ideal for everything except cricket and motorsport, where you need a longer lens. Since then I've added a 500mm f/4 and I also use an 80–200mm f/2.8 zoom a lot. If I need anything longer, such as a 600mm f/4, I'll hire it.

'For cameras I use Nikon F90xs and Nikon F5s, both of which allow $^1/_3$ stop shutter-speed adjustment. This is invaluable, because being able to shoot at $^1/_{160}$ second or $^1/_{200}$ second instead of $^1/_{125}$ can make a big difference when

Simon chose an alternative back view for this shot so that he could make full use of the beautiful backlighting. In doing so he has also created a perfect stock image because the athletes' faces aren't visible, eliminating the need for model releases.

you're trying to freeze a moving subject.

'Overall, the best advice I can offer is to practise, practise, then practise some more. Look at sports magazines and newspapers to see how professionals approach a subject, and keep things simple – perhaps going to an event with just one lens. Don't be afraid to experiment with techniques such as panning, zooming, multiple exposures or using slow shutter speeds to blur your subject.

'Finally, shoot film – lots of it. Forget about buying expensive fast lenses initially. Hire them and spend your money on film, because the only way to get better in this game is by taking pictures.'

LIVE PICTURES
MOTOCROSS

These pictures were taken during a Sunday afternoon visit to a disused brickworks a few miles from my home. With its water-filled pools, muddy tracks and hilly terrain, this location has become a Mecca for trail bike and motocross enthusiasts, who gather by the dozen every weekend.

On the day, I approached a couple of riders who looked as if they knew what they were doing to see if they would allow me to photograph them in action. When shooting sport for stock you need to make sure that your subjects are correctly equipped and correctly dressed, so in this case full crash helmets and one-piece suits were essential, plus modern motocross bikes.

Technique

The weather was dull and cloudy, making light levels too low to achieve action-stopping shutter speeds with slow film. However, this was intentional because rather than try to freeze the action using high shutter speeds, I decided to do the job with electronic flash and use a

RIGHT My favourite shot of the session was taken as one of the riders splashed through a muddy puddle, sending a spray of water into the air. Shot at 1/15 second.

technique known as slow-sync flash.

This involves combining a burst of flash with a slow shutter speed, so that the flash freezes your subject while the slow shutter speed records any subject movement as a blur – the slower the shutter speed, the more blur you get.

I set my flashgun to automatic and selected an auto aperture setting on it that was 1 stop wider than the aperture I had set on the lens. This achieved a flash-to-daylight ratio of 1:2, which gives a pleasing balance. My camera was then set to aperture priority so that it would automatically select a shutter speed to expose the ambient light correctly, while I controlled the lens aperture to ensure correct flash exposure.

Once I had explained to the two riders what I wanted, they rode up and down, one after the other, while I photographed them from close range with a 28mm wide-angle lens or 50mm standard. I tracked them through the camera's viewfinder as they approached, and tripped the shutter once they were opposite my position, while still panning the camera to get plenty of background blur.

EQUIPMENT AND TECHNIQUE

Camera: Olympus OM4-Ti
Lenses: 50mm, 28mm
Flash: Olympus T45 hammerhead gun, GN45 (m/ISO100)
Film: Fujichrome Velvia
Exposure: Shutter speeds from $^1/30$–$^1/8$ second and apertures from f/5.6 to f/11

TECHNIQUE TIPS

• Slow-sync flash is a great technique to use if your action photography skills aren't that hot – it leaves a lot of room for error but the results always look striking.

• To make your flash-lit subject stand out even more, try underexposing the ambient light a little by shooting in aperture priority mode with your camera's exposure compensation facility set to $-^1/2$ or -1.

• Use the technique for motocross, car rallying, mountain biking, cycling, athletics, and other subjects where you can get relatively close to your subject.

BEST SELLERS

ANGLERS AT SUNSET

This picture was taken at Rutland Water, Europe's biggest manmade lake, which is situated about 30 minutes' drive from my home. I had spent the afternoon photographing anglers with a 400mm lens, and this was one of the last shots taken as the sun sank towards the horizon.

What makes it sell?

Anglers fishing for trout at sunset: it's a dream scene, suggesting tranquillity, peace and calm, and the muted colours, courtesy of hazy weather and fast, grainy film, add bags of atmosphere. Almost makes you want to pick up a fishing rod and head for the nearest lake.

FACTS & FIGURES

Equipment *Olympus OM4-Ti, Tamron 400mm f/4.5 lens, 81B warm-up filter, tripod*
Film *Agfachrome 1000RS*
Number of sales to date 6
Catalogue image? No
Where sold *UK, Germany, USA, France*
Used for *Travel brochure, angling magazine, newspaper editorial, calendar, photographic magazine*
Total sales to date *£320*

SLALOM PADDLER

The River Tay near Aberfeldy is home to one of Scotland's premier slalom courses for canoeists, and Duncan McEwan tries to get up there at least once a year. The close proximity of the canoeists meant that he was able to fill the frame with action using just a 200mm lens — though it takes skill and perfect timing to capture shots of this magnitude.

What makes it sell?

The excitement and drama of the frozen water and the expression on the canoeist's face. Canoeing, along with motocross and cycling, is a popular stock sport.

FUN RUN

Duncan McEwan took this photograph at the start of a fun run, shooting from a nearby embankment. Low light levels prevented him from using a shutter speed fast enough to freeze the runners, so he decided to set a slow speed — $1/15$ second — and blur them. The effect was exaggerated by panning the camera down in a vertical movement as the race began.

He recalls: 'This shot was taken more with my camera club competition in mind than the picture library, but in fact it has since proved to be one of my best-selling pictures.'

What makes it sell?

The sense of movement, the bright colours and the fact that you can't identify the runners, which makes it a perfect generic image for illustrating not only running, but also energy, competitiveness, winning and anything else associated with exercise, success and sport.

FACTS & FIGURES

Equipment *Minolta 8000i, 100–200mm zoom*
Film *Fujichrome RD100*
Number of sales to date 5
Catalogue image? *Yes*
Where sold *UK, Ireland, Canada*
Used for *Brochure, calendar, magazine, audio-visual*
Total sales to date *£410*

FACTS & FIGURES

Equipment *Minolta X700, 70–2100mm zoom*
Film *Fujichrome RD100*
Number of sales to date *40*
Catalogue image? *Yes*
Where sold *Germany, USA, Australia, Canada, Portugal, Taiwan, Hong Kong, Belgium, Sweden, Japan, Turkey, Spain, UK, Ireland, Finland*
Used for *Display exhibition, trade advertisement, brochure , magazine, audio-visual. Most uses unknown*
Total sales to date *£2,700*

BUSINESS AND FINANCE

There are two main categories of business and finance photography – the first depicts people in business/work situations, and the second is shooting concept images.

Of the two, concept shots are by far the most accessible to aspiring freelance photographers, so let's begin with them.

Concept photography involves creating images that deliver a clear message or that can be used to imply certain things – you will find a more in-depth discussion of this in Chapter 13. In terms of business and finance, the most common images are those depicting currencies of the world's major economies – pounds sterling, US dollars, Japanese yen, French francs, German marks. Essentially they're just still-life shots of money, something anyone could shoot – though for this very reason you will need to come up with something fresh and exciting if regular sales are your aim, because nowadays more and more photographers are jumping on this particular bandwagon.

If you're going to go to the effort of setting up a shoot, it also makes sense to work with more than one currency. Stock catalogues are distributed around the world, so there's no reason why a British photographer couldn't sell pictures of Japanese yen in Japan, or US dollars in the States. Equally, a photographer based in the USA could sell pictures of French francs to markets in France, and so on. There will also be a need for pictures of foreign currencies in your own country.

You can 'buy' all these currencies through banks or a Bureau de Change. I prefer to use my own bank because the staff are aware that I'm a photographer and they try to ensure that I receive crisp, new bank notes and shiny coins, which helps to give the pictures that little something special.

Ask for a selection of coins and notes in all the main denominations. If you're dealing with several currencies at once this can involve handing over a large sum of money, but once you have finished photographing them, foreign currencies can be returned to your bank and cashed in for a small commission, so in real terms it costs very little.

Alternatively, start out with the currency of your own country initially, come up with some interesting ideas for pictures, then over a period of time use the same set-ups and techniques on different currencies, shooting them one at a time.

Currency still-lifes usually involve working at close focusing distances, so a macro lens, extension tubes or supplementary close-up lenses will be required. I use a 105mm macro lens on a Nikon SLR almost exclusively – you don't really need a format bigger than 35mm.

In terms of lighting, experiment with a variety of sources. Windowlight is one option, though it can be a little flat. I prefer to use a slide projector or a studio flash unit to create highlights on the coins, though you can produce interesting effects with a pocket torch, using it to 'paint' with light in a darkened room and modifying the light with coloured gels.

The properties of different films can also be exploited. I mainly use Fujichrome Velvia or Sensia, but tungsten-balanced slide film will produce a cold, blue cast when exposed to daylight or flash. Black and white is also worth trying, and either colour negative or colour slide film cross-processed to give weird colours. Colour slide film such as Fujichrome Provia processed in C-41 chemistry gives great effects, though you end up with a colour print instead of a slide, and it will need to be re-photographed back on to slide film before submission to your picture library.

Here are three examples of simple business concept images, all shot in windowlight. The overall blue cast – which is very popular at the moment with picture libraries – was created by using unfiltered tungsten-balanced film.
Camera: Nikon F90x **Lens:** 105mm macro
Film: Fujichrome 64T
Exposure: 1/60 second at f/2.8

Business mind

Currency is only one popular subject, of course, and once you start thinking along the right lines, it's surprising how many ideas for pictures you can come up with.

Mobile phones are still highly symbolic of the busy businessman today, so they should definitely be on your shot list. Shoot the phone as a still-life prop from unusual angles, using some of the film and lighting techniques mentioned above. Ask someone to hold the phone and then

photograph a hand punching numbers on the keypad (see back cover), moving the camera or asking your subject to move the phone during exposure to introduce blur and a sense of urgency – remember, busy businessmen are always on the move.

Make sure the brand name of the phone isn't visible, as this will make the shots too specific. Desk telephones also make a good subject – place one on a plain background and shoot it with your lens at maximum aperture both on and off

the hook, capture it among the clutter of an untidy desk, use a slow shutter speed to photograph a hand reaching to pick the phone up, or a hand dialling/punching in a number to make a call.

Other office items can be a source of great pictures – a pile of paper clips, a calculator, a stapler, drawing pins, a ball made of rubber bands, a personal organizer or diary, the lock on a briefcase, a computer keyboard shot from an acute angle, or an old typewriter to compare new and old technology.

Use a slow shutter speed to photograph hands typing at a computer keyboard, punching numbers into a

calculator or moving a computer mouse
so that any movement records as blur.
Close-ups of alphabetical and numerical
filing systems are highly symbolic of the
office and organization, while creative
photographs of clocks and watches
symbolize time, or the lack of it, which is
of prime importance in business – time
is money, and all that.

Heavy symbolism

You could also get a little more obscure
and shoot objects that are symbolic of
business and money in an indirect way.
Playing cards, dominoes and dice all
suggest gambling, loss, risk and chance,
for example. In all cases, creativity is the
key – use differential focusing, unusual
camera angles and selective lighting to
make what are essentially uninteresting
objects come to life.

In this age of borrowing and spending,
credit cards are another sure-fire seller –
and the chances are that you already have
a selection of cards of your very own that
can be used as props.

One classic image that has countless
uses is of a credit card being handed over.
I have taken this shot several times using
tungsten-balanced film in daylight,

daylight-balanced film in tungsten light,
cross-processed film, black and white and
so on. In each case I mounted the camera
– a Nikon SLR with 105mm macro lens –
on a tripod and then photographed my
own right hand reaching out in front of
the camera with a credit card held
between thumb and forefinger. By peering
through the viewfinder I was able to focus
the lens with my left hand, keep the right
hand steady and shoot – though a
perfectly steady hand isn't essential

because a little blur in a shot like this
never hurts as it helps to give the feeling
that the card is being handed over. Neither
does holding the card almost horizontal
and shooting at maximum aperture so that
the card number can't be read and the
logo isn't visible. You need to keep pictures
like this generic if they're to sell and sell.

Another project worth trying is to shoot
a series of financial concepts based
around charts and graphs which symbolize
performance. Financial newspapers publish

these in every issue, but you can also generate them on a computer. Introduce other items, too, such as a calculator, a classy pen – fountain pens always go down well – and perhaps a stylish pair of unisex spectacles that could be worn by a businessman or businesswoman. Close-up shots of a cheque or important document being signed are also almost certain to sell if selected for catalogue use, so set them up, using a spouse or friend as a hand model, and again shoot at maximum aperture, focusing your lens on the pen nib so that it's the only thing in focus.

People at work

Taking people pictures that have a business theme is much more involved, but can reap handsome rewards and is well worth trying.

Initially, think of ideas that can be executed using family, friends or colleagues so that you don't have to incur the costs of hiring models. For example, slow shutter-speed panned shots of men and women

striding purposefully along are highly popular as they symbolize the fast pace of business. You could produce a set of these images featuring anyone – there will be so much blur that your subject won't be identifiable. So, why not ask someone you know if they will spare you a couple of hours to try out some new ideas?

Use an office building as a backdrop and take the pictures on a Sunday when city centres, especially financial districts, are quiet. Your model will also need to wear a business suit so that they are dressed for the occasion.

Take a range of different shots, all panned and at shutter speeds of $\frac{1}{15}$ second down to $\frac{1}{2}$ second or even 1 second – the slower you go, the more blur there will be. Begin with a classic side-on shot of your subject walking along swinging a briefcase, holding an umbrella if it's raining, or perhaps chatting on a mobile phone. Keep the background quite neutral and fire off a series of frames in quick succession. Next, try walking alongside your subject while shooting so they don't blur quite so much, but so that the background goes out completely.

Financial newspapers and brochures provide lots of charts and graphs that can be used to symbolize the ups and downs of the world's financial markets. Adding other business paraphernalia such as pens, spectacles and personal organizers helps to complete the picture.
Camera: *Nikon F90x* **Lens:** *105mm macro*
Film: *Fujichrome Sensia 100* **Lighting:** *Slide projector*
Exposure: *¹⁄₆₀ second at f/2.8*

Slow shutter-speed pictures of crowds of commuters are popular stock shots, so it's well worth planning a visit to a busy city during the morning or evening rush hour to take some. For this shot, I positioned myself on London Bridge around 7.45am, then waited for the hoards to arrive. Shooting with a long lens compressed perspective to emphasize the crowding effect.
Camera: *Nikon F90x*
Lens: *80–200mm zoom* **Film:** *Fuji Velvia*
Exposure: *1 second at f/22*

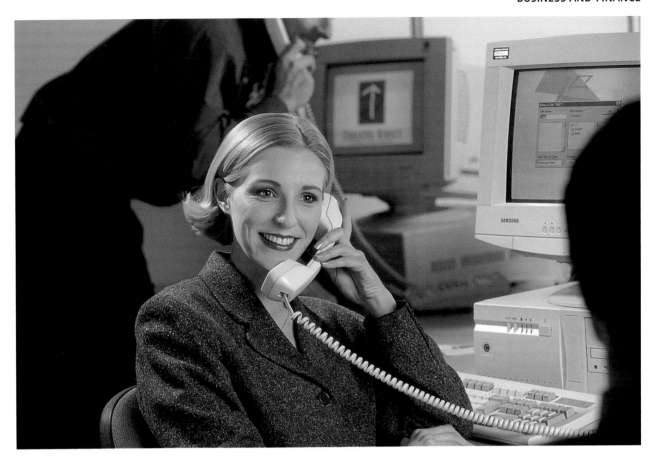

ABOVE Pictures of people in a business environment take a lot of planning if you want them to look natural – here the main subject is the woman on the telephone, but two other models were also required to add interest while the computers in the background help to create a familiar scenario.
Camera: *Canon EOS1n* **Lens:** *70–210mm at 100mm*
Film: *Kodak Ektachrome E100S*
Lighting: *3 studio flash heads with softboxes and brollies* **Exposure:** *¹⁄₂₅ second at f/5.6*

LEFT A slide projector was used to light this pile of British £1 coins – its warm light enhances the natural golden colour of the coins, while the blue card background adds an eye-catching contrast. Another simple tabletop still-life that anyone could shoot.
Camera: *Nikon F90x* **Lens:** *105mm macro*
Film: *Fujichrome Sensia 100*
Exposure: *¹⁄₆₀ second at f/2.8*

Once you're satisfied with these shots, try the same idea with your subject walking up and down a flight of steps to the entrance of an office building, or any other imposing building. Then shoot them dashing along with an arm raised as if hailing a cab, walk behind them and take pictures while on the move, shoot closer pictures of your subject checking their watch while moving. When you've done that, take a series of slow shutter-speed pictures that concentrate on their legs, shot from the waist or knee down, and panning the camera again in order to introduce motion.

If you have two willing models, be sure to take some pictures of them shaking hands – this is a classic business image. Close-ups of the hands clasped together are the most popular, so frame the shot from the elbows down. Stick to a plain background, and use a slow shutter speed to record a little blur. Indoors, do

the same shot in tungsten light to add a warm colour cast.

... and shopping
Panning at slow shutter speed can also be used for a series of 'shopping' pictures, where your subject swaps a business suit for casual clothing and you photograph them on busy streets or inside shopping centres (malls) laden down with bags or piled high with boxes. Supermarkets are also great locations for pictures related to consumerism. Ask permission to visit out of hours, when the aisles are empty and the shelves stacked high, then take panned shots of both male and female subjects carrying baskets or pushing shopping trolleys.

One shot you see time and time again in stock catalogues is of a frustrated mother (or father) pushing a fully laden shopping trolley down the aisles of a supermarket with a young child sitting in

143

the front. The best way to take this is by clamping your camera and a wide-angle lens to the front of the trolley, pointing towards your subject. You follow the trolley from behind the camera and trip the shutter with a remote release. By shooting at a shutter speed of ¼–½ second, the shelves either side of your subject will blur, but he or she will record in sharp focus because the camera remains at exactly the same distance from them throughout the exposure due to its fixed position. Try using flash on a few frames, too, to produce interesting slow-sync flash effects.

Once you start taking pictures where your subjects are clearly identifiable, two factors must be considered. First, they need to have the right 'look'. Generally, both men and women must be young(ish) – mid-twenties to late thirties – attractive, intelligent-looking and suitably dressed for business. Secondly they must sign model release forms (see page 81).

The hiring of professional models is an expensive proposition – you should expect to pay around £40 per hour plus expenses on average for a model outside London – so try to use your relations, friends or colleagues where possible.

In the office

If you already go to work in a business environment you will be at a distinct advantage because you can use all the facilities there – such as computers, switchboards, meeting rooms and the general office environment – as a backdrop. Colleagues, already dressed in suitable clothing, will make ideal models and you can take pictures during the lunch break, or outside office hours. If you don't work in an office, and don't have access to one, then make use of friends and relatives who do. Failing that, you will have to knock on doors and ask permission, or set up a suitable environment in your own home or in a studio.

Once the setting is right, all kinds of

Kathy Collins shot this picture of the trading floor at La Bourse, the Paris Stock Exchange. A lot of negotiating was required before permission was received from the powers that be, but it was worth the effort because despite being taken several years ago, this image is still selling.
Camera: *Nikon SLR* **Lens:** *85mm*
Film: *Fuji Velvia*
Exposure: *⅙₀ second at f/4*

pictures can be taken, so come up with a list of ideas that you can gradually work through. Begin with tight portraits, using a telephoto or telezoom to fill the frame and a wide aperture to throw distracting elements out of focus. Capture your subject looking at a computer monitor so that the light it gives off illuminates their face; or talking on the telephone in both a relaxed and angry manner as if a deal is turning sour; rubbing their forehead as if stressed, or with one hand across their mouth as if deep in thought; reclining on

their office chair, hands behind their head and feet on the desk; working at a laptop computer, and so on.

If you are in an office where there are banks of computers, then use them as foreground interest to lead the eye towards your subject. Partially obscuring your subject with office equipment, or shooting between objects, can also create a strong visual effect.

Office lighting tends to be fluorescent, which means that pictures taken on daylight-balanced film will have an ugly green cast. Shooting in black and white is the easiest way to avoid this problem, or shooting in colour and having the film cross-processed – you should try both these things anyway, for creative rather than technical reasons. If you want natural-looking colour shots, either shoot close to a window so that daylight is the predominant source, set up studio flash, or use filters to correct the green cast – an FLD or CC30 magenta gel will do a reasonable job.

Pictures of meetings can be big sellers, but logistically they take a lot of setting up and you need to get everything spot on, so initially at least you will be better off concentrating on more accessible shots and working with just one or two people.

State-of-the-art office buildings with huge open spaces and glass walls make great locations in which to set up shots of your subject walking through the scene carrying papers or a briefcase as if *en route* to a meeting, or chatting to a colleague on a landing.

... and outside

Outdoors, take pictures of your subject chatting on a mobile phone against the backdrop of an office building – use a telephoto lens and shoot from a distance, then move in close and shoot from a low viewpoint with a wide-angle lens in order to show the building

towering up behind your subject.

While you're outdoors, look for an expensive car in the office car park and set up some shots with your subject posing near it, or ask them to sit inside their own car while you take pictures of them supposedly chatting on a mobile or using a laptop computer. Again, ordinary, accessible shots, but by shooting from unusual viewpoints and using differential focusing to concentrate attention on your subject, it's possible to produce stock images that will sell and sell.

Pictures that depict business scenes can be huge sellers, so it's worth going to the effort of finding suitable locations into which models can be placed.
Camera: *Canon EOS1n*
Lens: *70–200mm at 135mm*
Film: *Kodak Ektachrome E100S*
Exposure: *⅟₆₀ second at f/2.8*

LIVE PICTURES
BUSINESS PORTRAITS

This shoot was set up in the offices of *Practical Photography*, a magazine I write for and supply with pictures. I have had close ties with *PP* for over a decade now – before going freelance I was assistant editor for a couple of years – so I know the team and the facilities well.

My subject in these pictures is the magazine's features editor, David Corfield, who kindly agreed to sacrifice a lunchbreak so that I could take them (in return for a Big Mac and Coke!) The idea for the shoot was to produce a selection of different business images using various photographic techniques, but as the dress code for the office is very casual and no one wears a suit, I knew I would have to take mainly tightly cropped portraits to overcome this.

With only an hour available I also knew I would have to work quickly to make best use of the limited time, so beforehand I came up with a list of simple picture ideas, all making use of available light.

One thing I decided while flicking through stock catalogues to get a feel for the type of pictures used is that both men and women tend to look more businesslike and serious when wearing spectacles. David doesn't wear them himself but my wife does, so I took along a couple of her spare pairs – unisex designs by Giorgio Armani and Dolce & Gabbana – which he could wear for some of the shots.

Equipment was kept to a minimum – just a single 35mm SLR body and three lenses – plus colour slide, colour negative (for cross-processing) and black and white film. Arriving at the office just before 1pm, I didn't have to wait long before the editorial team disappeared for lunch, leaving David and I to get on with the task in hand.

Against the clock

The first shot I tackled was a tightly cropped black and white portrait of David looking at a computer monitor. I shot from slightly behind the monitor so that I could include part of it in the picture, and set my 80–200mm zoom to 200mm and f/2.8 to fill the frame and minimize depth-of-field.

All David had to do was sit tight for a couple of minutes while I captured him on film. I used Ilford XP2 film for this shot so that I could get the shots processed quickly at a local minilab.

Next, I decided to photograph him chatting on his mobile phone, so I positioned myself across the office and included a pile of files on a nearby desk in the shot – knowing they would be thrown out of focus with the zoom at 200mm and f/2.8. To encourage an animated expression, I asked him to have a conversation with someone sitting opposite and I fired off a dozen or so frames.

With that shot in the bag, I gestured towards a slide-viewing lightbox and suggested we try a few shots there. Lightboxes make a great light source and I took a range of pictures, in black and white and colour, of David lit from beneath by the illuminated panel.

The third idea was for a series of head shots of David looking stressed – a pose he had no problems striking! These were all shot in windowlight using Agfa Optima

The first shot of the session – a simple portrait of my subject looking at his computer monitor.

Mobile phones are an essential part of business life today, so it makes sense to include them in some of your shots.

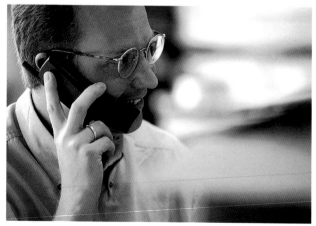

200 colour print film, which I would later have cross-processed to produce some wacky effects. We tried hand over mouth, eyes closed, eyes open and various other poses, and I shot handheld from close range with a 105mm macro lens at f/2.8 to give minimal depth-of-field. I also bracketed exposures 2 stops over and under the metered exposure, in ½ stop increments, mainly because I had never used this particular film for cross-processing before, and every film responds to the treatment differently.

With time running out, I finished the shoot by taking a sequence of panned pictures of David walking across the office, using colour negative film which was later cross-processed.

The idea was to try to capture a sense of the fast pace of modern business, so I used shutter speeds ranging from ⅟₁₅

ABOVE This is the shot taken of David leaning over a lightbox. I am not sure if it will sell, but I like the lighting effect.

second to ¼ second to add plenty of blur.

Finally, I finished off rolls of black and white and colour slide film by shooting close-ups of David punching a number into his mobile phone. For some I asked David to move his fingers and I shot

TECHNIQUE TIPS

- Lunch hour is the best time to take pictures like this as most people will leave their desks, so you can work in peace and quiet.
- Come up with a list of picture ideas beforehand – look through stock catalogues to see which themes keep cropping up time after time and try to interpret them in a new way.
- Experiment with different photographic techniques. Black and white and cross-processing are very fashionable at the moment. Both these techniques will also avoid problems of colour casts caused by interior office lighting – usually fluorescent.
- Take variations of the same idea so that your picture library has a choice of shots.

handheld at slow shutter speeds to blur the image, while for others I mounted the camera on a tripod and asked David to keep his hands still for sharper results.

Despite the shortage of time, I managed to put a range of ideas into practice, and I was more than happy with the results – many of which have already been posted off to my picture library.

Working in a cluttered office with an amateur model could never be described as easy, but if you start out with a few firm ideas in mind, it's surprising what you can come up with under less-than-ideal circumstances.

EQUIPMENT AND TECHNIQUE

Camera: Nikon F90x 35mm SLR
Lenses: Nikkor 80–200mm f/2.8 zoom and 105mm f/2.8 macro
Tripod: Gitzo Studex
Film: Fujichrome Sensia 100, Ilford XP2 Plus, Agfa Scala 200, Agfa Optima 200
Filters: None
Lighting: Windowlight and office fluorescent lighting

Expert view: Derek Croucher

Derek Croucher has been a full-time professional photographer for ten years. He takes pictures on commission for a range of clients, but for the last six years has also been heavily involved in stock photography. Today his work is marketed worldwide by several leading libraries which together hold upwards of 20,000 of his pictures.

La Defense, in particular La Grande Arche, in Paris is Derek's favourite financial district thanks to its superb modern architecture and open spaces.

'When I first started out as a professional photographer I took on all kinds of work, from shooting building sites to portraits of businessmen. All that changed, however, when I heard about picture libraries and how they operated, and these days most of the work I do is stock.

'My main interests are nature and landscape photography, but I began to see that big money could be made from pictures of financial centres so I started photographing them as well. The stock market is saturated with landscapes and travel shots, but not with business and financial photography.

'In recent years I've photographed a number of important financial centres, including London, Paris, Frankfurt and Toronto. The pictures I take are mainly architectural – of financial buildings such as the Bank of England in London, Deutschebank in Frankfurt, La Grande Arche in Paris. I also shoot street scenes, skylines and so on.

'When I plan one of these city trips I put a lot of effort into researching what to photograph and where to photograph it from. My libraries offer some guidance as to the type of shots they want, but I also look at books, brochures and stock catalogues to get an idea of the most popular viewpoints. I also get hold of street maps so I can determine which direction the most important buildings face, and from that, the best time of day to photograph them.

'As well as taking pictures during the day, I also shoot a lot at night – in the short twilight period when there's still

This is the Deutschebank building in Frankfurt, Germany, captured in perfect light with a large-format camera.

some colour in the sky. Many important buildings are floodlit, and city skylines can look amazing. Shooting at night is also a good way of avoiding people and traffic, which can spoil the view during the day. If people are moving through the scene at night, they won't record because you need to use such long exposures – usually 30 seconds or more.

'For pictures of buildings I use a Linhof Technikarden large-format camera, usually with a 6x9cm back, so I can correct converging verticals. I also have a Mamiya RZ67 medium-format camera with a range of lenses.

'My favourite film, surprise, surprise, is Fuji Velvia, though I also use Fuji Provia 100 when I need extra speed and to reduce exposure times when shooting at night.'

BEST SELLERS

CREDIT CARDS

Taking this shot was simplicity itself – I selected three credit cards from my wallet, laid them on a sheet of yellow card on my kitchen table and fired away with my lens set to maximum aperture so that only a small area would be in sharp focus.

What makes it sell?

The bright colours and use of differential focusing give it a stylish look, though the fact that the Visa, Mastercard and Midland Bank logos are clearly visible has undoubtedly hindered sales. Also, Midland Bank has changed its name recently to HSBC, rendering this image unsaleable. Still, not a bad return on two minutes' work.

FACTS & FIGURES

Equipment *Nikon F90x, 105mm macro*
Lighting *Windowlight*
Film *Fujichrome Sensia 100*
Number of sales to date *3*
Catalogue image? *No*
Where sold *UK*
Used for *Magazine, mailer*
Total sales to date *£215*

£1 COINS

This photograph was taken a couple of years ago as part of my first set of stock currency shots – I 'bought' a selection of UK £1 coins and various new, unmarked bank notes from my bank and then spent a day photographing them in different ways. It was an experiment really, to see if I could shoot financial still-lifes that would sell, and although the returns haven't been enormous, sales from this shot alone have more than paid for my time and the materials used.

What makes it sell?

An established, general picture library will have hundreds, if not thousands, of currency shots on its files and in stock catalogues, so it's impossible to know if any you take will sell. This shot is very clean, simple and well lit, but at the end of the day it's down to the personal taste of the picture buyer.

FACTS & FIGURES

Equipment *Nikon F90x, 105mm macro lens*
Lighting *Windowlight*
Film *Fujichrome Velvia*
Number of sales to date *7*
Catalogue image? *No*
Where sold *UK, Canada*
Used for *Magazine, newspaper editorial, corporate audio–visual/CD/video, CD cover, mailer*
Total sales to date *£415*

PERSONAL ORGANIZER

Items that are used in business, such as the obligatory FiloFax and mobile phone, are popular stock subjects, which is why I took this picture. Rather than go for a 'sharp, shiny' effect, however, I decided on a more romantic interpretation and used fast, grainy film, and lit the still life using a tungsten reading lamp to add the warm cast.

What makes it sell?

It's a little different to the norm, which some picture buyers clearly prefer, and oozes warmth and atmosphere – business isn't always cut and thrust, so a more sympathetic view of it is often required.

FACTS & FIGURES

Equipment *Nikon F90x, 105mm macro lens*
Lighting *Reading lamp*
Film *Fujichrome Provia 400 rated at ISO1600 and pushed 2 stops*
Number of sales to date *5*
Catalogue image? *No*
Where sold *UK, France*
Used for *Magazines, mailer, newspaper supplement*
Total sales to date *£275*

TRANSPORT, INDUSTRY AND SCIENCE

Industrial photography is a very broad discipline that takes in many different subjects. One thing is for certain, however – it can be highly lucrative.

I know of several freelancers who have made large sums of money by taking pictures on the advice of their libraries that they wouldn't have normally considered – landscape specialists asked to shoot petrochemical plants and cooling towers, and travel photographers managing to capture environmental issues on film or photographing transport.

The beauty of 'industrial' photography is that it covers many subjects which are accessible to all, so you don't have to embark on ambitious expeditions or invest large sums of money to take saleable pictures. In fact, many can be taken in the comfort of your own home, using props that are already to hand – the key is to use your imagination and interpret the subject in new and innovative ways.

Transport

Transport is a wide-ranging theme that any photographer can shoot – you only have to walk down a busy street to see cars, buses, taxis and trucks. Trains, aircraft and ships can also be lucrative stock subjects, plus police cars, fire engines and ambulances answering emergency calls.

The thing to bear in mind is that your pictures must be generic if they are to have wide appeal. Picture buyers don't usually want to know the make or model of the vehicle you are photographing; nor will they accept details that date a shot or suggest where it was taken, such as registration plates and tax discs. Avoid including these things by shooting from a low viewpoint or capturing a side view.

This panned shot of a bright red double-decker bus at Piccadilly Circus in London is typical of the type of transport picture that always sells – simple, bold and colourful.
Camera: *Olympus OM4-Ti* **Lens:** *35–70mm*
Film: *Fujichrome Velvia*
Exposure: *⅛ second at f/22*

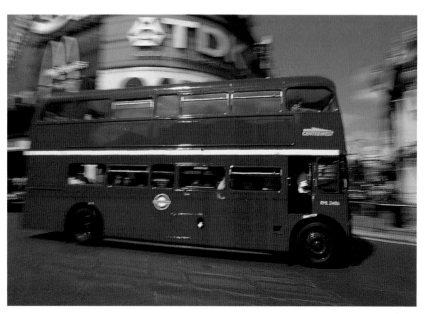

Alternatively, if you are setting up a shot, remove the plates and discs.

Panning is a popular technique, as it not only adds a powerful sense of action to a picture but the blurring will also help to obscure unwanted details. For vehicles travelling at high speed, try panning with shutter speeds of $\frac{1}{125}$ second or $\frac{1}{250}$ second initially, then try slower shutter speeds once your skills have improved. Also, remember to include details in the shot such as trees and foliage that will look effective when blurred.

Alternatively, mount your camera on a tripod so that it's sturdy and then use a slow shutter speed to photograph passing vehicles. That way, the background will come out sharp but the vehicle will blur –

by varying degrees, depending on the speed at which it's travelling and the shutter speed you set. Try speeds from $\frac{1}{60}$ second to $\frac{1}{2}$ second – the slower it is, the more blur you will get.

Finding suitable subject matter is easy – just set yourself up near a busy road and it will be in constant supply. Remember to take care, however, as roads can often be dangerous places – use a telephoto lens so that you can fill the frame from a safe distance. Bridges over roads, motorways and railway lines also make ideal vantage points and you can look down on passing traffic.

As well as the vehicles themselves, shoot related subjects. Traffic congestion is a major problem in big cities, so pictures of

This dramatic picture shows a ship moored beneath the famous Tyne bridge in Newcastle-upon-Tyne. Taken in late afternoon sunlight, it characterizes heavy industry in the north-east of England, an area renowned for both its bridges and its shipbuilding.
Camera: *Pentax 67* **Lens:** *165mm*
Film: *Fujichrome Velvia* **Filters:** *81B warm-up*
Exposure: *$\frac{1}{60}$ second at f/16*

traffic jams at rush hour are always being requested – use a telephoto lens to emphasize the crowding effect. Other ideas include a wheel on double yellow lines, parking meters, a traffic warden issuing a parking ticket, a wheel clamp in place, a car being refuelled, a close-up showing fumes coming from a car's exhaust, cars

that have been involved in accidents and so on. I even spent a fruitful couple of hours at a local car breaker's yard, shooting rusting old cars waiting to be scrapped, piles of old car tyres and so on.

Photographically, many of these subjects are rather uninspiring, but if you use your imagination it is possible to take interesting pictures of them. Try shooting from unusual viewpoints, or experiment with techniques such as cross-processing or differential focusing.

Rail and sea

Rail travel provides further opportunities, and if you spend a morning in a busy railway station you will be surprised at the number of different pictures you can take.

Arrive before rush hour so that you can photograph crowds of commuters spilling off arriving trains and hurrying along the platform. Use a telephoto lens to fill the frame, and a slow shutter speed – $\frac{1}{4}$–1 second – to blur all those scurrying feet and swinging arms. A high viewpoint is ideal for this type of shot, though you can take good pictures from platform level, too.

Stationary trains with sunlight glancing along the carriages look attractive – use a telephoto lens again to fill the frame. For trains passing through the station without stopping, use a slow shutter speed and pan the camera. The same applies with trains pulling out of the station after picking up passengers. They move slowly at first, so to give an impression of speed use a shutter speed of $\frac{1}{4}$ second or even $\frac{1}{2}$ second and pan quite swiftly.

Shipping is another subject well worth shooting if you live close to a port, or are willing to travel. Container ships tend to be the most popular, so make them your priority. Take wide-angle shots from the quayside, looking up to the towering vessels and using the mooring ropes and chains as foreground interest, or home in

on the stacks of containers that are waiting to be unloaded.

Ports can look beautiful at dawn and dusk, when golden sunlight glances off moored boats, and gigantic dockside cranes and bridges are thrown into silhouette – use a telephoto lens to compress perspective, and make a feature of this. Or wait until nightfall, when powerful floodlighting is switched on to light up the docks and creates pools of vivid colour against the ever-darkening sky.

Roads

Success, advancement, the journey ahead, direction, optimism, the future – roads have great symbolic power, making them a

Railways can be atmospheric. I took this picture on a misty winter's morning using a 300mm lens to compress perspective and emphasize the complicated network of cables over the tracks.
Camera: *Olympus OM4-Ti* **Lens:** *300mm*
Film: *Fujichrome 400 rated at ISO1600*
Exposure: *⅟₆₀ second at f/8*

popular subject for advertising, marketing and promotional use.

Long, straight roads stretching as far as the eye can see are the most powerful. To emphasize this effect, stand in the middle of the road and use a wide-angle lens with a focal length of 28mm or less, so that the parallel sides of the road converge dramatically to the horizon. You should also include the 'vanishing point' – the point at which these lines seem to meet in the distance – and shoot at a small aperture to keep everything in sharp focus.

For something different, tilt your camera over to an angle of 30–45 degrees so that the central line in the road appears from one corner of the picture, and shoot some frames with the camera on its side so that you can include more road and sky.

Countries such as the USA and Australia, where roads cover vast distances in areas where the landscape is perfectly flat, are the best places to take these classic shots. Saying that, you can find them in the UK, too – the flat Fenlands of East Anglia are a good place to look. I also photographed several during a trip to Morocco.

Ideally, the road surface should be in good condition to heighten the graphic simplicity of the scene – though many photographers now tidy up their pictures

digitally to remove tyre tracks or make the road markings cleaner.

In the country

Country roads and lanes are another popular option. Straight sections lined with trees make great pictures, and by using a telephoto lens you can compress perspective so that the trees seem much closer together. Shoot from the middle of the road itself so the trees recede into the distance, and from one side.

For winding country roads, use a telephoto lens again to emphasize the

Traffic trails can be captured on any busy road – here I shot from a bridge overlooking a dual carriageway just a couple of miles from my home.
Camera: *Nikon F90x* **Lens:** *28mm*
Film: *Fujichrome Velvia*
Exposure: *90 seconds at f/22*

bends, or find a higher viewpoint where you can look down on the road and clearly see it meandering across the landscape. In both cases, wait until the road is free of traffic – empty roads tend to sell better.

Unless, that is, you intentionally want to include traffic, of course – traffic congestion is a much-discussed topic these days, so pictures which illustrate it are always required. Any motorway or dual carriageway leading into a major town or city will provide just what you need during

Wherever you are, keep your eyes peeled for interesting roads and never overlook the opportunity to shoot one. Sales from this picture, taken in southern Morocco, have already gone a long way towards paying for the whole trip.
Camera: *Nikon F90x* **Lens:** *21mm*
Film: *Fujichrome Velvia* **Filters:** *Polarizer and 81B warm-up* **Exposure:** *⅛ second at f/16*

weekday mornings, and leading out in the evening. Monday mornings and Friday evenings are the two busiest periods of the week.

Another technique worth trying with country lanes is to shoot from a moving vehicle, using a slow shutter speed so that the road and anything you pass while shooting will blur, capturing a dramatic sense of speed and motion. Open-top (convertible) cars are perfect for this, but you can also take great pictures from the open boot (trunk) of a car, or by standing on the rear seat and shooting through an open sunroof.

Choose a quiet location where your companion can drive the car up and down several times while you shoot, and ideally use a stretch of road that's lined with trees as you need something obvious in the shots to blur. You don't need to be travelling very fast – 30kmph (20mph) will be fine. The trick is to use a slow shutter speed – $\frac{1}{15}$ or $\frac{1}{8}$ second – so that you can capture an impression of great speed even if you're hardly moving. You could even take this type of shot while driving the car yourself – by attaching your camera to the back of the car using a sucker pod, and tripping the shutter using a long electronic release trailed back to the steering wheel.

Traffic trails

Finally, there are traffic trail shots, taken at night so that the head and tail lights of moving traffic record as continuous red and white light trails.

To capture traffic trails on film, all you need to do is find a viewpoint overlooking a busy road. It can be straight or winding and have any number of lanes; the main criterion is that at dusk, when the sun has set but there is still colour in the sky, the road comes alive with rushing traffic. In the UK and northern America, winter is an ideal time to shoot traffic trails because rush hour coincides with dusk, whereas

during the summer the sun doesn't set until 9 or 10pm, by which time most roads will be too quiet.

Once you have found a suitable location, all you have to do is open the shutter for 30 seconds or more while traffic passes beneath. Use a wide-angle lens if you're looking along a road or motorway, so that the traffic trails create colourful converging lines stretching off into the distance, or pick out a particularly busy section of road with a telephoto lens.

A word of warning: if you do need to stand on a road to take pictures, be extremely careful. As a minimum, make sure you can see clearly both in front and behind you, and listen for any approaching traffic. Better still, take a friend along who can be your eyes and ears while you are busy taking pictures. I have never heard of a photographer being injured or killed while photographing a road, but there's always a first time.

Heavy industry

No stock catalogue would be complete without a selection of shots depicting heavy industry, but they're not included merely to look nice – industrial photography always sells in a big way.

Anything to do with energy generation can be particularly lucrative, so this is one reason whey petrochemical plants, nuclear power plants and cooling towers should be on the top of your list.

The first two are still few and far between, so give your picture library a call and ask which ones they've got shots of so you know roughly where they are. You can then plan to photograph one during a trip to the area – or you may discover that there's something suitable within a reasonable distance of your home.

Pictures taken both during the day and at night sell – night shots tend to look more dramatic because the plants are lit up and you can record smoke from the chimneys drifting into the sky. Don't worry about getting too close – most plants are so enormous that you need to be some distance away to capture the

Generic industrial images are in constant demand for both editorial and advertising use. This photograph of a sugar factory belching smoke into the atmosphere was captured at sunrise to simplify the scene and increase its saleability.
Camera: *Olympus OM2n* **Lens:** *200mm*
Film: *Fujichrome Velvia* **Filters:** *81B warm-up*
Exposure: *$\frac{1}{30}$ second at f/11*

You don't have to photograph huge industrial plant to produce saleable stock images – small-scale operations such as welding and engineering can be just as effective.
Camera: *Nikon F90x* **Lens:** *50mm*
Film: *Fujichrome Velvia*
Exposure: *½ second at f/4*

In all cases your aim should be to capture the essence of the operation in a single image, so make that your priority.

Be constructive

Then there's the construction industry, of course. Everywhere you look in this day and age there are new buildings being constructed. City skylines are often littered with huge tower cranes, areas of vacant urban land are developed for residential housing, while new factories and warehouses are forever appearing on industrial estates.

Shots of building work in progress with half-built walls or skeletal steel frames are worth shooting, along with cranes and plant silhouetted against the sky at sunset, complicated scaffold designs, piles of building materials and so on. Keep your pictures simple and as generic as possible, avoiding trademarks or business names. Use a wide-angle lens from a low viewpoint to create dynamic compositions and shoot in bright, sunny weather. A telephoto or telezoom lens can also be used to home in on interesting details or to capture construction workers in precarious positions, such as on the end of a steel beam high above the ground or clinging to a scaffold tower.

Safety is uppermost in everyone's mind on construction sites, so you may not be allowed access, especially on large-scale or industrial sites. However, there's usually plenty of building work going on in the heart of towns and cities which you can

whole thing, and by keeping well clear of the plant's perimeter you will avoid possible confrontation with guards. The security at these plants tends to be very tight and the management don't like to see photographers wandering around, taking pictures without permission – I was almost arrested a few years ago while photographing a local power station at night.

Anything else to do with energy is well worth shooting, too – towering gasometer plants, electricity pylons, solar panels on buildings, smoke billowing from factory chimneys, wind turbines, hydroelectric

schemes, and so on – the list is endless.

Getting inside factories and plants to photograph work in progress requires more effort, because you will need permission from the management, and the red tape can be frustratingly difficult to break through. It's well worth trying, though, and you can always offer free use of some photographs in return for being allowed access.

Steel works and foundries are particularly dramatic, but print works containing huge presses, engineering plants, car production lines and any other type of heavy industry is worth considering.

I noticed this 'Men at Work' sign while driving through roadworks, so I stopped and shot it against the vivid blue sky to create a simple, graphic image.

Camera: Olympus OM4-Ti

Lens: 28mm

Film: Fujichrome Velvia

Filters: Polarizer

Exposure: 1/30 second at f/8

shoot from close range without having to step on to the site itself. Failing that, a polite word with the site manager may get you in, especially if it's during a quiet spell when there's not a lot of activity, such as during the workers' lunch break.

Concepts

Finally, as well as pictures of obvious industrial subjects, there's a growing need for conceptual images which you can take without ever going near a factory or a powerplant.

Cogs, springs and wheels suggest heavy industry, for example. Fibre optics, circuit boards, electrical components and shiny compact discs imply hi-tech operations. Nuts, bolts, nails and screws are symbolic of the building profession, as are plans, technical instruments, hard hats and tools.

I have taken many pictures like this, using items from my own tool box or which I've picked up from local hardware stores. It's the way you photograph them that counts, so experiment with different lighting techniques and film types – the use of tungsten-balanced film and cross-processed film can make the most

mundane objects look visually interesting. A macro lens at maximum aperture to give shallow depth-of-field can be used to great effect here, as it can with other subjects.

Medicine and science

The most accessible pictures to take that fall into this category are pharmaceutical still-lifes of tablets and pills.

All you need to do is pop down to your local chemist or supermarket and buy a selection of pills that bear no trademark or symbol – they need to be completely generic to maximize photo sales and avoid copyright problems. Vitamin pills are ideal because they come in all shapes, sizes and colours. As well as plain pills, look for capsules that contain hundreds of tiny particles in a clear soluble shell – photographically they always look most impressive, and they appear far more lethal than they are.

To photograph the pills and capsules you will need a macro lens or extension tubes so that you can focus nice and close and fill the frame – I use a 105mm macro lens which can achieve lifesize (1:1)

reproduction. Lighting can be natural or artificial. I mainly use windowlight, but when I want to create a more colourful or unusual effect I use a 35mm slide projector and place colour slides in its light path to modify the illumination. Both types of lighting are continuous, so you can see exactly what you're going to get on film.

If you use your imagination it's possible to take a wide range of different pictures using just a small selection of props. Shoot each type of pill individually, then mix them together for yet more pictures. Vary the lighting and composition. Use different-coloured backgrounds. Take some shots with an empty pill bottle in the background so that the pills appear to be spilling from it, and so on.

Staying on the still-life theme, there are numerous objects you can get hold of that imply medicine or science.

The chances are you already have a thermometer for taking body temperature, and a first-aid kit with plasters, bandages and so on. If so, how about taking a series of pictures of one of your children having their temperature taken, accepting a spoonful of medicine, a close-up of their knee with a plaster on it?

Glass measuring beakers, cylinders, pipettes and other apparatus could be obtained from a medical supplier and photographed, first in turn and then together as a group. Keep pictures like this simple, perhaps shooting them on a plain background and using tungsten-balanced film so that your pictures have a cool blue cast. You don't have to photograph the whole object either – move in close and concentrate on just a small area such as the measurement scales.

Preganancy and birth

Pregnancy is always a big seller, so any opportunity you have to capture it on film would be well worthwhile. We have already discussed photographing newborn babies in Chapter 5 (see page 79). However, there are other ways to approach the subject.

If you have a wife, relative or close friend who is pregnant, you could take a camera along to one of your partner's scan appointments and photograph the image of the unborn baby on the ultrasound monitor – or have a printout of the image made and photograph it at home. Pregnancy tests showing positive are also very symbolic of pregnancy – and can be mocked up if necessary.

Taking pictures of the actual birth isn't impossible, though you would need to get clearance from the midwife – and the mother – before doing so, and keep out of the way during the delivery. But even if you elect not to capture this momentous event on film, there are always shots to be taken of the baby as soon as it is born, and of it being washed and weighed.

Other shots

If you happen to work in a hospital or medical practice, then you will have the opportunity to photograph many other subjects: X-rays being examined, medical procedures such as plaster casts being applied to broken limbs and so on, though obviously you will need to seek permission first.

Beyond that, things start getting complicated. Stock catalogues often feature dramatic hospital scenes where casualties are being rushed through wards on a trolley, paramedics are attending a road accident victim or a doctor is rushing to a medical emergency. However, more often than not these pictures have been set up using models, at great expense, and are not worth considering if you shoot stock part-time – the logistics and cost are just too great, and it's possible to make just as much money through the sale of simple, conceptual images.

Here's a good example of an industrial concept. The screws were photographed indoors in windowlight. I used tungsten-balanced film to create the blue colour cast, and overexposed to burn out the highlights.
Camera: *Nikon F90x* **Lens:** *105mm macro*
Film: *Fujichrome 64T* **Exposure:** *¹⁄₆₀ second at f/2.8*

This medical still-life was set up on my kitchen windowsill and lit using windowlight. I had previously bought the props – vitamin C capsules – from my local chemist, and the shot has since been selected for catalogue use by my picture library.
Camera: *Nikon F90x* **Lens:** *105mm macro*
Film: *Fujichrome Velvia* **Exposure:** *¹⁄₁₅ second at f/2.8*

LIVE PICTURES
RECYCLING

With the world's natural resources being depleted at an alarming rate and mountains of unnecessary refuse growing by the day, recycling has become big business. Governments and local councils regularly launch campaigns to raise the public's awareness of the need to recycle materials such as glass, plastic and paper, the subject is discussed in newspapers and magazines on an almost daily basis, and picture libraries constantly receive requests for pictures that show recycling in progress.

When a recycling plant opened in my home town a few months ago, I was therefore very eager to exploit the photo opportunities it might offer and promptly wrote to the manager asking for permission to visit the site and take photographs.

While waiting for a response I began researching the subject in more detail, looking through stock catalogues to see what type of images are favoured, and phoning my picture library to see if they had any specific requirements. Then a week or so later I was given the go-ahead.

Site visit

The majority of the pictures shown here were taken during a single afternoon at the plant. I waited for a bright, sunny day before visiting as I wanted to make a feature of the colours and patterns of the materials.

I also decided at an early stage that I would shoot everything on 35mm, so that I could work quickly and freely, and use a range of different lenses. You don't really need a bigger format for a subject like this, so it seemed silly to shoot medium format which costs far more per shot than 35mm.

When I first arrived I spent a little while

The neatly compacted bales of plastic, paper and aluminium cans made great details shots.

wandering around, getting a feel for the place and establishing exactly what there was to photograph. Most of the materials had been compacted into neat bales and then stacked in huge towers ready for recycling – coloured plastic bottles, clear plastic bottles, brown paper, coloured paper and crushed aluminium cans, all stacked in separate areas.

My first task was to shoot these materials in turn, first using an 80–200mm zoom to take frame-filling detail shots of the bales, and then switching to an 18–35mm zoom to take

wide-angle pictures of the towering bales. Nothing fancy – just straightforward, unfiltered shots.

Once I had photographed all the different materials, I then moved over to an area that had still to be sorted and was a mish-mash of cans, tattered plastic sheeting, chemical drums and all kinds of rubbish. This gave a more negative insight into refuse dumping which contrasted nicely with the neat bundles of materials that had been carefully sorted and compacted. I also found an area where chemical drums were piled up, so I spent a little while shooting them and looking

I used an 18–35mm wide-angle zoom to capture these towering bales of coloured paper against the sky.

This mountain of recycled glass was photographed first with a wide-angle lens, then a telephoto to home-in on a smaller detail.

for details on the barrels such as warning messages or symbols indicating that the contents were hazardous – nothing to do with recycling, but with a strong environmental message and therefore a viable stock shot.

Finally, I moved on to an area where there were mountains of broken glass ready for recycling and took a series of both wide-angle and telephoto shots.

In the space of three hours I had shot over 200 new stock pictures. Within two days I'd had the films processed, completed a loose edit to weed out any technically inferior shots, and mailed the rest to my picture library for selection. Several have since been selected for catalogue use, and although I have yet to make any sales, I am confident these pictures will show a good profit very soon.

EQUIPMENT AND TECHNIQUE
Camera: Nikon F90x 35mm SLR
Lenses: 18–35mm, 50mm, 80–200mm
Tripod: Gitzo Studex
Film: Fujichrome Velvia
Exposure: $\frac{1}{60}$ second at f/11 to f/16

TECHNIQUE TIPS

• Most large towns and cities have some kind of recycling system in operation. If you're not sure, phone your local council or check through your local telephone directory.

• Explain what you want to do and emphasize that you will not include the company's name or logo in any pictures. You shouldn't do this anyway, as it will make the pictures less commercial. I took along a stock catalogue and pointed out the type of pictures I wanted to take.

• Bottle, paper and clothing banks can also be found in most towns and cities – you could take shots of your kids or a friend depositing materials in them.

• Set up recycling still-life shots using suitable items – old newspaper, cardboard boxes, empty wine and beer bottles, aluminium cans, plastic detergent bottles and so on. Remove any labels so that no brand names are visible.

Barrels and chemical drums make good stock subjects as they always suggest something hazardous.

Expert view: Granville Harris

Granville Harris has worked as a commercial photographer in Leeds for the last 32 years. He began shooting stock landscape and travel images in the early 1980s, and for the last decade has also dedicated much of his spare time to heavy industry and transport photography.

'I started shooting industrial stock pictures when I realized that there were few photographers doing it. I'm involved in industrial photography on a day-to-day basis, so over the years I've built up a network of contacts and it was relatively easy for me to find suitable subjects.

'I also got a lot of encouragement from my picture library. When I first joined they were still finding their feet, so there were a lot of gaps in the files and I would receive 'wants' lists asking for shots of textiles, shipping, heavy engineering, transport and all sorts of industrial subjects.

'Leeds is a good place to be for this kind of photography. The M62 is ideal for transport and traffic trail shots, and there's a lot of heavy industry in the surrounding area. I have photographed steel works in Sheffield on several occasions, petrochemical plants on Teesside, paper mills, timber yards, food production lines, the ICI works, and travelled down to Southampton to photograph the docks at the request of my picture library.

'Some subjects, such as petrochemical plants and power stations, can be photographed from roads and footpaths, so it's simply a case of finding a suitable viewpoint. Many require permission, however, and that's getting more difficult these days.

'I usually begin by making a telephone call to find out who I need to speak to, then I explain to that person what I want

ABOVE LEFT Traffic trails on the M62 motorway have been a reliable earner for Granville – this one has sold 52 times to date and is still going strong.

LEFT This shot, taken in a steel works, sums up the whole industry in a single image – which is probably why it has sold 48 times to date.

to do. Offering free use of some of the pictures usually helps, and I put my request in writing to make it official if necessary.

'The reaction you get varies. Usually people are great, but occasionally your request is treated with suspicion and turned down. It's a case of persevering until someone says yes. I subscribe to a regional business magazine covering Yorkshire and Lincolnshire and that provides me with some useful leads such as new companies trying to get established, or businesses promoting the fact they have installed new equipment. I read about one company that had installed robotic welding gear, for example, so I went along, photographed it, and the pictures have sold really well. Looking through your local *Yellow Pages* can also provide leads.

'These days I work in two formats – 6x7cm and more recently 6x17cm panoramic. I used a Pentax 67 system for the former, with 45mm, 55mm, 90mm and 200mm lenses – and occasionally hire a 300mm, 400mm or 500mm when required – while for Panoramics I use a Fuji GX617 with 90mm lens.

'Because I essentially work full time as a commercial photographer, I book days off when I want to shoot stock so I have to plan things carefully. I also make good use of the longer summer days to take pictures once the working day is over.

'It takes a lot of discipline to do this, but the rewards can be high and about half of my income now comes from stock. For example, one of my pictures of traffic trails on the M62 has sold 52 times, a shot of steel works 48 times, and last year I received £2,000 for a single sale of a picture of the cooling towers at Ferrybridge on the A1 in Yorkshire, which I'd taken five or six years ago.'

BEST SELLERS

TAXIS, PICCADILLY CIRCUS

I had gone to Piccadilly Circus primarily to shoot the famous illuminated advertising signs, then decided to finish off the roll by taking a few slow shutter-speed panning shots of taxis racing across the Circus with the lights in the background recorded as colourful streaks.

I had no idea if they would be successful or not, as action photography isn't my strong point. Fortunately, a couple of them worked really well and were promptly snapped up by my picture library.

To date I have only achieved a single sale, but luckily for me it happened to be a four-figure sum. The shots of the illuminated signs never did sell.

What makes it sell?
The sense of urgency and motion created by panning the camera undoubtedly helps, as does the fact that black cabs are instantly recognizable.

FACTS & FIGURES
Equipment *Olympus OM4-Ti, 35–70mm zoom*
Film *Fujichrome Velvia*
Number of sales to date *1*
Catalogue image? *No*
Where sold *UK*
Used for *Trade advertisement*
Total sales to date *£1,890*

RED SPORTS CAR

This shot was taken on the Honister Pass in the Lake District. I had parked my car by the roadside while I wandered off to take some pictures. As I walked back I was confronted by this beautiful view and fired off a few frames.

What makes it sell?
Undoubtedly the colours – red is the most popular choice for a car throughout the world. The shot also hints at a desirable lifestyle – taking your sports car for a spin in the country.

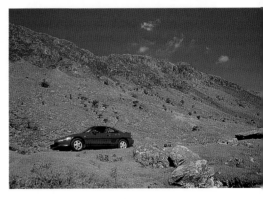

FACTS & FIGURES
Equipment *Olympus OM4-Ti, 21mm lens, polarizer*
Film *Fujichrome Velvia*
Number of sales to date *2*
Catalogue image? *No*
Where sold *UK*
Used for *Four-page mailer, photographic magazine*
Total sales to date *£200*

ROAD, GLENCOE

I had risen early to capture stunning dawn light over Rannoch Moor. Instead, I was confronted with the dullest, greyest morning imaginable. This shot was taken *en route* back to my hotel. I had doubts that it would ever sell, but I took it anyway – which is just as well, because sales from this shot alone have almost paid for the whole trip to Scotland.

What makes it sell?
Shots of long, straight roads can be big sellers – you'll see them in every general stock catalogue. This image works because the road had recently been resurfaced so the tarmac is clean and the white markings pristine. It also has a pleasant monochromatic quality.

FACTS & FIGURES
Equipment *Pentax 67, 55mm lens*
Film *Fujichrome Velvia*
Number of sales to date *4*
Catalogue image? *No*
Where sold *UK*
Used for *Brochure, commercial audio, video and CD*
Total sales to date *£320*

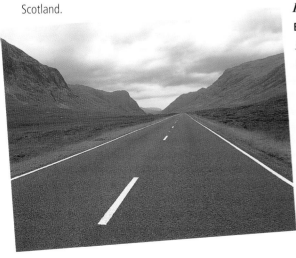

ANIMALS AND WILDLIFE

Wildlife photography is perhaps the trickiest of all stock subjects, not least because it requires a reasonable level of specialist knowledge to tackle successfully, and the subject matter can be notoriously difficult to capture on film.

At the same time, however, it can be a highly lucrative subject and as there are far fewer photographers shooting wildlife, compared to more popular subjects such as landscapes or travel.

If wildlife and nature photography is your main preoccupation, or you intend it to be, then it's advisable to look at placing your work with both specialized and general picture libraries.

Specialized nature libraries tend to be used by markets that require pictures of specific species, so they're ideal for large collections of images that may cover a subject in great depth. General libraries, on the other hand, are more interested in generic images, so they will only take the shots that they feel have a wide sales potential. By carefully picking and choosing which images go to which library, you can therefore maximize sales.

The other thing to consider is equipment. Given the technical difficulties of photographing most wildlife subjects, 35mm is accepted almost universally as the most practical format, so there is little point in going to the expense and trouble of shooting large formats.

Small wonder

In terms of subjects, let's begin with the smallest – and, in many cases, the most accessible. Insects, bugs, butterflies, bees, spiders, ladybirds – all these subjects appear with alarming regularity in stock catalogues, and most can be photographed literally in your own back garden.

Small subjects require close focusing, and to make that possible you will need some kind of macro set-up.

Bellows, extension tubes, close-focusing zooms and supplementary close-up lenses are all options, but by far the best means of filling the frame with small subjects is to use a macro lens with a reproduction ratio up to lifesize (1:1). I use a 105mm f/2.8 Micro Nikkor, which is superb, but independent lens manufacturers such as Sigma, Elicar and Tamron also produce excellent models.

You will also need a sturdy tripod to keep the camera steady and aid accurate focusing, a reflector or two and a cable release. Many nature photographers also use flash for close-ups as it solves two major problems. Firstly, the brief pulse of light will freeze any subject or camera movement to ensure you get sharp images. Secondly, flash will allow you to set smaller lens apertures. This is important because depth-of-field is severely limited at close focusing distances, although you can

I set up this amusing shot in my garden, placing a ladybird on the grassy stalk, waiting for it to crawl to the top, and then quickly taking the picture before it flew away. The background foliage was some distance away, which is why it's nicely blurred, and the end result is a simple yet effective stock image that has already achieved several sales.
Camera: *Nikon F90x* **Lens:** *105mm macro*
Film: *Fujichrome Velvia*
Exposure: *¹⁄₂₅ second at f/4*

Capturing the subject

Photographing such small subjects demands patience and skill, as most will take flight when you approach or never stay in one spot for any length of time.

The only way to overcome these problems is by trial and error, and learning as much as possible about your subject's habits and habitat. Armed with this knowledge you can then increase the odds of success – knowing that certain species of butterfly tend to frequent certain

produce stunning effects by shooting at maximum aperture so that only a tiny area is recorded in sharp focus. Even if you're photographing something like a butterfly from above, generally you will need to shoot at f/11 or f/16 so that its open wings are in the same plane of focus.

It takes great skill and lots of patience to take close-ups of this magnitude. The subject, a horsefly, measures just a few millimetres in real life, but by shooting at a reproduction ratio of ?x lifesize, Geoff Du Feu has revealed the amazing colours and patterns of its compound eyes.
Camera: *Canon E05 S* **Lens:** *Novartex bellows with 28mm reversed Canon lens*
Film: *Fujichrome Sensia 100*
Exposure: *⅙₀ second at f/11*

Simon Stafford photographed this common frog in his garden pond, setting the camera at a low angle so that he was looking directly across at this subject to capture its amazing eyes and the reflection in the still water. Critical focusing and careful choice of lens aperture have ensured the eyes are pin sharp while the background is thrown well out of focus.
Camera: *Nikon F5* **Lens:** *200mm f/4 macro*
Film: *Fujichrome Provia 100* **Exposure:** *⅙₀ second at f/4*

flowers, for example, or that dragonflies and damselflies tend to rest when the sun goes in, giving you the chance to capture them on film before they fly away.

You can also attract subjects to the camera by baiting them with food. Sugared water is favoured by butterflies, for instance, while flies will be unable to resist a small piece of fresh meat. Similarly, if you see a fly caught in a spider's web you can be pretty certain that a spider will be on the scene at any moment. All you have to do is set up your camera and wait.

Once a shot is set up and your subject is in position, use your camera's depth-of-field preview to check focus. This is not only helpful in confirming that everything you want to be sharply focused will be, but also to check that the background isn't brought too much into focus at the aperture you're using, otherwise it could take attention away from your subject. Using plain, uncluttered backgrounds can help here – foliage is ideal – but it isn't unknown for photographers to slip a sheet of coloured card behind their subject to provide an artificial background.

Slightly bigger

Reptiles such as frogs, toads, lizards and snakes are also popular stock subjects, and they can be photographed successfully both in the wild and in captivity.

I know one photographer who created a small garden pond for his young daughter which was quickly adopted by a colony of frogs. This was never his intention, but over the last couple of years he has taken many superb pictures of the uninvited guests. Another visited a local pet shop which kept various exotic lizards and iguanas, and with the owner's permission

was able to shoot amazing close-ups.

The easiest way to photograph reptiles and small mammals such as mice and voles is by constructing a 'vivarium', which is essentially a large glass tank like an aquarium in which you can create an artificial habitat. Vivariums are ideal because they limit the movements of the inhabitants so that they are easier to capture on film, and you can set up suitable lighting to ensure perfect results.

Flights of fancy

Birds may appear to be the most difficult subject on earth to photograph, simply because they tend to take flight before you get anywhere near close enough. However, life needn't be so difficult. Garden birds can be surprisingly tame, so if you attract them with food and conceal yourself it can be possible to take a frame-filling shot with nothing more than a 75–300mm telezoom lens.

Water birds such as ducks, geese and swans are relatively easy to photograph as they tend to congregate in large groups in parks, waterfowl centres, lakes and so on. Swans in particular are always worth photographing, as their grace, beauty and

poise is appreciated the world over.

Static shots are fine, but in-flight pictures tend to be far more dramatic and are likely to achieve a greater number of sales. Take slow shutter-speed panned shots of swans, ducks and geese taking off or landing, and use the same technique to photograph large flocks of birds so that you get lots of blur. Atmospheric backlit pictures and silhouettes taken at sunrise or sunset can also be good sellers.

For pictures of birds of prey, visit a local bird sanctuary or falconry centre. There you will find many species of bird and owl tethered to perches for the visitors to see, and it's usually possible to get within 1m (3ft) or so. Consequently, you can take stunning portraits of these magnificent birds with a telezoom lens, and by choosing an angle so that the bird is against a neutral background and shooting at a wide aperture it will be impossible to see that it was in captivity.

Pet subjects

High quality shots of cats and dogs can be good sellers, so if you keep any yourself, or you have family and friends who do, make the most of this by putting together a set of pictures. Local breeders are also worth contacting – in return for a few free prints, most will be more than happy to let you photograph their animals.

Shoot tight portraits of both cats and dogs, either indoors using studio lighting or outdoors in natural daylight. Think about the type of pictures you see

Pictures of swans are requested all the time by all manner of markets, so never miss the opportunity to photograph them. Geoff Du Feu gave this shot of a mute swan taking off an added twist by panning the camera to blur the background and its wing beats.
Camera: *Canon EOS/n* **Lens:** *70–200 with 2x teleconverter* **Film:** *Fujichrome Sensia 100*
Exposure: *1/60 second at f/11*

Dogs, cats, hamsters, ponies, guinea pigs, rabbits – domestic pets of all shapes and sizes make ideal stock subjects. This beautiful portrait of a Dalmatian by Geoff Du Feu illustrates the kind of standard you must achieve if regular sales are to be forthcoming.
Camera: Canon EOS 5 **Lens:** 100 macro
Film: Fujichrome Sensia 100
Exposure: 1/60 second at f/5.6

used to advertise pet food and pet products and then try to match that standard. For something different, move in really close with a 28mm or 24mm wide-angle lens to produce distorted images, with your subject's nose out of focus but its eyes pin sharp.

Puppy dogs and kittens are ideal for the kind of cute, cuddly pictures favoured by greetings card manufacturers. Photograph them curled up together asleep, nuzzling up to their mother or getting up to mischief. Flick through a few stock catalogues to get an idea of the type of pictures used, then try to better them.

Horses offer lots of potential for saleable stock shots – take telephoto pictures of them galloping across open fields and of young foals standing beside their mothers, and make the most of atmospheric weather conditions such as

early-morning mist or golden light at sunset to produce moody generic images. At closer range, use a wide-angle lens from a low viewpoint to capture your subject towering against the blue sky, or move in really close as it chews on a mouthful of hay, showing off its enormous teeth.

All at sea

Dolphins and whales are perhaps the two subjects most frequently requested, so if you are going to be in an area where you may have the chance to see either, it's worth planning ahead so that you're prepared to take pictures, too – or actually booking yourself onto a whale- or dolphin-watching excursion on which you can shoot from a boat.

Pictures of dolphins and porpoises diving through the air should be your priority, taken with a long telephoto lens and an action-stopping shutter speed. Similar shots can also be taken of whales, though the classic image every wildlife photographer seems to aim for is of the whale's tail protruding out of the water as it prepares to dive.

You needn't travel to the ends of the earth to take such pictures – marine life centres can be just as productive if you attend a show where trained dolphins, and occasionally killer whales, perform all sorts of amazing stunts for the crowds.

The enormous aquariums in sea-life centres containing sharks, exotic fish and all manner of marine life can also be the source of great pictures – by fitting a rubber hood to your lens and pressing it tight up against the side of the aquarium, it's possible to take pictures without picking up reflections from the glass. Not quite as good as being in there yourself, but a close second and well worth trying.

Don't be afraid to try something different. Simon Stafford took this beautiful photograph of a sandpiper while on holiday in Florida – the off-centre composition and beautiful colours reflecting in the sand and sea turn what could have been a rather mundane record shot into something special.
Camera: Nikon F4s **Lens:** 300mm with 1.4x converter
Film: Fuji Velvia **Exposure:** 1/25 second at f/4

Wild thing

Photographing animals in the wild is a highly skilled process that takes great determination and dedication. Most species are incredibly suspicious of man, so getting close enough to them to take frame-filling pictures can be incredibly difficult.

Long lenses undoubtedly help – a 400mm telephoto is about the minimum you can get away with generally for shots of animals such as rabbits, hares, deer, squirrels and foxes. Shooting from a hide can reduce the camera-to-subject distance significantly, but you still need to be surprisingly close to smaller mammals such as rabbits if they're to be more than just a blot on the landscape, even with a long lens.

Even smaller mammals, such as mice and voles, require a different approach as you will need to work at close range with a macro lens – a vivarium will help here, allowing you to restrict the movements of your subject.

Stock catalogues from general picture libraries tend to feature few shots of common mammals and they are almost always the most common species photographed in a tried and tested way: atmospheric shots of deer backlit in the early morning sunlight; foxes and rabbits peering suspiciously through long grass; a hare sprinting across a field; a hedgehog rustling through autumn leaves and perhaps a squirrel nibbling on an acorn.

The main reason for this is that most general libraries operate on a global scale, so they are unlikely to achieve big sales from pictures of animals that are native to a particular country.

The big time

What does feature heavily in stock catalogues is big game. Elephants, rhino, hippos, big cats, zebras, giraffes – all the most common creatures known to frequent the plains of Africa can be good sellers. Wolves and apes are also popular subjects, not only in markets that require pictures of animals, but also for symbolic use – wolves because they are cunning predators; apes because they so closely resemble humans.

If you've got the time and the money, nothing beats going on location to photograph these animals in their natural habitat – not only for the variety of wildlife you're likely to see, but also because you get to see and photograph the animals in their true environment. Initially, however, you could dip a tentative toe into big game photography by visiting a wildlife park in your home country. Modern parks can be surprisingly good, allowing you to get relatively close to exotic animals and take pictures that could easily have been shot on the Serengeti Plains.

Either way you are going to need a long telephoto lens, ideally 400–600mm, or a 300mm with a 1.4x or 2x teleconverter, so you can fill the frame from a safe distance.

Another benefit of using such long lenses is that they reduce depth-of-field significantly when set to maximum aperture, allowing you to throw the background well out-of-focus so that your subject is prominent in the frame – and perhaps hide the fact that you were shooting in a wildlife park if you can't stretch to a pukka safari.

Rabbits and hares are incredibly sensitive creatures, so taking frame-filling pictures like this one by Geoff Du Feu takes patience, skill and a long lens. The effort is worthwhile, however, because if you reach this high standard of photography, sales are almost guaranteed.
Camera: *Canon EOS RT* **Lens:** *Tamron 400 F/4*
Film: *Fujichrome Sensia 100*
Exposure: *1/30 second at f/5.6*

Geoff Du Feu photographed this lion in Kenya's Masai Mara game reserve. However, similar shots wouldn't be out of the question in a wildlife park thousands of miles from Africa, so make the most of more local opportunities first.
Camera: *Canon EOS RT* **Lens:** *Tamron 400mm*
Film: *Fujichrome Velvia*
Exposure: *1/250 second at f/8*

LIVE PICTURES
GEOFF DU FEU – GREYHOUNDS

Geoff Du Feu took these powerful action shots of greyhounds running on a beach as a speculative stock idea for his picture libraries – he supplies a number of different libraries around the world, mainly with natural history subjects.

The idea for the shoot resulted from

Geoff walking rescue dogs on the beach near his home in Norfolk – seeing the greyhounds racing up and down the sands inspired him to take a camera along the next time.

The location for the shoot was Waxham beach, Norfolk, in Spring 1998 and Geoff arranged it for 10am so he could take advantage of a relatively low sun. The dogs belong to the owners of a nearby animal rescue centre, and as Geoff and his family often walk their rescue dogs, the owners were more than happy to let him take pictures.

Geoff decided to take mainly panned pictures to emphasize the speed and agility of the dogs. Having had plenty of practice panning birds taking off from moving boats this posed no real problem – choosing shutter speed was the only hit-and-miss thing, and he experimented

with speeds from ⅟₃₀–⅛ sec to vary the degree of blur.

Three people came along to help to hold the dogs, and to throw a ball to each other. Co-ordinating this proved harder than taking the pictures, as greyhounds have speed but no stamina – after an hour the shoot was stopped. In all Geoff exposed ten rolls of film. This sounds like a lot, but with a camera that exposes six frames per second he only got three runs per roll of film. Also, as action photography like this is rather hit-and-miss in terms of the dog's position and expression at the point of exposure, it's worth over-shooting than under-shooting – Geoff will only need to make one modest sale to recoup all his costs, which were basically just for film and processing.

Only one in ten shots were retained by Geoff. Most were technically fine, but the movement and shape of the dog was only pleasing in a few shots. So far around 30 shots have been taken up by libraries and seven have been selected for use in catalogues. They have started selling, but it's early days yet to judge their true potential.

Geoff expects them to sell well due to the good uptake, and since the greyhound is the dog equivalent of the cheetah, the images deliver a strong message of speed, agility and power.

TECHNIQUE TIPS
- Try setting up a shoot like this – any breed of dog is suitable, though ones known for their power and energy will be more commercial.
- Any open space can be used as a suitable location as well as a beach.
- Take lots of shots to increase your chance of producing a few perfect frames.

EQUIPMENT AND TECHNIQUE
Camera: Canon EOS 1RS
Lenses: 70–200mm f/2.8 zoom
Film: Fujichrome Sensia 100 and Velvia
Exposure: Various shutter speeds from ⅟₃₀–⅛ sec
Accessories: Monopod with ball and socket head

Here are just two of the 30-odd shots Geoff selected from the ten rolls of film he exposed on the day.

Expert view: Duncan McEwan

School teacher Duncan McEwan became interested in nature photography 25 years ago, after studying for a degree in botany. Despite taking pictures on a part-time basis only, he has achieved great success and his work is marketed worldwide by two leading picture libraries.

This poplar hawk moth was photographed in the Scottish Highlands with a Minolta 8000i SLR and 100mm macro lens. Duncan's efforts have so far been rewarded with £360 in sales.

'Knowledge of your chosen subject is important because the more you know about its habits and habitat, the greater the chance of taking successful pictures. My background in botany undoubtedly helps because it taught me where to look and made me curious.

'If you want to sell nature pictures, technical quality and attention to detail is important. I spend a lot of time selecting subject matter, and I pay a lot of attention to the background, using the depth-of-field preview on my camera to see how it will record at the aperture I'm using.

'All my nature photography is done using 35mm equipment. I have always used Minolta SLRs, and at present I use the Dynax 9, with either a 50mm or 100mm macro lens for close-ups. Both give lifesize (1:1) reproduction, though the 100mm achieves it at a greater camera-to-subject distance so it's more practical for timid subjects.

'Wherever possible I prefer to work in natural daylight. Bright overcast weather is ideal as it provides reasonable light levels, but the quality of light is really nice. I also use reflectors to bounce the light onto my subject – usually a sheet of white card with crumpled kitchen foil stuck on one side so I have a choice of reflector – silver reflects more light than white so you get a stronger effect.

'Early morning is a good time to photograph invertebrates because the cooler temperature makes them sluggish and more likely to stay put long enough for you to take pictures. Dragonflies tend

to settle when the sun goes in, for example, so you can set up, wait for the sun to come out so they spread their wings, then you have a few seconds to get a shot before they take off. With butterflies, you need to be careful not to cast your shadow over them if you're shooting in sunlight.

'I use a tripod whenever possible, with a fine-focus rail to help me get the focusing spot on. Saying that, you can't photograph things like butterflies with the camera on a tripod because you need to have more freedom of movement.

'Where flash is used I tend to mount one or two guns on bracket either side of the lens. I also have a Minolta macro flash unit, which fits on the lens like a ring flash but has four separate tubes that can be controlled independently.

'Film is either Kodachrome 25 or Fujichrome Velvia. I tend to prefer Kodachrome because it's so sharp and the colours are accurate – though it is slow. Velvia is chosen when I want to bring out maximum colour and detail in a subject, such as lichens.'

In a rare departure from his normal close-ups, Duncan photographed this puffin on the Scottish island of Lunga using a Minolta Dynax 9xi and 300mm lens. The shot has sold six times to date, and has made £420 for Duncan.

BEST SELLERS

ARCTIC TERN

This Arctic tern was photographed near Fort William in Scotland by Duncan McEwan. He was being dive-bombed by a number of terns at the time and captured them on film as they soared away, handholding the camera and focusing manually. It was rather hit and miss and many frames were wasted – but you only need one perfect shot to

make a lot of money and Duncan's determination and skill have been justly rewarded.

What makes it sell?
It's a strong, simple, graphic image with bold colours and a beautiful composition – the tern's wings are perfectly spread and the blue sky is stunning.

FACTS & FIGURES

Equipment *Minolta 8000i, 100–200mm zoom*
Film *Fujichrome RD100*
Number of sales to date *15*
Catalogue image? *Yes*
Where sold *USA, France, Turkey, Ireland, UK*
Used for *Brochure, calendar, postcard, magazine. Most uses unknown*
Total sales to date *£1,860*

SMALL PEARL-BORDERED FRITILLARY

Duncan McEwan photographed this butterfly in Glen Spean in the Scottish Highlands. At the time he was just looking around, not only for nature subjects but also interesting scenery as well, and spotted the butterfly in its favourite moorland habitat. The shot was taken handheld, using flash to brighten up the colours, allowing a smaller lens aperture to be used, and helping to ensure a sharp result.

What makes it sell?
Duncan is puzzled as to why this particular shot has been such a good seller, and says he has taken much more interesting pictures of butterflies. Inclusion in one of his library's stock catalogues undoubtedly helps.

FACTS & FIGURES

Equipment *Minolta X700 SLR, 100mm macro lens, flash*
Film *Kodachrome 25*
Number of sales to date *15*
Catalogue image? *Yes*
Where sold *France, Singapore, Argentina, Canada, Columbia, Australia, Sweden, USA, Ireland, Italy, Finland, UK*
Used for *Wallchart, magazine, four-page mailer. Most uses unknown*
Total sales to date: *£2,700*

DAMSELFLY

Duncan McEwan's superb close-up of a damselfly was taken early in the morning near Fort William in Scotland. This particular damselfly had only just hatched so its wings were still drying out and it was unable to fly – allowing Duncan to move in close with his macro lens and shoot almost at lifesize reproduction. The picture was taken handheld.

What makes it sell?
As well as being an excellent nature shot, this picture is also symbolic of new birth or new beginnings, so it has a wide potential market.

FACTS & FIGURES

Equipment *Minolta X700, 100mm macro lens, twin flashguns fitted on brackets*
Film *Kodachrome 25*
Number of sales to date *6*
Catalogue image? *No*
Where sold *UK*
Used for *Poster, brochure, magazine, book, display*
Total sales to date *£480*

AGRICULTURE, FOOD AND DRINK

This chapter takes in a wide range of subjects and photographic styles, but most, if not all, are accessible to part-time freelancers so they're well worth considering.

Top of the list are agricultural landscapes, which you can shoot pretty much anywhere – even city dwellers shouldn't have to travel very far to reach an area of open farmland.

Sweeping views of fields planted with different crops are constantly required for both editorial and advertising use, so it's a good idea to explore your local area and note any interesting locations that can be returned to. Many farmers still rotate their crops to prevent the soil being drained of specific nutrients, so over a period of several years you could photograph the same scene containing different crops. If you thumb through stock catalogues you will often see different shots of the same scene, so once you have discovered a location that works well photographically, you might as well make the most of it.

In terms of specific crops, the most popular are undoubtedly cereals such as wheat, barley and corn, but potatoes, carrots, oil-seed rape, sugar beet, cabbages, lettuce, maize and others are

always worth shooting. As well as the crops farmed in your own country you should also consider others when travelling abroad, such as lavender, sunflowers, vines and olives in Italy, France and Spain.

The seasons

Agricultural landscapes can be photographed throughout the year. Start in spring, when new crops begin to thrive, carpeting fields in lush green, then continue shooting every few weeks as the crops grow and mature. Even better, why not shoot the same scene from the same position through the seasons so that you end up with a comparison set of pictures that show how the agricultural landscape changes over the course of a year? Picture libraries always go for seasonal picture sets like this, and if the whole set happens to be used – which is likely – you will be paid for four shots instead of one.

Harvesting is another good subject to shoot – combine harvesters at work in the fields, bales scattered across the

Chapter 12

ABOVE Agricultural landscapes are in great demand, so it's always worth making the most of interesting scenes as and when you find them. This scene was photographed from the end of the garden at my old house, which backed on to open fields, so I was able to wait until the light was just right to emphasize the golden glow of the ripening crops.
Camera: *Olympus OM4-Ti* **Lens:** *21mm*
Film: *Kodachrome 64* **Filters:** *81C warm-up*
Exposure: *⅙ second at f/16*

LEFT Spring in the UK sees vibrant fields of oil-seed rape dominating the landscape. They're a perennial favourite among picture libraries, especially when photographed on a perfect day like this.
Camera: *Olympus OM4-Ti* **Lens:** *28mm*
Film: *Fujichrome Velvia* **Filters:** *Polarizer*
Exposure: *⅟₆₀ second at f/11*

landscape, stubble being burned and so on. Finally, the soil is ploughed ready for the next crop — neat furrows stretching off into the distance make for great pictures.

Use a wide-angle lens to capture sweeping views of fields of crops, emphasizing the converging lines created by young crops planted in neat rows or freshly ploughed furrows to add impact to your composition, or filling the foreground with crops close to the camera's position. Wide-angle lenses are also ideal when used from a low viewpoint to capture crops such as barley, wheat and oil-seed rape against the sky. Use a telephoto lens, too, to isolate interesting parts of the scene such as the patterns and colours created by different crops planted in neighbouring fields.

You don't need to be too creative here.

Bright, sunny blue-sky weather will provide ideal conditions for shooting agricultural landscapes — use a polarizing filter to increase colour saturation and deepen blue sky. The warm light of late afternoon is also perfect for enhancing the warm hues of mature cereal crops such as wheat and barley, and an 81B or 81C warm-up filter can be used if necessary.

Around harvest time, use a telephoto lens to capture tractors and combine harvesters busy in the fields. Shots of tractors pulling ploughs with flocks of seagulls trailing behind are also popular. Other shots to take include anything to do with crop spraying and pesticides, crops ruined by bad weather, cracked earth baked hard by the sun, farmers examining their crops and so on.

Farm animals

Good pictures of livestock are in constant demand, so it's worth including them on your shot list.

The easiest way to photograph farm animals is simply by going for a drive into the countryside and looking for suitable subjects. A popular technique at present involves photographing cows, sheep, pigs and horses with a wide-angle lens from close range, to produce amusing distorted images – often with the nose or snout out of focus because the subject was too close. Try this technique with both black and white and colour film. Straightforward shots taken in sunny weather are also required by most picture libraries – both landscapes containing livestock, and portraits of the animals themselves.

If you know a farmer, or are willing to find one, you will be presented with many more subjects and photo opportunities.

Hens, ducks and geese can be good sellers, especially if you take cute or amusing pictures that have uses beyond illustrating farming. Farming activities such as milking the cows and moving livestock around can also be captured on film.

Really, the shots you get depend on how hard you're willing to work, though the most commercial are undoubtedly agricultural landscapes, and they also happen to be the most accessible and easiest to take.

Food for thought

The same applies to food and drink pictures. Photographers who specialize in these subjects often go to great lengths to ensure everything is spot on, from choosing perfect specimens of whatever it is they are photographing to having qualified chefs and food stylists on site to cook and prepare dishes in the studio's kitchens.

ABOVE Late spring and summer are ideal times of year to photograph pastoral green landscapes. I captured this scene near Ambleside in the Lake District, and it has already been used in a calendar, a book of poetry and various magazines.
Camera: *Nikon F90x* **Lens:** *80–200mm*
Film: *Fujichrome Velvia*
Filters: *Polarizer and 81B warm-up*
Exposure: *⅟₆₀ second at f/16*

RIGHT Garlic is a common ingredient in many recipes, as well as having known medicinal properties, so it's a popular stock subject. I arranged these garlic bulbs on a copy of the French newspaper Le Monde to give them a more authentic look, and used fast, grainy film to add atmosphere.
Camera: *Pentax 67* **Lens:** *135mm macro*
Film: *Fujichrome Provia 400 rated at ISO1600 and pushed 2 stops* **Filters:** *Soft focus*
Lighting: *Single studio flash head with softbox from one side*
Exposure: *⅟₂₅₀ second at f/5.6*

Fortunately, you needn't go to these lengths to take saleable shots. My knowledge of cookery is minimal, yet I still have hundreds of food and drink pictures with my picture library, many of which have been, or are about to be used in stock catalogues.

The key is to study the market and find out what type of pictures are being used, and my investigation of magazines, books, supermarket brochures and other publications led me to the conclusion that simple, uncluttered shots are in the greatest demand.

Fashion and beauty magazines tend to run regular articles on healthy eating for example, and illustrate them with pictures of fresh fruit, vegetables, herbs and other foodstuffs. These pictures are nothing elaborate – more often than not they're close-ups of specific items on a plain background, rather than complicated still-lifes or prepared meals. So, that's what I shoot.

Subject and set-up

Another great thing about food photography is the accessibility of the subject matter. All I do, quite literally, is take a trip to my local supermarket with a long list of the things I have decided to photograph, buy them, return home and start shooting. Fruit, vegetables, bread, pasta – they're all there in abundance. You can also spend time selecting the best specimens, and the quantities can be as big or as small as you like.

Once home, I then get down to photographing everything, concentrating on each item in turn and taking a variety of different pictures. I might photograph a tomato whole, for example, then slice it in half and take a shot of one whole tomato with one half next to it to show what the inside of the fruit looks like. This may be repeated with apples, oranges, pears, onions and various other fruits and vegetables such as onions, potatoes and garlic.

My usual set-up is simplicity itself. The food items are placed on a sheet of white

ABOVE These pictures were all shot on my kitchen windowsill, using daylight flooding in through a nearby window as the main source of illumination. I also used the same equipment and film, shooting at maximum aperture to reduce depth-of-field. Once you discover an effective technique it's worth using it time after time – I have shot hundreds of pictures using this set-up.
Camera: Nikon F90x Lens: 105mm macro
Film: Fujichrome Sensia 100 Filters: None
Exposure: 1/60 second at f/2.8

or coloured card which acts as the background, and the pictures are taken on my kitchen windowsill using daylight for illumination and perhaps another sheet of white card as a reflector to bounce the light around (see page 188 for set-up). I almost always take food shots on 35mm, with a Nikon SLR, and my favoured technique is to use a 105mm macro lens at maximum aperture – f/2.8 – so that only a tiny area is recorded in sharp focus.

This may seem a strange way to photograph food, but if you look through stock catalogues or books and magazines, you will see that this style is very popular.

If you have a slide-viewing lightbox this can also be put to good use as a source of illumination. All you do is cut thin slices of translucent fruits and vegetables, and then lay them on the top of the lightbox so that they're backlit. This emphasizes the colours and patterns brilliantly, allowing you to produce unusual images of popular subjects. Citrus fruits such as oranges, lemons and limes are ideal, along with water melon, red onions, kiwi fruit, cucumber and so on. Other translucent

foodstuffs such as children's boiled sweets can also be photographed this way.

And don't ignore black and white. The appeal of most fruits and vegetables comes from the fact that they're colourful, so it's natural to want to record this. However, in their on-going search for original photography, picture buyers will always consider something different and black and white food shots are growing in popularity.

Liquid assets

Photographing popular drinks is well worthwhile, though it isn't necessarily as straightforward as shooting food.

Alcoholic beverages such as wine, beer, champagne and spirits are especially sought after. Mineral water is also all the rage these days, and coffee is a perennial favourite – tea less so because it doesn't have the same international appeal.

The main options you have here are either to take pictures that symbolize a particular drink, or to photograph the drink as part of a set-up. For example, champagne is symbolic of love, wealth,

success, good taste and celebration, so you can photograph it in a number of ways. One option is to capture two glasses and a champagne bottle against different backgrounds – a roaring log fire, a sumptuous room set with streamers and party hats, next to a bunch of red roses and so on. Photographers have even been known to take a couple of glasses and a bottle of bubbly to locations such as the Eiffel Tower in Paris, or on a gondola in Venice, and then use the setting as an out-of-focus background.

The most common popular shot of champagne is with the cork exploding and champagne gushing from the bottle.

To capture this effect on film, photographers employ a little trickery. First, the bottle is opened and emptied and the 'bulge' in the bottom of the bottle is knocked out with a hammer and bolt. Next, the bottle is angled with the bottom uppermost and held in a clamp, then the cork is attached to the neck of the bottle using a piece of fine wire. The final stage is to place a funnel in the bottom of the bottle and pour water into it. The idea is that water gushes out of the bottle like an explosion of champagne and covers the wire holding the cork, so

that the cork itself appears to be caught in mid-flight.

It takes a little time and patience to get the flow of water just right, and the position of the cork may need to be adjusted so that it looks convincing. To freeze the water as it gushes from the bottle you will need to use electronic flash – either a portable flashgun or a studio flash unit.

Beer, white wine, glasses of champagne and other pale-coloured drinks look their most effective when backlit, so that the colour of the liquid is highlighted. You can

do this using windowlight, or studio flash (see page 176). Shots of beer can be made to look more enticing by using cold glasses that frost over when the beer is poured, or by pouring a little too much so that the white frothy head spills over the top of the glass and runs down the side. Any drink containing bubbles – such as beer, champagne and sparkling wine – also needs to be photographed quickly after being poured, before the bubbles get a chance to settle.

LIVE PICTURES
WINE AND WATER

Here are two more variations on the original idea, taken with the same camera, lens, lighting and exposure.

This is the set-up used to take the red wine shots. For the mineral water pictures I simply removed the black card strip so that the softbox became the background.

These pictures were shot specifically for catalogue use by my picture library. I had seen similar techniques used before by other stock photographers, to create generic images of wine, beer, water and other drinks, but I didn't really have a clue how the lighting effect was achieved. So I set myself a project to find out.

Initially I planned to shoot the red wine

This was the shot I initially had in mind – and I felt incredibly satisfied once I had worked out how to create it.

pictures, so I purchased a couple of bottles of decent full-bodied plonk (knowing the contents would have to be consumed afterwards), cleaned and polished a pair of wine glasses, and got to work.

Light fantastic

It was clear that I would have to backlight the wine bottle and glass in some way while shooting it against a black background to produce simple rim lighting. This effect is created because the density of the wine allows little light to pass through, but the clearer edges of the bottle and glass do, so if you get the exposure right, the edge of the bottle and glass will record as a fine white line, with a narrow band of red just inside it.

After playing around with different set-ups, things started to go according to plan. Instead of positioning two studio lights behind the props, I tried taping a strip of black card to the centre section of a large, square (1x1m/3x3ft) softbox attached to a single studio flash head. This had the effect of turning the single light source into two strip lights, while the black card created a perfect, pure black background between them (see opposite).

All that remained was to determine the correct exposure. I did this by shooting a test roll of film, varying the lens aperture setting from f/2.8 to f/22 in ½ stop increments. Once the film had been processed, I then examined the images to see which frame was the most successful. Referring back to my notes, I then knew which lens aperture to use. Providing the bottles and glasses were kept the same distance from the softbox placed directly behind them, I also knew I could use the same aperture setting for any variations on the initial idea.

The bottles and glasses of mineral water were photographed in a similar way, only this time I used the softbox itself as a background so that the bottles and glasses were backlit and the background recorded as pure white.

Again, a test roll was shot to determine which lens aperture would correctly expose the flash, then I used the same aperture for all subsequent pictures.

ABOVE AND RIGHT Here are two variations on the mineral water idea. The monochromatic effect is highly effective, and relied on getting the exposure spot on. For the water being poured into the glass, I held a bottle out of shot and poured by hand, tripping the shutter with a cable release held in my other hand. The brief duration of electronic flash makes it possible to freeze moving water.

All in all, it took a full day to work out the lighting set-ups and shoot the test rolls. I then waited until nightfall before shooting the final films. During daylight hours, when there was ambient daylight around, I couldn't get rid of annoying reflections in the glass and plastic. Shooting at night avoided this problem because with the curtains drawn and the room lights switched off, the only light on the bottles and glasses was that coming from the softbox.

EQUIPMENT AND TECHNIQUE

Camera: Nikon F90x 35mm SLR
Lens: 105mm macro
Tripod: Gitzo Studex
Lighting: Single 250 Joule studio flash head with 1m (3ft) square softbox
Accessories: Black card
Film: Fujichrome Velvia
Exposure: $\frac{1}{60}$ second at f/11 to f/16

TECHNIQUE TIPS

• When backlighting reflective materials such as glass or plastic, make sure they are spotlessly clean, otherwise any fingermarks or dust will show up.

• Remove labels from the bottles – picture libraries will not accept images that show a specific brand name or trademark, as it limits their use and could cause copyright problems.

• Try as many variations on the initial theme as you can think of – these set-ups could be used for white wine as well as red, and beer as well as water.

Expert view: Steve Brooks

Although he still has a full-time job, Steve Brooks manages to shoot for a thriving picture library in his spare time and makes enough money from sales not only to cover all his photographic costs but to show a reasonable profit as well.

Here are just a few examples of the simple pattern shots Steve has taken using fruits and vegetables as his props.

'I wouldn't consider myself to be a food photographer in any sense – I shoot anything that catches my eye. However, I often photograph fruit and vegetables because I love the vibrant colours and the intricate patterns that occur in them naturally or which you can create. The subject matter is also easy to get hold of – I can just pop down the road to my local corner shop and buy it, though many pictures are taken of things I find in the kitchen cupboards.

'Beans and pulses are great because you can buy small packets of different varieties – red kidney beans, black-eye beans, broad beans. I also love to photograph things like red and green peppers, chilli peppers and exotic fruits – lychees, physalis, that kind of thing – and at the end of it all I get to eat my props!

'Despite this small scale of working, my "food" pictures sell quite well through the picture library. I have noticed one or two of them in print while flicking through magazines, and recently a shot I did of a plate of baked beans was used for one of those "impossible" jigsaw puzzles.

'All my pictures are taken with 35mm equipment – nothing fancy, just a Pentax manual-focus SLR with a standard 50mm lens and extension tubes so I can focus nice and close.

'I light the shots mainly with a studio flash unit and softbox which I place over the set-up, though if it's sunny I will take the pictures outdoors, using a wooden frame with tracing paper stapled over it to diffuse the sunlight – I made the frame myself. I also have a lightbox which I use to backlight things like kiwi fruit – you can reveal some amazing patterns by cutting thin slices of different fruits and vegetables, then placing them on a lightbox. To get the exposure right when doing this I first set the camera to aperture priority, then bracket exposures 2 stops over what the meter says, in ½ stop increments.'

BEST SELLERS

YOUNG CROPS

I used to drive past this field on my way to and from the office each day. Then one day I had the bright idea of taking a picture of the same scene every calendar month for a whole year, using the same camera, lens and film and shooting from exactly the same viewpoint, to document how seasonal changes affected it. Each stop took no more than ten minutes, and with the full set complete I posted them off to my picture library.

Four were eventually chosen for catalogue use – shots taken in spring, summer, autumn and winter. However, it's this particular shot, taken in spring, which has sold best.

What makes it sell?

Simple composition, beautiful blue sky, lush green crops – it's symbolic of spring and the bursting forth of new life in the landscape.

FACTS & FIGURES

Equipment *Olympus OM4-Ti, 28mm lens*
Film *Fujichrome Velvia*
Number of sales to date 11
Catalogue image? *Yes, as part of a seasonal set*
Where sold *UK, France, Germany, Turkey, Belgium, Luxembourg, Taiwan, Portugal, Singapore, the Netherlands*
Used for *Magazine, brochure, single-sheet mailer. Most uses unknown*
Total sales to date *£580*

BROWN BREAD

Most of the food pictures I take are very simple and feature only one or two items, so this still-life of different loaves of bread was a bit of a departure for me. I set up the shot on a pine kitchen table and cropped in close to remove distracting details in the room. Lighting was provided using a pair of studio flash heads fitted with softboxes.

What makes it sell?

Photographically I actually find this shot rather boring, and haven't taken anything remotely like it since. As a stock illustration, however, it works well, showing what the bread looks like instead of trying to be too clever.

FACTS & FIGURES

Equipment *Pentax 67, 165mm lens*
Lighting *2 studio flash heads with softboxes*
Film *Fujichrome RDP100*
Number of sales to date *1*
Catalogue image? *No*
Where sold *UK*
Used for *Single-sheet mailer*
Total sales to date *£130*

PEPPERS

These colourful peppers were purchased from a local supermarket during one of my occasional food photography frenzies. Once home, I arranged them into an interesting composition, set up a single studio flash head and softbox above and behind them, and took the shot. Quick, simple, but effective.

What makes it sell?

Peppers are an integral part of many recipes, from *chilli con carne* to salads, so pictures of them are often requested. Being so colourful they also make for vibrant, graphic images, and tend to be used in a big way – this shot was chosen for a brochure cover.

FACTS & FIGURES

Equipment *Nikon F90x, 105mm macro lens*
Lighting *Single flash head with softbox*
Film *Fujichrome Velvia*
Number of sales to date *3*
Catalogue image? *No*
Where sold *UK*
Used for *Brochure cover, photographic magazine article*
Total sales to date *£350*

Concepts and Style

One of the biggest developments in the stock photography industry in the last five years has been the emergence of the 'concept' image.

Most general stock catalogues will feature a chapter that bears this title, and several have even gone as far as producing concept catalogues.

So what exactly is a concept image? Difficult to say, really, because unlike nature, travel, people and wildlife, this elusive badge relates more to a state of mind or attitude than a readily identifiable subject. Concept images encapsulate moods, symbols, thoughts, feelings and ideas in a stylish and imaginative way, and can do so using all manner of subjects, from people and nature to inanimate objects.

Photographers have always produced conceptual images, but traditionally they were done on commission, following an art director's brief and with a specific end use in mind. Given the rise in the popularity and standards of stock photography today, however, the opposite

RIGHT 'I love you', 'Sorry', 'Thanks for last night' – this simple note left with an empty coffee cup could suggest many things and is a good example of a stylish, contemporary concept image. I shot it in windowlight, using unfiltered tungsten-balanced film to create the cold blue colour cast.
Camera: *Nikon F90x* **Lens:** *105mm macro*
Film: *Kodak Ektachrome 320T rated at ISO640 and push-processed 1 stop*
Exposure: *1/30 second at f/4*

BELOW Simple, imaginative images can be big sellers. These playing cards were lit with a slide projector to create the warm colour cast, and I intentionally overexposed the shot to burn out the white highlights. Shooting at maximum aperture has also minimized depth-of-field, so that only the red heart is in sharp focus and all attention is drawn towards it.
Camera: *Nikon F90x* **Lens:** *105mm macro*
Film: *Fujichrome Sensia 100*
Exposure: *1/15 second at f/2.8*

chapter 13

now applies and many of those very same art directors instead turn to picture libraries, hoping an image already exists that offers a visual solution to a particular creative problem.

Photographers producing concept images therefore have to try to second-guess the type of thing that may be required, and interpret age-old themes and ideas in new and exciting ways.

Whatever the idea or theme happens to be, however, the current trend seems to be to let your imagination run riot and see what happens. Slow shutter speeds, jaunty camera angles, cross-processing film to create weird and wonderful colours, infrared, digital image manipulation, image transfer, deliberately throwing the subject out of focus, creative overexposure – anything goes, and the more unusual the better.

To creative photographers everywhere this has come as a much-needed breath of fresh air. Picture libraries were for a long time a hotbed of boring, predictable images, but today their appetite for something fresh and innovative is insatiable, giving those willing to try the opportunity to stretch their imagination and aesthetic skills to the limit.

Experiment and predict

My involvement in conceptual photography is a recent development, brought on partly by noticing changes in the stock industry but also by a desire to be a little more outlandish with the type of pictures I take, and to experiment with ideas and techniques that before I could never find an application for.

As most of my photography still revolves around landscape and travel subjects, producing concept images also allows me to make full use of any time I have between trips away, or when plans change due to bad weather.

The great thing about this type of photography is that you can literally wake up in the morning with no plans, scratch your head, and come up with an idea to work on. Fashion and lifestyle magazines, books and advertising commercials can be a great source of ideas because they reflect the current way in which photography is being used by the media. Plus there are always stock catalogues to fall back on, and it's well worth speaking to your own picture library to see if they have any current needs.

The key is to try to think ahead and predict how trends may change. The same ideas and concepts will continue to be used, but the way in which they're depicted visually will change. So, by all means look at stock catalogues for general ideas, but remember that the pictures you see will have been taken two years ago or more, and already the market will be looking for something different.

ABOVE Not all concept images have an obvious use – sometimes a picture can sell well simply because it's wacky. Here, colour infrared film was used to create this bizarre 'Casper the Friendly Ghost' effect.
Camera: *Nikon F90x* **Lens:** *28mm*
Film: *Kodak Ektachrome EIR colour infrared*
Filters: *Deep yellow*
Exposure: *¹⁄₆₀ second at f/16*

LEFT The simplest ideas can be good sellers. Here, a tape measure around an apple could be used to illustrate anything from dieting to healthy eating, while to an art director those three rubber ducks could represent single parenthood, leadership and various other concepts.
Camera: *Nikon F90x* **Lens:** *105mm macro*
Film: *Fujichrome Sensia 100* **Lighting:** *Windowlight*
Exposure: *½ second at f/16*

RIGHT It may be a little clichéd, but the blurred alarm clock is still a popular stock image – I created the blur in this shot by shaking the camera during a ½ second exposure.
Camera: *Nikon F90x* **Lens:** *105mm macro*
Film: *Fujichrome Sensia 100* **Filters:** *Blue 80B*
Lighting: *Windowlight*
Exposure: *½ second at f/16*

Equally important is that when you shoot concept pictures, you do so intending them to be selected for catalogue use by your picture library. If they're not, it's unlikely you will achieve sales because they're not the type of pictures someone is going to ask for. Who, for example, would think to request a melting ice cube shaped like a heart, or a close-up of the 'Help' key on a computer keyboard lit with blue light? They wouldn't – usually because the thought had never even entered their head. But seeing such an image in a stock catalogue, or on a library website for that matter, could spark an idea which until that minute didn't exist.

Creating the image

The first step in producing concept images is to come up with a theme. Time, love, stress, hope, life, party, the future, dreams, touch, wonder, relax, gamble, escape, speed, danger, hot, cold, energy, risk, force, struggle, age ... These are just a few off the top of my head. Then there are different colours – red, yellow, green, blue, white, black, pink – and what they symbolize.

Next, come up with a list of different ways in which that theme or idea can be interpreted. For example, love could be something obvious like a couple kissing, but a heart carved in tree bark is just as symbolic without being so obvious.

ABOVE A close-up of a cigarette stubbed out on a dinner plate says everything there is to say about the social issues of smoking.
Camera: Nikon F90x **Lens:** 105mm macro
Film: Fujichrome Sensia 100 **Lighting:** Windowlight
Exposure: Various

RIGHT This toned black and white image immediately says 'old person', even though you can't see the subject's face. The clothes, the shoes and the bags say it all, allowing a clear message to be put across in an innovative way – and without the need for a model release because the person is unidentifiable.
Camera: Nikon F5 **Lens:** 80–200mm
Film: Fuji Neopan 1600
Exposure: 1/500 second at f/8

Similarly, escape could be suggested by a person running, an arrow on a road sign, a waterfall and so on.

In many cases, it's not so much what you photograph to suggest a certain concept, but how you photograph it. If people are included in a shot, for example, it doesn't necessarily matter that you can see their faces – often the shot will be more commercial if you can't, because the idea is that the image could apply to anyone. Shooting at maximum aperture so that only a small part of the subject or scene is recorded in sharp focus is especially popular these days, regardless of the subject. By doing so you can hint at something without being too obvious about it so, again, the concept you're trying to capture can be widely applied. Remember, less is more.

Think laterally, rather than literally. Ignore your first ideas – the chances are they will be too obvious, and everyone else will think of them, too. Scribble notes and thoughts. Make connections and associations. If you have a creative mind you will find this process challenging and satisfying; if you don't, it will be frustrating and fruitless.

Whenever you are out and about, keep an eye open for possible props that can be used in future photographs, or let the things you see trigger ideas – junk shops and antique fairs are great places to find subject matter for still-life images, though you can also find a lot of material around your own home. Your daughter's tatty old doll could be used to symbolize abuse and neglect, for

example, but when nursed in the arms of your daughter the message implied is completely different – love, companionship, best friends. It's all down to the way you photograph the subject matter.

Technicalities

I shoot most concept images using 35mm equipment – a Nikon SLR and 105mm macro lens usually – not only because it's quick and versatile, but also because the cost per shot is low compared to medium or large format. This means I can experiment with different techniques and shoot lots of variations on the same theme without having to worry too much about how much film I'm using. Remember: a

ABOVE A popular technique when shooting concept images is to set your lens to its widest aperture, so that only a small part of the subject is recorded in sharp focus. By using the technique here you can still identify the subject, but visually it makes the image much more interesting.
Camera: *Nikon F90x* **Lens:** *105mm macro*
Film: *Fujichrome 64T tungsten-balanced*
Lighting: *Windowlight*
Exposure: *¹⁄₃₀ second at f/2.8*

LEFT The surreal colours in this image were created by treating the original black and white print in a Colorvir pseudo-solarization bath. Similar effects are now much easier to achieve digitally.
Camera: *Olympus OM1n* **Lens:** *85mm macro*
Film: *Ilford HP5* **Lighting:** *Windowlight*
Exposure: *¹⁄₂₅ second at f/5.6*

single stock image can earn you very large sums in royalties, so sometimes it is necessary to waste a little film in your quest for those big sellers.

In terms of lighting, I use windowlight whenever possible for still-life shots because it's so easy to work with, totally free and highly versatile – reflectors can be used to bounce the light around, and you can vary the quality of light by shooting at different times of day, in different weather conditions and using windows that face in different directions.

For soft, shadowless light, for example, you need a window that faces away from the sun and only admits reflected light, and dull weather. For harsh, contrasty

light, choose a window that admits direct sunlight and shoot in bright conditions. For warm light, shoot early or late in the day, using a window that admits direct light. I have taken literally hundreds of concept pictures on my kitchen windowsill.

I also enjoy experimenting with a 35mm slide projector, using its narrow, powerful beam of light to illuminate parts of the subject selectively.

The bulb used in a slide projector has a low colour temperature, so pictures taken on daylight-balanced film will come out with a strong, warm colour cast. This can look highly effective on the right subject, but you can tone it down using cool filters from the 82 and 80 series.

Alternatively, you can modify the light by actually placing colour slides in the projector so that an image is cast on your subject. If you defocus the lens, the image won't be identifiable, but by using this technique you can create an interesting patterned lighting effect, and vary the colour of the light – a picture taken at sunset will warm the light significantly, while a shot with a strong blue cast will cool it down.

Capturing lifestyle

As well as suggesting a certain mood or emotion, good concept images also need to be stylish and reflect the times we live in.

In recent years, the appreciation of

ABOVE Here's another example of shooting at maximum aperture. This time I did it to prevent the addresses in my personal organizer from being readable, but it's still clear what the subject matter is.
Camera: *Nikon F90x* **Lens:** *105mm macro*
Film: *Fujichrome Velvia*
Lighting: *Tungsten reading lamp*
Exposure: *⅛ second at f/2.8*

BELOW Chains are symbolic of all kinds of things – struggle, confinement, power. I took this shot using tungsten-balanced film overexposed in daylight to create the graphic blue-on-white effect. The chain was purchased from a local DIY store.
Camera: *Nikon F90x* **Lens:** *105mm macro*
Film: *Kodak Ektachrome 160T*
Lighting: *Windowlight* **Exposure:** *1/60 second at f/2.8*

creative photography has grown enormously thanks to its innovative use in fashion and lifestyle magazines, so the public demand and expect something a little out of the ordinary.

Fashion photography has taken this to the extreme. In some campaigns the images are so blurred or out of focus that you can't even identify the clothing or the models. But that's the whole idea. Young, stylish people of today don't buy designer labels because they necessarily look good, but because they suggest or promise a certain lifestyle. The type of photography used to advertise those labels is instrumental in feeding the viewer the right messages.

And that, essentially, is what concept photography is all about – putting ideas into people's heads through the creative use of subject matter, lighting and photographic technique.

Expert view: Steve Allen

Award-winning photographer Steve Allen shoots stock for The Image Bank, one of the world's leading picture libraries, as well as producing images for high quality, royalty-free CDs.

'Planning is the key to my work. Before shooting anything, I have already mapped out exactly what will be done in-camera and what, if anything, will be done digitally. This makes producing the final image fairly straightforward and also allows me to get as close to perfection as possible.

'For the royalty-free CDs I would come up with a working title that would set the theme, and if that was accepted I would then produce a list of around 120 individual images, from which 100 would eventually be chosen.

'One of the CDs I did was called 'Drips, Drops, Splashes and Pours', which is self-explanatory really. To get ideas for the shots I could take, I looked in magazines, watched TV commercials, thumbed through stock catalogues and so on. I would never blatantly copy a picture someone else has taken, but looking at other photographs sparks off ideas.

'I had a five-week deadline to produce all the images, so I worked on that project almost exclusively. The pictures varied considerably, from close-ups of water droplets on leaves and petals, which I shot in my garden with 35mm equipment, to quite complicated studio set-ups. I shot paint dripping off a paint brush, balls being dropped into pools, the froth being blown off the top of a beer glass, cream being poured onto strawberries, and so on.

'For the splash shot shown here I exposed a single roll of 120 film on a 6x7cm medium-format camera of an ice cube being dropped into the glass, and froze the splashing water with flash. A couple of the shots were reasonable, but for the final image I scanned a few of the slides, cut out the splash from each one with the lasso tool in Adobe Photoshop, then combined them on a single image to

This superb image was produced by Steve for a project entitled Drips, Drops, Splashes and Pours.

create the perfect splash. Because all the shots had been taken using the same lighting and same background, this was quite easy to do.

'The vase of flowers was from a different shoot altogether. I positioned the flowers on a pine cabinet with the decanter and glasses against a plain wall, which I coloured using a Hosemaster lighting system. Once that image had been scanned, I then placed a frame around it, multiplied the image and placed one copy on another to give the effect of a frame within a frame, within a frame.

'A lot of what I do involves experimentation. You have an idea, try it, and see what happens. Sometimes things don't go according to plan so you try again until you get it right.'

Steve spends a lot of time coming up with innovative ideas, then uses his skills and experience to make them happen.

LIVE PICTURES
YELLOW FLOWERS

Photographs of flowers have a variety of uses as stock images: for calendars, greetings cards, framed prints, magazine illustration and, more lucratively, to advertise everything from banking to lifestyles. They're also good subjects for photographic magazines, illustrating creative use of colour, still-life and close-up technique, and so on.

The flowers used in the main shot are some kind of daisy (sorry, I'm no botanist), which I noticed growing in the car park of my processing lab. I was struck by their vibrant colour, so I asked the owner if I could pick a few to photograph and he kindly agreed.

I also purchased a selection of gerbera in different colours from a local florist. Along with sunflowers, tulips and poppies, gerbera are fashionable flowers that never date and are therefore more likely to sell over an extended period. They're also very graphic, with a bold, well-defined shape and vibrant colours – ideal for creating strong images.

Next, I headed to a local art shop and purchased large sheets of card in various bright colours – blue, green, red and plain white – to use as backgrounds.

It's a set-up
Once home, the flowers were placed individually in bottles of water to keep the delicate heads apart and I photographed

each colour in turn against a contrasting coloured background or plain white.

The pictures shown here were all taken on my kitchen worktop, using nothing more elaborate than daylight flooding in through a nearby window. The window is

Of all the pictures taken, this one is my favourite. I love the vibrant colours of the flowers contrasting with the vivid blue background and cup. It's also the one which my picture library preferred – always a good sign.

north-facing so it never admits direct sunlight, which means that even on sunny days the light flooding in is soft and almost shadowless – very similar to that produced by studio flash units fitted with large diffusers.

I have used this set-up many times to shoot literally hundreds of stock pictures.

The 'behind the scene' picture here shows the set-up used. Not exactly glamorous, I admit, but it's the end result that matters, not how you took it, and once you discover a lighting set-up that

works, it can be used again and again to produce saleable pictures of a wide range of subjects.

Initially, I photographed just the head of the flower from different angles, with the flower placed in a bottle to support the stem. Next, I decided to be a little more adventurous and started looking for something to place the flowers in that would add more colour and could be included in the shot. A quick rummage through my kitchen cupboards revealed a pile of colourful plastic picnic cups. Perfect.

The next shots were taken using exactly the same set-up on the kitchen worktop, only this time I cut the stems much shorter and placed the flowers in the cups –

EQUIPMENT AND TECHNIQUE

Camera: Nikon F90x 35mm SLR
Lens: Nikkor 105mm f/2.8 macro
Tripod: Gitzo Studex
Film: Fujichrome Sensia 100
Filters: None
Lighting: Windowlight

yellow gerbera in blue cup, red gerbera in green cup and so on. I also placed a sheet of white card on the worktop to cover up its mottled pattern and create a clean, simple base so that I could include the bottom of the cup in the shot.

A number of variations on the idea were produced – first one flower in the cup, then two, then three. After doing this with all the different colours of gerbera, I repeated the whole thing but from a different angle.

Some shots were taken with the lens set to its widest aperture – f/2.8 – so only the main point of focus came out sharp, while for the shots with the colourful cups I stopped the lens down to f/16 to record everything in sharp focus.

All in all, I spent around four hours working on this idea. By the end of it I had produced more than 200 colourful, graphic images.

TECHNIQUE TIPS

• Start out with a definite concept in mind, but once you begin shooting be prepared to vary it and work on other ideas.

• Once you find a lighting set-up that works, exploit it. I use the light from my kitchen window for many different shots. It's free, it's easy, but most important of all, it's effective.

• A single, modest sale can easily cover the cost of ten rolls of film, so don't be afraid to experiment with new ideas, or waste a few frames. You've got to speculate to accumulate.

Here are some of the shots taken on the same day, using identical equipment and lighting. Variety is the key to success with stock photography.

BEST SELLERS

GRAINY FACE

This is my friend, Peter Bargh, editor of *Digital Photo FX* magazine. I took the original photograph years ago, while experimenting with infrared film, and made a 16x12in print which was subsequently sepia toned. Much later, I decided to copy part of the print back onto colour slide film to emphasize the coarse grain, which gives the image a graphic simplicity.

What makes it sell?

Photographically it shows good use of grain, but as a concept image it's ideal for illustrating anything to do with confusion, contemplation, decision-making and similar themes. Again, it's a very simple, clean image.

FACTS & FIGURES

Equipment *Olympus OM4-Ti , 85mm lens*
Film *Kodak High Speed Mono Infrared*
Number of sales to date *8*
Catalogue image? *No*
Where sold *UK, Singapore, Spain, Germany, France, USA*
Used for *Magazines, brochure, mailer, newspaper editorial*
Total sales to date *£540*

TOYOTA MR2

I used to own a gleaming red Toyota MR2 sports car, and occasionally got my wife to drive it while I took some action pictures. In this case I wanted to capture a strong feeling of power, speed and drama without the make or model of the car being identifiable, so I crouched down by the side of a narrow country lane and as the car passed by at close range I took panned shots at slow shutter speed.

What makes it sell?

Again, it's a very simple image that implies speed, action, escape, life in the fast lane and any other related concepts. Red is also the strongest colour to use for shots like this as it leaps out from the background, and although you can see that the subject is a car, only those with a trained eye could identify it. Anonymity is usually important with concept images because it's the message that counts, not the subject.

FACTS & FIGURES

Equipment *Nikon F90x SLR, 28mm lens*
Film *Fujichrome Velvia*
Number of sales to date *9*
Catalogue image? *No*
Where sold *UK, USA, Germany, France, Australia*
Used for *Photographic and in-house magazines, single-sheet mailer. Most uses unknown*
Total sales to date *£380*

NOAH STRESSED!

Another shot of my young son, this time in a less favourable light. I had spent a little time chasing him around the house shooting slow-sync flash pictures, but eventually he got fed up with it and had a little temper tantrum when I refused to stop. This was the last frame I exposed, and ironically it proved to be the best.

What makes it sell?

The combination of Noah's expression and all that blur going on in the background makes this shot ideal to illustrate anything to do with stress, anger, bad temper and childhood tantrums. It's also a good example of slow-sync flash as a photographic technique.

FACTS & FIGURES

Equipment *Nikon F90x, 28mm lens, Vivitar 283 flashgun*
Film *Fujichrome Velvia*
Number of sales to date *3*
Catalogue image? *No*
Where sold *UK*
Used for *Photographic magazine, parenting magazine, book*
Total sales to date *£250*

USEFUL ADDRESSES

Below you will find contact details for a number of organizations that are relevant to photographers trying to shoot and sell stock images.

BAPLA, CEPIC, PIAG and PACA are the main trade associations representing picture libraries and agencies in Britain, Europe and the USA, respectively – the national member associations of CEPIC for different European countries are also listed.

In the UK, the Bureau of Freelance Photographers (BFP) provides its members with sales leads and market information in a monthly newsletter, plus an annual market handbook listing hundreds of potential outlets for your work (see below). If you are a freelance photographer based in the UK, the BFP is well worth joining. This service seems to be pretty unique, and despite many attempts I failed to locate similar freelance organizations in Europe, the USA or anywhere else in the world.

I have intentionally avoided listing specific picture libraries, as there are too many to include and up-to-date information can be obtained from the relevant trade associations.

American Society of Media Photographers (ASMP)
150 North 2nd Street, Philadelphia, PA 19106, USA
Tel: 215 451 2767
Fax: 215 451 0880
Website: www.asmp.org

Asociacion Empresarial de Agencias de Prensa y Archivos Fotograficos (AEAPAF)
Viladomat, 174 E-08015 Barcelona, Spain
Tel: (34) 93 487 4000
Fax: (34) 93 487 1428

Bildverantorernas Forening (BLF)
Sliparvagen 4, S-146 36 Tullinge, Sweden
Tel: (46) 8 778 78 14
Fax: (46) 8 778 78 15

British Association of Picture Libraries and Agencies (BAPLA)
18 Vine Hill, London EC1R 5DZ
Tel: 020 7713 1780
Fax: 020 7713 1211
E-mail: bapla@bapla.org.uk
Website: www.bapla.org.uk

British Photographers' Liaison Committee (BPLC)
81 Leonard's Street, London EC2A 4QS
Tel: 020 7739 6669
Fax: 020 7739 8707
E-mail: general@aophoto.co.uk
Website: www.aophoto.co.uk

Bundesverband der Pressbild-Agenturen und Bildarchive e.V. (BVPA)
Lietzenburger str. 91, D-10 719 Berlin, Germany
Tel: (49) 30 324 99 17
Fax: (49) 30 324 70 01

Bureau of Freelance Photographers (BFP)
Focus House, 497 Green Lanes, London N13 4BP
Tel: 020 8882 3315
Fax: 020 8886 5174
Website: www.thebfp.com
Organization dedicated to helping photographers find markets for their work.

Co-ordination of European Picture Agencies (CEPIC)
Teutonen str. 22, 14129 Berlin, Germany
Tel: (00 49) 30 816 99429
Fax: (00 49) 30 816 99445
E-mail: cepic@akg.de
Website: www.cepic.org

Copyright Belgium Association (CBA)
19 Rue Pechere, B-1380 Lasne, Belgium
Tel: (322) 6-33 000
Fax: (322) 6-333 407

Design & Artists' Copyright Society (DACS)
Parchment House, 13 Northborough Street, London EC1V 0AH
Tel: 020 7336 8811
Fax: 020 7336 8822
E-mail: info@dacs.co.uk
Website: www.dacs.co.uk

Federation Nationales des Agences de Presse Photo et Information (FNAPPI)
13 Rue Lafayette, F-75009, Paris, France
Tel: (33) 1-44 927923
Fax: (33) 1-44 927910

Holland Press Agency (HPA)
Postbus 14658, NL-1001 LD Amsterdam, Holland
Tel: (31) 20 5306070
Fax: (31) 20 6203729

Norske Bildbyraers Forening (NBBE)
Jan Greve Scanpix, PB 1178 Sentrum, N-0107 Oslo, Norway
Tel: (47) 22 00 32 00
Fax: (47) 47 00 32 10

Picture Agency Council of America (PACA)
PO Box 308, Northfield, MN 55057-0308, USA
Tel: 800 457 7222
Fax: 800 645 7066
Website: www.indexstock.com/pages/paca.htm

Picture Research Association (PRA)
The Studio, 5a Alvanley Gardens, London NW6 1JD
Tel: 020 7431 9886
Fax: 020 7431 9887
E-mail: pra@pictures.demon.co.uk

Presse Informations Agentur GmbH (PIAG)
Stefanien str. 25, D-76530 Baden-Baden, Germany
Tel: (00 49) 7221 301 7560
Fax: (00 49) 7221 301 7561
E-mail: piag.visuell@t-online.de
Website: www.piag.de

Schweizerische Arbeitsgemeinschaft der Bild-Agenturen und-Archive (SAB) Association Suisse des Banques d'Images et Archives Photographiques (ASBI)
PO Box 15, CH-5303 Wurenlingen, Switzerland
Tel: (41) 56 281 12 31
Fax: (41) 56 281 22 49

Svensk Bilbyraforening (SBF)
c/o IMS, PO Box 45242, S-104 30 Stockholm, Sweden
Tel: (46) 8 30 25 00
Fax: (46) 8 33 88 75

Voice of the Specialist Libraries
Photo-Arte Gallery, 19 Ashfield Parade, London N14 5EH
Tel: 020 8882 6441
Fax: 020 8882 6303
E-mail: lupe.cunha@btinternet.com
Website: www.sldirect.co.uk

USEFUL PUBLICATIONS

ASMP Bulletin
Journal published ten times per year by the American Society of Media Photographers (see Useful Addresses). Available to members only, it provides market and business information for photographers working primarily in the magazine industry.

The Freelance Photographer's Market Handbook
Published annually by the BFP (see Useful Addresses). Contains contact details and general picture requirements for hundreds of book, magazine, postcard, greetings card and calendar publishers, plus listing of picture libraries in the UK and advice on how to make sales in each market. Available direct from the BFP.

Lightbox magazine
Published by BAPLA (see Useful Addresses) four times per year, this magazine contains information of relevance and interest to anyone serious about stock photography. It's available on subscription to non-members, but is mailed to BAPLA members free of charge.

Market Newsletter
Monthly bulletin from the BFP (see Useful Addresses) which provides up-to-date information about changes in the publishing industry such as new magazine launches, interviews with editors and specific picture requirements from a wide range of markets. Only available to members of the BFP.

Photographer's Market
Writer's Digest Books, 1507 Dana Avenue, Cincinnati, Ohio 45207, USA.
Tel: 513 531 222
The American equivalent of *The Freelance Photographer's Market Handbook*, published annually and detailing hundreds of markets throughout the USA for pictures, plus over 200 picture libraries. Copies can be obtained direct from the BFP in the UK (see Useful Addresses) and from the publisher in the USA.

The Writers' and Artists' Yearbook
A&C Black Publishers Ltd, 35 Bedford Row, London WC1R 4JH. Tel: 020 7242 0946.
Annual guide listing magazines, book publishers, picture libraries, postcard, greetings card and calendar publishers in the UK. Similar to *The Freelance Photographer's Market Handbook*, but worth buying both for wider coverage of the markets. Available from good bookshops or by special order.

INDEX